Expressive Painting
in
Mixed Media

Soraya French

EXPRESSIVE PAINTING
in
MIXED MEDIA

SORAYA FRENCH

THE CROWOOD PRESS

First published in 2014 by
The Crowood Press Ltd
Ramsbury, Marlborough
Wiltshire SN8 2HR

www.crowood.com

British Library Cataloguing-in-Publication Data
A catalogue record for this book is available from the British Library.

ISBN 978 1 84797 798 4

Frontispiece: *Pink Sensation*

Typeset by Jean Cussons Typesetting, Diss, Norfolk

Printed and bound in Malaysia by Times Offset (M) Sdn Bhd

CONTENTS

ACKNOWLEDGEMENTS

My sincere thanks and gratitude to Golden Artist Colors along with Sandy and Jason Mackie at Global Art Supplies for their continued support over many years. Special thanks to Patti Brady for organizing the supplies for this book. I would also like to extend my great appreciation and thanks to St Cuthbert's Mill for their generous supply of Saunders Waterford paper over the last few years.

My deepest gratitude to my special daughter for her patient and meticulous help with photography, layout and text reviews, you are so clever and the most gentle and wonderful teacher, it was pure joy working with you.

I am so glad that I had the insight all those years ago as an eighteen-year-old to choose a husband with so much practical and technological knowhow. Your love and support throughout our life together has enabled me to follow my dream and for that there are no words to thank you enough.

This book is dedicated to Tim, Yasmin and Saasha.

The author in her studio.

INTRODUCTION

If you are reading this book, the chances are that you are ready to take the challenge of delving into the exhilarating world of painting in mixed media. This genre of painting is by far the most liberating form of expression for artists. Each medium's individual characteristics bring something fresh to the table and broaden your artistic horizons with a myriad of possible techniques. You can set aside many of the anxieties associated with the limitations of working in a single medium and push the creative boundaries by the many different and exciting combinations. Incorporating gels, pastes and paper collage as well as a whole host of mark making materials widens the margin for experimentation and will help you create exciting visual and tactile textural effects in your paintings.

However, thinking creatively and the ability to process your creative ideas in a cohesive manner are just as important as your expertise in applying the materials and the elements and principles of design. I am hoping that this book will help you develop your understanding of a variety of possible painting techniques with mixed media, as well as address some of the behind-the-scenes psychological factors that go hand in hand with the technical aspects to help you create better paintings and, most importantly, increase your enjoyment of the process.

A word of advice: ensure that you take time to get to know the attributes of each medium so that you can make informed decisions about its contribution to your painting. This simple step will help you avoid producing paintings overladen with incompatible layers of discordant materials.

To get the most out of this book be prepared to step out of your comfort zone and start experimenting with some new and challenging ideas to help you progress with your painting.

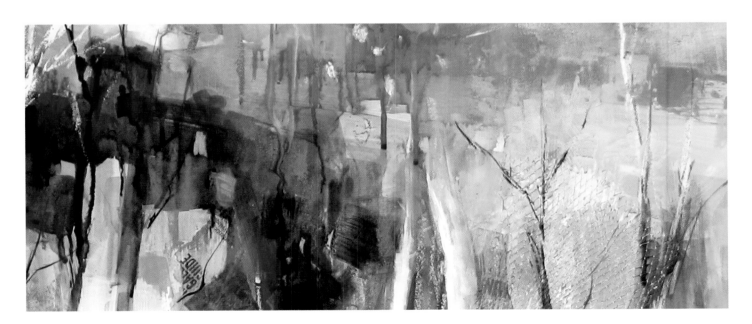

The City Beyond *detail.*

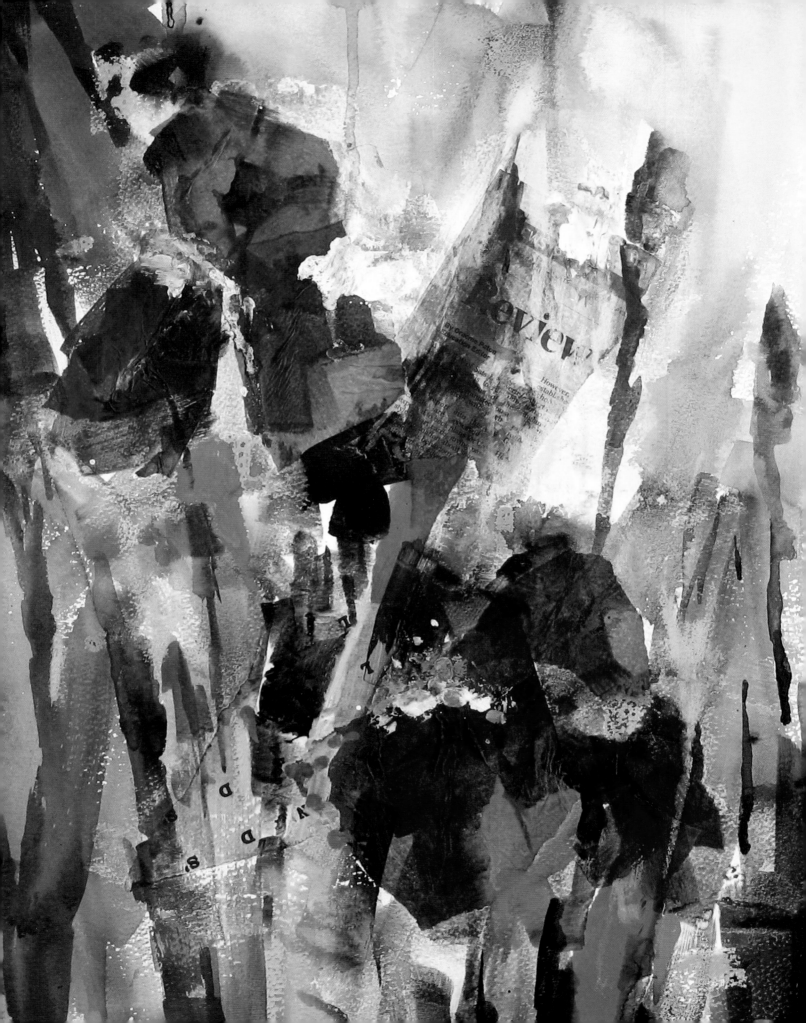

GETTING STARTED

The craft aspect of painting deals with the ability to apply the materials in the most creative and dynamic way using all the elements and principles of design. However, in any creative pursuit, and painting is no exception, there are also psychological barriers that may get in the way of the artist achieving their full artistic potential. Sometimes these factors are caused by external influences such as lack of encouragement in childhood, or they can be due to internal limitations: setting ourselves unrealistic goals, having high expectations, aiming for perfection and above all, the fear of failure.

In this chapter, as well as exploring practical matters such as some of the essential equipment you need, we will also be looking at the ways in which you can gain confidence, by putting aside the fear of failure and building a positive, creative frame of mind. Learning the best way to format and compose your painting, being prepared to experiment without expecting a masterpiece at the end of each session and recognizing your level of ability to avoid disappointment – these are just a few of the steps you can take to begin your journey. Discovering your sources of inspiration will help you find your ideal subject matter and keep you motivated so that you make time for your painting.

Learning to paint is no different from learning to play a musical instrument; it needs time, effort, patience and plenty of practice. Taking things one step at a time and setting realistic and achievable goals will help you progress so much more in the long run. Painting in mixed media offers you the freedom of experimenting and applying the materials in any sequence until you find your own natural rhythm.

OPPOSITE: **French Irises** *(watercolour, acrylic inks, oil pastels and collage).*

Purple Rain *(acrylic, collage and aquarelle pencils).*

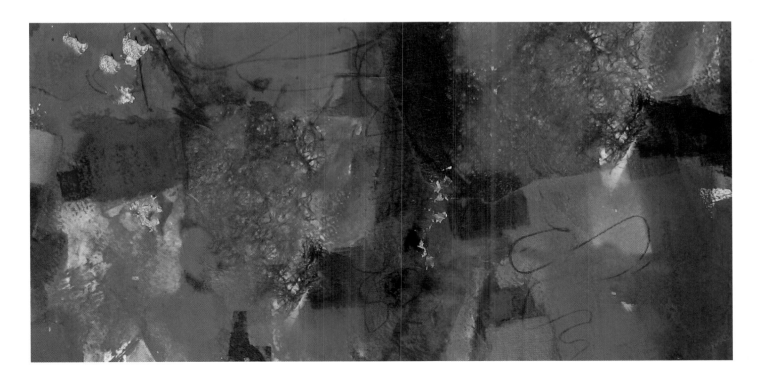

Steps along the way

Visualization

I am often asked by my students if I have a clear idea of the image I wish to achieve before I start a painting. The answer to that is both yes and no. As is the case in many aspects of painting there is not a clear-cut answer or solution. But the best way I can describe my personal approach is that I usually have a subject in mind but mostly I paint my reaction to a scene rather than what I actually see. I try to visualize the end result loosely while keeping an open mind and let the painting take its natural course and guide me along the way. In other words I find that by being too strict with my ideas I may lose the magic and the spontaneity. Laboured and forced brush marks applied through desperation and boredom can do no end of harm to the finished result, and on balance I am happier with a lively image even though it may not be exactly what I had in mind in the first place. Once in a while, however, one can get rewarded when not only does the visualized image come to fruition but the process is organic, enjoyable and fun. Inevitably there are some failures along the way; they are not only great teachers but make the successes taste even sweeter. Accepting the unpredictable nature of painting in a loose and free style is a step towards getting tougher in the face of the inevitable failures and celebrating the successes.

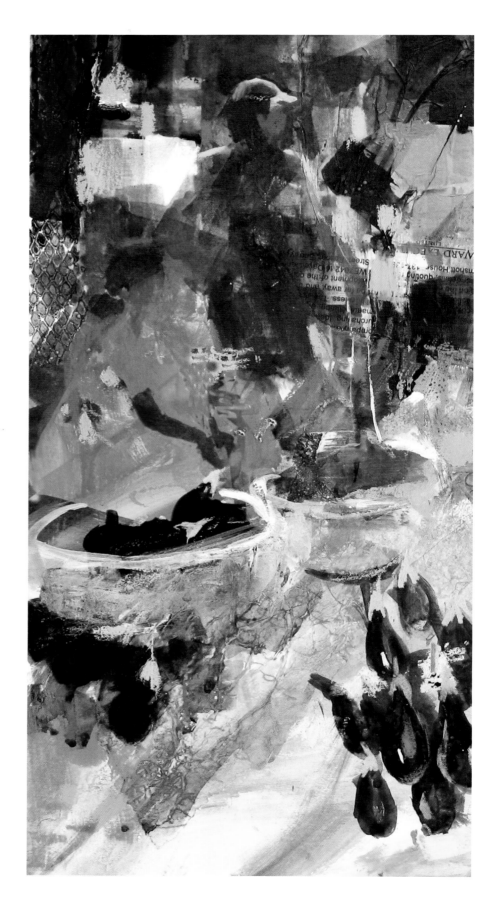

Kathmandu Market *(collage, acrylic ink, water mixable wax crayons), an example of letting the painting build up layer by layer and leaving the abstract marks for the viewers' imagination.*

Sources of inspiration

Sources of inspiration and subject matter are not one and the same thing, although sometimes the line between the two can become blurred. Our sources of inspiration lead us to find the subject matter that we can connect with at a deeper level. The source of inspiration deals with the bigger picture; for example, subjects such as landscapes, seascapes, rocks, flowers and trees will come under the umbrella of the natural world, while architectural subjects and the urban landscape attract those who are interested in all things man-made. Some artists are inspired by certain elements of design itself, such as colour combinations, textures, shapes and patterns, and will be inspired by a wide range of totally unconnected sources that will allow them to manipulate and explore these elements. For example, an artist whose source of inspiration is light but has no interest in depicting the natural world may choose a floral subject purely to portray the effect of light.

What inspires us differs immensely from one artist to another, and something that is highly inspirational for one artist may leave another totally cold and uninspired. In my workshops I often meet individuals who desperately wish to be creative but have not yet found what inspires them. Discovering the elements that excite you and set your heart racing and make you run for your paints and brushes is such an important breakthrough for a newcomer to painting. A whole world of possibilities will open up to you, helping you to focus and never be short of subjects to paint. Conversely emotional detachment with your subject is the biggest killer of a painting.

Recognize whether your sources of inspiration are internal and come from your life experiences or whether inspiration is triggered by external influences. Through learning to 'see' you will become hypersensitive to all the stimuli around you and more receptive to creative ideas.

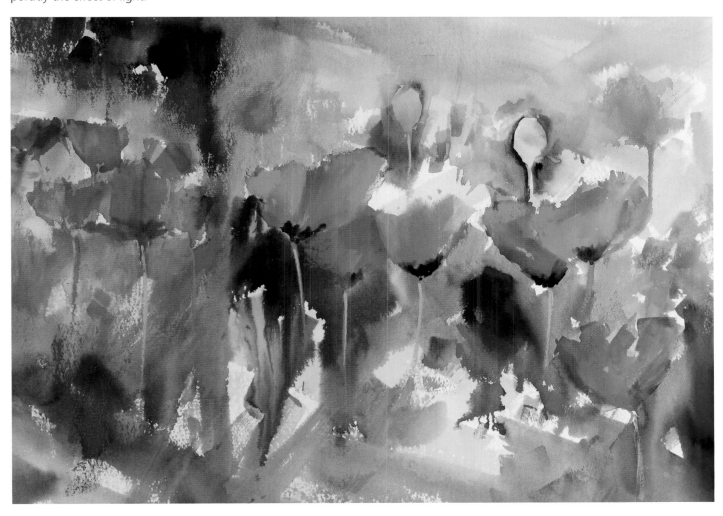

The Edge of the Poppy Field.

Loosening up

Painting in a loose and free style is far from just slapping on the paint and hoping for the best. There is great skill involved in a painting that looks effortless and spontaneous. Many of the great masters of the past and contemporary artists with this kind of style are capable of painting in both traditional and representational detailed work. To paint successfully in this way you still need the knowledge of sound composition, balanced colour scheme, correct value structure and all the rest of the elements that go into making a painting successful. Unfortunately beginner's luck does not strike too many times. You need to know the rules to earn the right to break them in a meaningful way.

A solid and worthwhile impressionist and free style is a progression and comes with much hard work and practice. Those seemingly random blobs of colour are put together with knowledge and thought, or the end result will be a confusing muddle. If you are new to painting and wish to work this way, be patient and take things one step at a time. Painting the same subject several times is good practice, starting with a careful study and detailed depiction of the subject until you get to know the details intimately. The next stage is learning how to simplify and being selective about the components of the subject – what you leave out is just as important as the bits that you leave in.

There are several stages to this kind of style. Although there is a certain amount of planning involved before you start, nevertheless the early stages of an impressionist painting in mixed media offers more freedom. Then it is necessary to take time and observe the painting from a distance so that you can preserve the happy accidental marks which add the magic to the painting. The following stages are about careful observation and control capitalizing on the manipulation of the random shapes within the painting. So the end result may look free and spontaneous but the process is a combination of free application with some thoughtful observation and a high degree of control, without the tentativeness that comes with inexperience.

Painting in mixed media is an ideal way to go towards this kind of style of painting as you are safe in the knowledge that you can rework the unwanted passages and rescue a failed painting. Learning when to stop is part of the process of loosening your existing style. A perfectly executed loose and free painting can easily go over the edge with just a few unnecessary extra touches and become tight and overworked. The devil is in the detail. Take frequent breaks to gauge your progress.

If you are a detailed painter who wishes to go towards this style allow yourself time and work your way towards your goal by practice, practice and more practice to be able to make informed choices.

Going with the flow

One of the joys of painting in mixed media is the ability to be spontaneous and not to have to bother with too much forward planning, such as stretching paper or masking out to preserve the whites or drawing outlines before you start. You will still need to have a good idea of composition, colour balance and similar issues. Often we put too much pressure on ourselves to be absolutely perfect in everything we do, and creative activities such as painting are no exception. We become too intent on slavishly replicating the subject matter, whether from life or a photographic source.

Learning to go with the natural flow of the painting can be incredibly liberating and a great skill to nurture. Let the painting guide you to where it wants to go. Take your time and assess the progress frequently by standing back to preserve the pleasing marks. You will be rewarded with much more expressive paintings that do not look laboured and overworked.

Generating ideas

You must gather ideas by any means you can to keep yourself motivated and to avoid the painter's block. Most artists have an inherently reasonable photographic memory, but use quick notes and loose sketches to back up their memory. A sketch book does not have to be elephant size – a small notebook and pencil for jotting down ideas are perfectly sufficient. In the absence of these, find a napkin, borrow a pen, write on an envelope or the back of your cheque book, but do not let ideas slip away. Embrace the new technology; digital or sophisticated phone cameras are brilliant for recording transient moments. We do not live in the dark ages, after all. Make use of modern gadgets such as an iPad if you own one, to record and store inspiring ideas. These are all valid tools for collecting valuable information.

Developing your skills

Never underestimate the importance of nurturing your drawing and observational skills. You can improve these skills and consequently help your painting enormously by attending regular life classes (if possible), by setting up a still life or sketching outdoors.

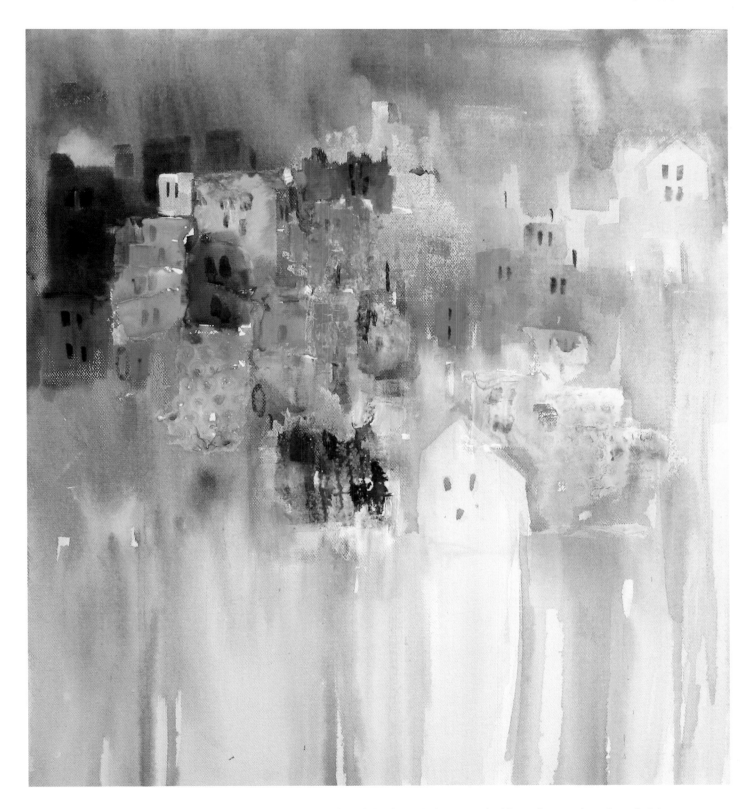

Hillside Greek Village *(acrylic ink on textured canvas with gel media). This painting started with random washes of acrylic inks on a textured ground, once the washes dried, I saw the shape of some of the building forming and carried on finding more shapes and let the painting evolve gradually. I could have gone on bringing more detail to the painting but felt this stage summed up my emotional response to the scene enough to leave it at this somewhat unresolved state.*

Do not let the old-fashioned and archaic ideas of a well-meaning tutor hold you back. Photo references are great as long as you use them alongside gaining experience of painting outdoors and can compensate for their shortcomings. Photographic source materials are not a substitute for drawing skill, which is a separate issue and must be done regularly. But do not let anyone make you feel that you are cheating by doing this. Remember the only form of cheating is copying another artist's work and claiming it as your own. Ultimately your aim is to create a painting that is totally original and has the right balance of design, colour and sound value structure, and would capture your viewer's imagination. No one cares whether you painted it inside, outside from a photo or a sketch. Be inspired but never copy; the emotional detachment associated with copied work will make the painting lack the feeling and the soul of the original piece. It will always be a paler imitation.

If you like painting from photographic sources then start the painting process by composing and taking your own photos; this way you can also experience a sense of place. At the other end of the spectrum it must be said that copying birthday cards and calendar photos can potentially create soulless results.

Sketch of a Yorkshire landscape.

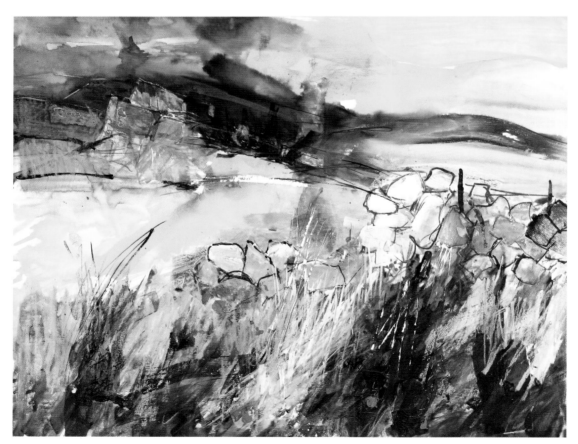

Yorkshire Vista *en plein air.*

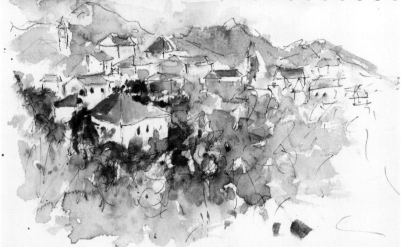

LEFT: Sketch of a French village, south of France.

BELOW: French market photo reference, south of France.

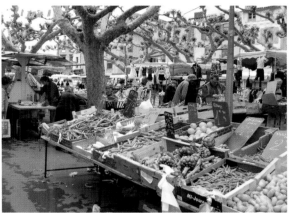

LEFT: Headland in Skiathos.

BELOW: Sketch of Andover market.

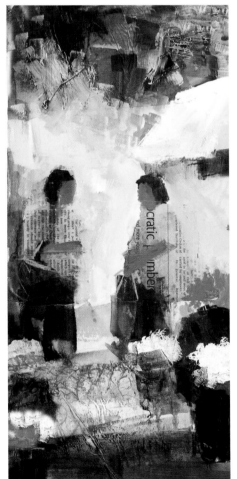

RIGHT: Poppies and olive tree, South of France.

LEFT: Sketch of two women in a French market.

Processing ideas

Setting aside a limited period of time for your painting and creative pursuits can lead to high expectations, when you may feel under pressure to produce a good painting within the alotted period. Painting should ideally have a natural process from the moment of that little spark of imagination to where you start applying the paint right through to the final stages should be an organic process. In other words life should not get in the way if you can help it. Expecting to produce a great painting on every day that you set aside for your creative activities can potentially lead to huge disappointment.

Some days it seems that you can do no wrong and everything you touch turns to gold; on other occasions all you manage might be thinking through various ideas. As a younger artist I used to get terribly anxious about these unproductive times,

feeling that I had wasted precious time. However, through experience I have come to regard these times as merely an incubation period for ideas until such time that through much contemplation, brain storming and exploring various avenues I reach the point of illumination and suddenly the floating and disparate ideas piece together like parts of a jigsaw puzzle.

It is so important to learn to live through these periods of seemingly dormant creative times. I find painting in mixed media is such a life-saver during these periods, where I rework unfinished or failed paintings by bringing other media into the equation. This process works for me by taking away the pressure associated with a fresh piece of work and it helps me to move forward. In time the ability to process and clarify fresh and cohesive ideas and inspirations returns, and all will be well with the world once again.

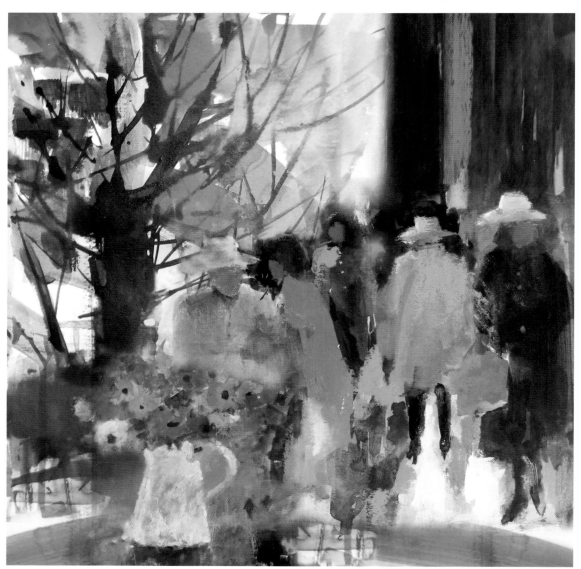

A fusion of doodles leading to sorting through ideas.

The power of doodling

I have come to respect and value what I once thought of as an annoying habit which I have had since childhood and occasionally got into trouble for. Doodling has always helped me to cope with boring situations – long repetitive lessons in the classroom, wait at the surgery or, and especially, during long telephone conversations. However, I have come to really appreciate its ad-vantages and meditative process, and for the last few years it has become my way of processing and sorting through my ideas. At the end of painting sessions, if time allows; I tend to doodle with my leftover inks rather than wasting the material. These seemingly simple and aimless pieces have sometimes taken me to a new direction. Without the pressures of having to produce something worthwhile, some magical things happen from time to time.

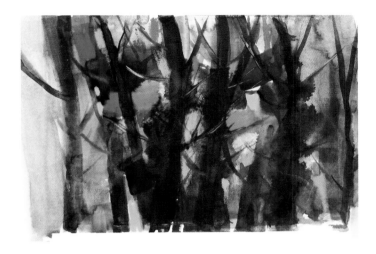

Doodle of trees.

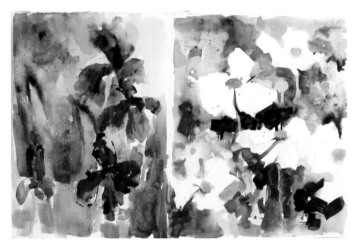

Doodle of flowers in sketch book.

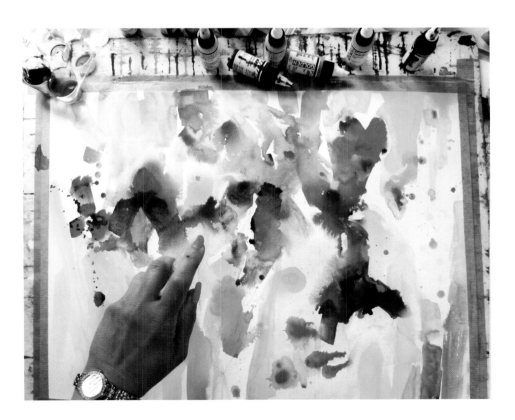

Ink doodles.

Composition and the elements of design

Composition is the arrangement and design of the components of your subject matter in the most pleasing and dynamic way in order to capture the viewer's attention. In other words it is the way you divide your picture plane using the elements of design, such as line, shape, form, colour, value and texture, creating a cohesive, dynamic and captivating image. A sound composition is the foundation of your painting.

However, applying the same rigid rules and formulas time after time can potentially make your work become stale and boring. Once you have mastered these guidelines, you can start to have fun by breaking them occasionally.

Elements of design

The following are some of the tools to help you compose your painting.

Line is the path between two points and creates a visual guide for the viewer to meander through the painting. It is one of the most expressive of all the elements of design. Line can be thick or thin, straight, jagged, horizontal, vertical or curved. You can imply motion, direction and orientation through line to convey a certain feeling. For example, curved lines suggest sensuality, horizontal lines create a feeling of serenity and calm, while vertical lines are about power and stability, and zigzag lines are dynamic and high energy. Used cleverly, line can be a very important tool.

Shapes are constructed by the closing of the lines. Shapes are defined by edges within the painting and should be separated by a change of colour and tone rather than outlines. Most components of any subject matter either fall into common geometric shapes such as circle, triangle, square and hexagonal or can be organic.

Colour is one of the first elements that engages your viewer with the painting, and as such the colour scheme of your painting has a great bearing on the overall success of the piece. Colour also has the power to affect our emotional response to paintings; colour psychology is extremely powerful and a fascinating subject that can be explored in great depth.

Value is the lightness and darkness of the tone within the chosen colours, which turns the shapes into form and gives the painting its fundamental structure. Without the correct tonal values, the painting can become flat and lifeless. Of the all the components of colour and indeed design itself, value is at the top of the list for composing with colour.

Forms have volume and a three-dimensional quality. A change of value in the colours turns a shape into a form.

Texture deals with the surface quality of your painting. In mixed media painting you can create tactile as well as visual illusions of textures.

Rule of thirds: it is a good idea to compose your painting according to a few simple rules until you are confident with composing and can get away with breaking the rules. Dividing your picture plane into thirds on each side and joining the lines will provide you with four intersections placed on the two thirds. These are the best areas to place the focal point of your painting, which could be the biggest shape or group of shapes, the most dazzling light or vivid colour, or the darkest point in the painting. This division is known as the rule of thirds and is a simple form of the more complex and scientific golden section. Not every painting has a clear focal point, but the artist usually compensates with other elements to create the impact that is usually delivered by the focal point.

Rhythm is the repetition of certain shapes, patterns, colour or texture that creates movement within the composition.

Variety: Although repetition of shapes creates rhythm and movement, too many similar shapes of the same size can be quite boring, so vary the size of the echoing shapes to create variety and excitement in the painting. It is good practice to choose odd numbers of similar elements.

Balance: It is very important to create a balance between the busy and quiet, light and dark areas as well as negative and positive shapes, the percentage of vivid to quiet colours and so on to create visual equilibrium. Assess your painting as you work by frequently standing back from it, turning it upside down or sideways or look at it in a mirror; you may be able to tell the unbalanced areas of the painting this way.

Simplify: Take time to study the source material fully; simplify the subject to the most important shapes that have something to contribute and leave out any unwanted components. If you are working from photographic source material, be selective and only include the important elements.

Lead in: Use lines to lead the viewer in, and arrange the components in such a way so the viewer is not immediately taken out of the picture.

Edges: Treatment of edges is such an important issue. Unless the subject or your style absolutely calls for it do not have a hard edge on every part of the painting. A balance of soft and hard edges encourages the viewer to engage with the painting.

The format of your painting

Choosing the right format for your painting is absolutely crucial to give you the most dynamic composition. If you are painting from life then a view finder can help you decide the best option. If you are working from your own sketch then there is a great chance that you have already chosen the best format.

However, working from photographic material can create a problem in this area. Always make sure that the shape of the source material matches the shape of your support. Producing a few thumbnail sketches from your photographic material will help you choose the best format and avoid the confusion of the paper shape you choose to paint on. This small step can save you a lot of frustration in the long run.

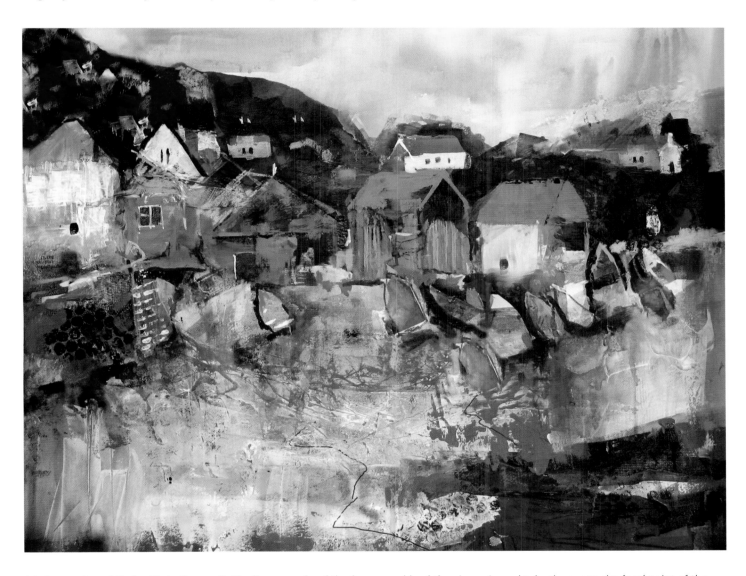

My impression of Cadgwith in Cornwall. The linear marks of the foreground lead the viewer in and take the eye to the focal point of the building and a cluster of dinghies placed on the two thirds within the picture plane. The repetition of dinghies and the buildings creates a rhythmic pattern and movement, their different sizes brings variety. The horizon line is also placed on the two thirds, so does not cut the picture in half. The double complementary colour scheme creates striking visual contrasts between the blue and the orange red and the visual complementary colours of yellow and blue.

The creative space

Workspace

Mixed media painting by nature is rather messy. In an ideal world every artist would have a designated studio. However, it is possible to create a mini studio in a corner of the house with a good size table and a shelf or a set of plastic draws for storage. My studio is located about eight miles from my house so I still maintain a small but quite efficient studio space in a spare room for working at home. For lighting, a strip of daylight bulb and some normal yellow light are helpful for working in the evenings. Ideally you should not be held back for the fear of making a mess on the carpet, so you can cover the area with an appropriate plastic covering. I would not recommend the kitchen, as media such as pastel are best kept away from areas of food preparation. In any case, you are more likely to do more painting if you do not have to tidy up the materials constantly.

Flat or upright?

Standing at an easel or working on a table or on the floor, either flat or at an angle, is a matter of personal choice. With experience you will find your own comfortable way of working. I often work flat if I need more control over the washes of colour and do not necessarily want to have dribbles of paint. Sometimes I work at an easel if I feel it is better for a particular piece of work. When working on a flat surface, however, it is good practice to prop the painting up from time to time to be able to look at it from a distance. Vertical lines can get distorted when you work on a flat surface.

Painting board and paper preparation

When you are working on paper it is best to attach the paper to a painting board which is larger than your paper – either with clips, masking tape or by stapling it to the board, as loose pieces of paper are very hard to work on and will hinder your progress. If you are painting on watercolour paper and aim to use a lot of wet washes, then either stretch your paper or save time by stapling the paper to the board; this way you will have a sturdy and rigid surface to work on. You may experience some buckling of lower weight watercolour paper that is not stretched, but this usually gets corrected once the paper dries. If the paper is still buckled after drying, wet the back of the paper and leave it under something heavy weight to dry.

A well-organized work space, however small, will help you concentrate on more important issues, which is creating your painting.

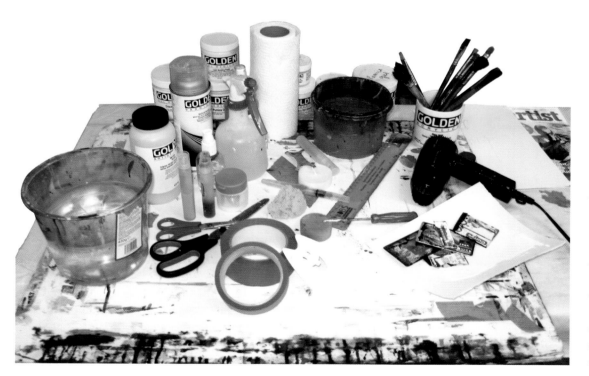

These humble items are indispensable: a good size painting board, masking tape, clips, spray bottle, kitchen roll, sponge, scissors, generous size water pots, discarded credit cards, scrapers, toothbrush, varnish and of course a hair dryer to speed up the drying of layers.

A variety of both acrylic and watercolour palettes. I use throw away food and other super market packaging which is a good way of recycling materials.

Essential equipment

Palettes

Acrylic paint dries into a hard plastic film that cannot be re-constituted, and in order to keep your acrylics wet and workable there is a choice of suitable palettes. A stay-wet palette can be either a shop-bought one which includes the appropriate layers for your paint to go on, or you can make your own with a shallow box with a lid and use dampened kitchen roll and grease proof paper to keep the paints wet for longer.

There are a number of new palettes on the market with air-tight lids which do not require any paper; they are not only easy to clean with water, but the dried-up paint can be peeled off the surface easily.

If you opt for a surface such as a tear-off palette, paper or porcelain plate, then spray your paints frequently to stop them from drying up. If you use additives such as retarders to slow down the drying time, follow the instructions carefully.

Acrylic inks stain the palette permanently once dry, so it is best to use separate watercolour palettes for your acrylic inks and your watercolours. You can either buy a few cheap water-colour palettes with generous wells for your acrylic inks, or simply use any appropriate containers such as food packaging and throw them away afterwards.

Varnish

If you have not used pastels in the painting you can varnish your acrylics to protect the surface, and you do not have to frame the painting behind glass. (I will expand on this subject in Chapter 8.)

Fixative

The use of soft pastels in mixed media painting is minimal so you do not have to use any fixative; however it is a personal choice, and should you wish to fix the pastels, use an artist quality version, as most hair sprays may contain a certain amount of oily conditioner which could eventually react with the paints and damage the painting.

Supports to paint on

When painting in mixed media you can choose from a wide range of supports to paint on. However, it is very important to remember that each type of surface you choose will have a significant effect on the outcome of the painting. Therefore, if something works for you, you do not need to change it. Every type of watercolour paper, acrylic paper, mount board or card, MDF (medium density fibre board) and of course canvas and canvas boards are suitable.

Always use common sense when choosing your support to make sure that the materials that you will be painting with are suitable for the type of support you have chosen. For example, if acrylic is part of your mixed media then do not use any greasy or shiny surface, as acrylic tends to peel off such surfaces once it dries.

Whatever support you use needs to have enough grip for your acrylics. Acrylic paints and some of the special acrylic-based grounds create a certain amount of tooth for your pastels. Or you can choose a wet and dry artist quality sandpaper which can take washes of watercolour or ink and still have plenty of tooth left for your pastels.

If you are incorporating pastels in your painting, avoid canvas and canvas boards and always use a support that will be displayed behind glass. The exposure of canvas surface to the elements makes this surface slightly more prone to environmental damage, so only use media that can be varnished over.

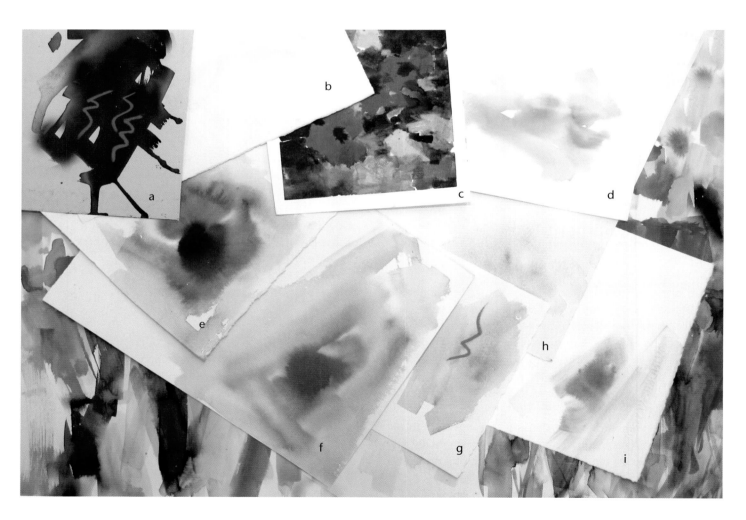

A selection of different types of watercolour paper, board and pastel paper. Apart from the watercolour board all surfaces are flexible and highly absorbent: (a) wet and dry artist quality sandpaper – I use Fisher 400, (b) Saunders Waterford 2001b NOT surface, (c) Claire Fontaine acrylic paper. (d) Saunders Bockingford 1401b NOT surface.(e) Saunders Waterford 3001b NOT surface, (f) Saunders Waterford 1401b NOT surface, (g) Arche 140 NOT surface, (h) Fabriano Artistico 1401b weight, (i) Saunders Waterford HP high white, (j) Daler-Rowney Langton watercolour board.

Hot pressed (HP), cold-pressed (NOT) surface and rough watercolour papers have different surfaces and produce totally different results. You can even use a piece of MDF board or a panel of wood primed with gesso; this makes a lovely and rigid surface for your mixed media painting. The available supports are varied and diverse, so experiment to find your ideal surface.

Which support?

To choose your appropriate support you need to ask yourself whether the subject requires absorbency or a non-porous surface. Should it be rough or smooth? Rigid or flexible? These can narrow down your choice and help you choose the right surface.

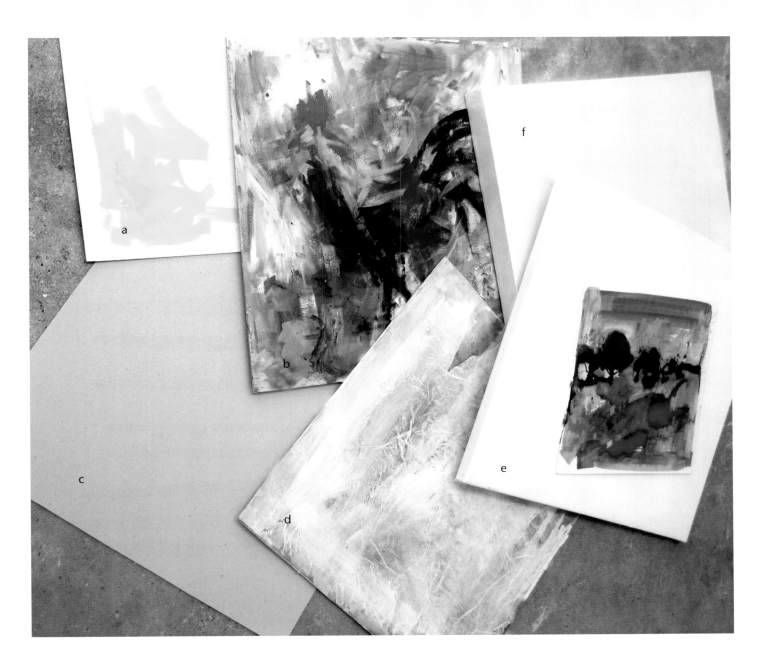

A selection of rigid surfaces, with different levels of absorbency: (a) mount board tinted with ink, (b) MDF board prepared with gesso, (c) grey board (always prime with gesso for good results), (d) mount board layered with tissue paper for texture, (e) primed canvas, (f) boxed canvas, (g) primed piece of card.

Brushes

Ideally you need a set of both watercolour and acrylic brushes. You need the softness of a watercolour brush to apply acrylic inks and watercolour washes. There are excellent and economically priced synthetic brushes on the market. However, if you have sable brushes these can be successfully used for acrylic inks with no adverse effect, as long as you rinse them off properly after each application.

For heavy body acrylics you need brushes with stiffer hair; these are more refined than simple bristle or hog brushes and will allow for much nicer brush marks.

Style of mark required

The shape and size of your brushes is closely related and depends on the style and the size of your paintings. The selection is individual to each artist. The following is a guide to the type of marks you can make with each brush:

Flat brushes create square marks and generally do not allow for detailed and fiddly marks so can help you towards a more loose and free style of painting.

Filberts have a rounded edge so the brush strokes are somewhat softer and rounded on the edge.

Round brushes are often pointed so you can create smaller marks with the point and use the belly of the brush for broader marks.

Rigger brushes help you create fine lines and are ideal for painting any long and narrow marks such as branches of trees or long grasses in a foreground.

A balanced art box should contain a few round brushes and some flat brushes. Choose the size to suit the size of your paintings. I recommend a couple of wash brushes in sizes 1in and ½in, but if you paint particularly large paintings then add a 2in or even bigger wash brush.

Palette and painting knives are also great for mixing paint and painting with. You can purchase inexpensive sets of palette knives in a variety of shapes from most art shops. Using knives to mix paints will also help you minimize any paint wastage.

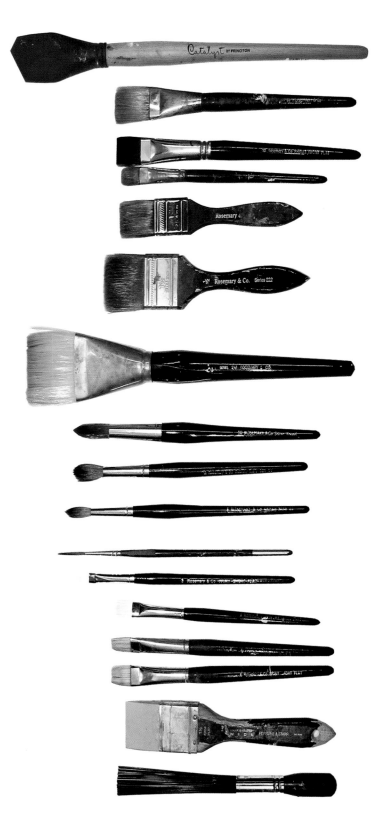

Different shaped watercolour and acrylic brushes.

Other implements

In acrylic and mixed media painting, brushes are not the only implements to paint with. You can get really inventive with your paint application tools. You can use rollers, the edge of a credit card, fingers, twigs, household brushes or anything that gives you the desired effect you are after.

Different shaped rollers, sponge, palette knife, specialty tools.

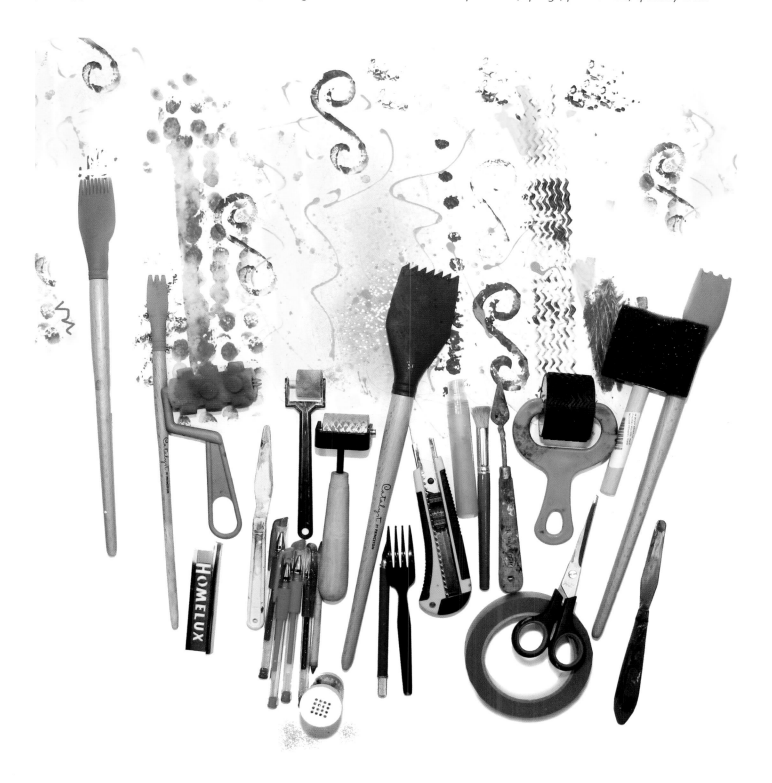

EXPLORING THE MEDIA

An amazing wealth of art materials is at our disposal today, with more and more varieties being introduced to the art market year after year, so it makes sense to take advantage of all these different media to help us achieve more expressive artwork.

It is crucial to get to know the variety of media you will be working with individually and intimately before combining them together. Understanding their unique characteristics and limitations is important, so that you can use them most effectively, and in the right place, to create certain effects or textures in your work.

Compatibility is a vital factor, and for this reason I personally leave oil colours out of the equation as they have a longer and a different drying process than water media. The quick-drying nature of most water-based paints allows for quick succession of paint application. There are great advantages of using more than one medium in one painting. For example, the transparency of watercolour does not leave much room for mistakes,

OPPOSITE: A medley of painting media.

Pink and Lime Fusion *(watercolour and gouache).*

and once the freshness of colour is lost the painting can fail miserably. This is where opaque media can come to the rescue, not only to rectify the mistakes but to enhance and transform an otherwise failed painting. There are certain colours that shine in a specific type of medium binder; for example, the dry powdery nature of soft pastels allows for the creation of some fabulous blues and magentas that burst with life and energy and are almost impossible to reproduce in wet media.

The mark-making ability of each medium also has a great bearing on its contribution to a mixed media painting. Thin and transparent media such as watercolours and inks are great for broad colour washes, glazing purposes and underpainting. Heavy body acrylics and pastels can be used successfully where you need linear marks or to create tactile texture on top layers, and their opacity offers great covering power. The combination of the transparent and opaque media, and the visual transition of one passage to another, creates great depth and energy in a mixed media painting.

In this chapter we will be exploring the potential of individual media before combining them together. Do not feel that in order to work in mixed media you need to have all the materials mentioned here. Take what is relevant to you and your art. The

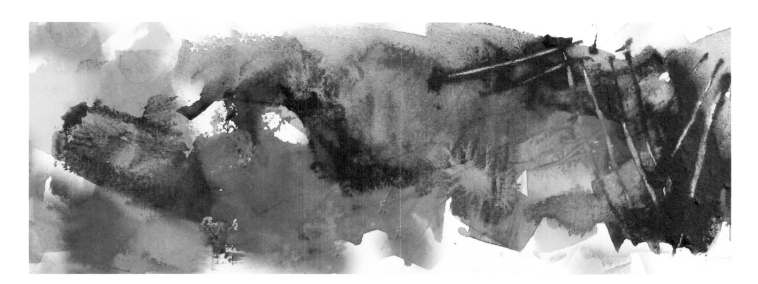

best advice I can give you is to spend the majority of your art budget on buying good quality artist's paints, brushes and supports. Luxury items such as an expensive easel or a smart portfolio folder may give you pleasure, but they have no great bearing on the quality of your painting.

Acrylic

Acrylic is by far the most versatile of all painting media. It can mimic both watercolours and oils but also has many unique characteristics and applications neither of those media is capable of.

As with other media artist-quality acrylics start with high quality pigments, but the binder in this case is a polymer emulsion resin which contains minute particles of polymer resin suspended in water. As the paint dries the water evaporates, and the pigment and polymer grip one another and adhere to the support. Depending on the thickness the paints dry within minutes, allowing numerous further layers to be superimposed without disturbing the underneath layers, which results in richness, depth of colour and texture. Acrylic's quick-drying quality makes it the most superb medium for glazing techniques. The polymer is rather cloudy and slightly white when wet, becoming clear as it dries, therefore, you may notice a slight colour shift towards a darker value; however this is much less noticeable in top quality paints.

There are no special rules about the use of acrylics; there is no need to abide by the fat-over-lean or light-to-dark rules as in oils and watercolours. Artist-grade acrylic is a highly permanent medium that does not yellow with age, and most colours can be used in outdoor murals as well as on paper and canvas for fine art. Acrylic is the most forgiving medium and a great option for beginners as all mistakes can be easily rectified. For the experienced and adventurous artist it is an invaluable

Gloss polymer medium.

Matte and gloss polymer mediums.

LEFT: Matte medium.

BELOW: Different consistencies of acrylics: (a) heavy body acrylic, (b) fluid acrylic, (c) high flow acrylic inks.

a b c

tool with myriad possibilities for experimentation. Once dried, acrylic paint creates a flexible and highly receptive surface for other media, making it an ideal base for mixed media work. Acrylic is available in different consistencies which gives the artist much greater scope for a wide range of applications and techniques. All types of acrylics are intermixable and can be used in the same painting alongside one another as well as mixed together.

Acrylic mediums

Acrylic medium is basically polymer resin suspended in water and can be used with the paints to extend and change the sheen and appearance of the paints and make them slightly more translucent. The mediums are available in gloss, matte and satin, and according to the surface finish you are after you can mix them directly with the paints while using your water pot merely for washing the brushes. The medium will replace the water as your means of thinning of the paints. Alternatively, you can brush them on at the last minute to create a unified look to the painting. The mediums act as glue and are ideal for adhering collage to your support and provide a protective surface over the collage into the bargain. There is no limit to how much medium you mix with your paint as it does not change the formula of the paint and the use of them is optional. One thing to remember is that the more medium you use, the thinner the paint layer will become – much like mixing with water. The medium does not act as varnish; once a layer of medium has been painted over the surface it cannot be removed to reveal the paint underneath, however, it does add a protective layer.

Glazing technique

Adding medium to your paints makes the colours more translucent and highly suitable for glazing techniques. It also helps the layers super impose on one another beautifully and create a lot of depth and richness in colours. Using the gloss medium adds a deep shine to your colours.

Heavy body acrylics

This is the heaviest consistency of acrylic paints. The modern acrylics are a far cry from the crude tubes that were first introduced to the art market in the early fifties. The heavy body viscosity allows for all types of oil painting techniques using brushes, palette knives or any other implements you wish to employ. Yet you can dilute the colour to tint the support if need be, bearing in mind that this will reduce the colour saturation considerably and also tends to weaken the paint film. If you wish to paint in watercolour style the best option is to use acrylic inks or fluids (soft body acrylics) rather than diluting your heavy body paints. For glazing techniques with heavy body paints the best option is to use one of the mediums to thin the paints.

Artist quality heavy body acrylics come in tubes or pots in all different sizes. The quality, colour choices and even viscosity varies a great deal from each brand. Applying oil painting techniques in acrylics works better with this type of viscosity. Any of the consistencies we have discussed can be made heavier by using heavy or extra heavy gels to extend the colour and make it go further, but more of that in later chapters.

These days we have a number of superb quality acrylics on the market in a mind-boggling array of vivid and wonderful colours, and we are truly spoilt for choice. In my opinion, acrylic as a medium can be a really powerful tool in the right hands; it is full of surprises, and when you think that you have discovered all there is to know about this super versatile medium, it shows you yet another weird and wonderful textural effect that is totally fresh and unique to this multi-facetted medium.

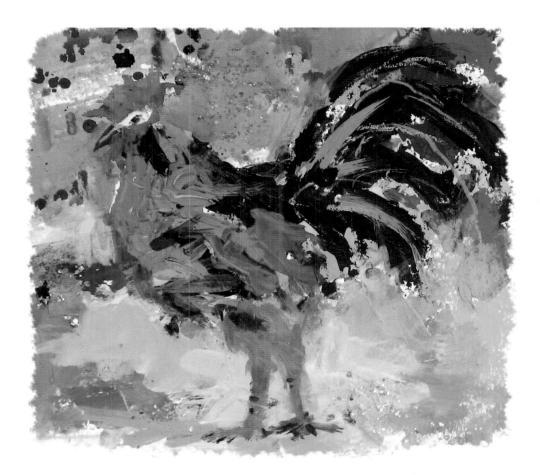

Colourful cockerel in heavy body acrylics.

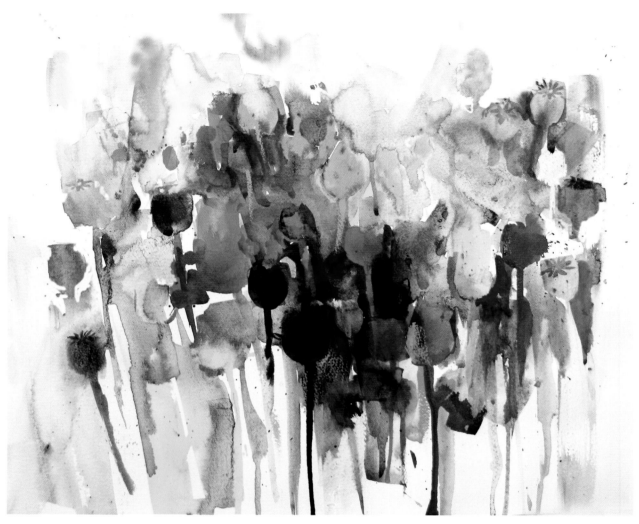

Seedheads
(acrylic inks).

Acrylic inks

Acrylic inks are the very fluid form of acrylic colours; they are highly saturated with lightfast pigments and a runny viscosity. You can think of them as less temperamental, well-behaved and very exciting watercolours. They are suitable for all types of watercolour techniques such as wet into wet and wet on dry and a combination of both. However, the inks dry to a waterproof film and the subsequent washes of colour do not disturb each other, and so the colours retain their freshness and vibrancy. The inks may appear too bright but can be toned down by diluting with water or made into a tint by mixing them with titanium white. Colour mixing with inks is very similar to both watercolour and acrylics, and the same principals apply to them. You can darken or tone down each colour by adding a little of its opposite colour or a dab of grey or an earth colour such as burnt sienna.

I find the inks incredibly exciting to work with; the mixing and mingling of colours is an unpredictable and exhilarating process which often leads to the appearance of some fascinating shapes as the inks dry. Learning to leave these happy accidents is the key to the success of painting with this wonderful medium. Little nuances of colour over the whiteness of paper are quite delightful and unlike any other medium. The inks are real team players and good to use as part of a mixed media painting as they accept other media on top with great results.

There are now many brands on the market; I have used FW inks by Daler-Rowney and Golden air brush colours for years. The recent arrival of High Flow acrylics by Golden has added a whole range of fabulous colours to my art box. A set of six to eight colours should be enough to start off with, but to save time you can gradually add already mixed secondary and tertiary colours. Absorbent surfaces such as all types of watercolour paper are ideal for the inks, but some canvases also respond well to ink applications. Experiment to find your own ideal surface.

Golden Summer *(fluid acrylics).*

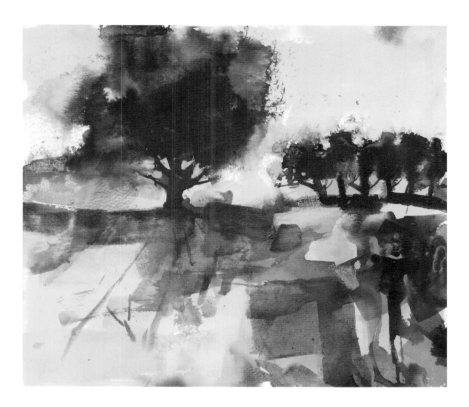

Fluid acrylics drizzles and pours, ideal for pouring and drizzling techniques.

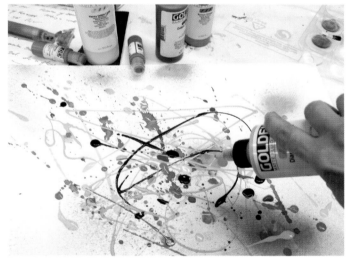

Fluids or soft body acrylics

The next grade of acrylic consistency is the soft body acrylics, which are slightly heavier than the inks but still fluid enough to be diluted easily for watercolour applications. These acrylics are formulated to be pourable without any loss of colour saturation; in other words they have the same pigment load as the heavy body acrylics, and in some cases can appear even more intense than the heavy body paints. They are ideal for pouring techniques where the liquid colour is poured onto the

Open

If you are using both Open and standard acrylic paints in one painting, either apply Open on top of the standard acrylics, or allow the Open to dry fully before applying standard acrylics over the top.

support, allowing the colours to mix and mingle freely, creating random abstract shapes. One of the main characteristics of these colours is their levelling ability and lack of visible brush marks after application. Some artists generally prefer the softer consistency of these acrylics and build up their paintings with layer-by-layer glazes of fluid colours and achieve an unbelievable richness and depth of tone. These artist-quality fluid acrylics, however, should not be mistaken for the student-grade paints which generally have a slightly thinner and runnier consistency due to their cheaper polymer and process of production.

My favourites are the Fluids by Golden. The high load of great quality pigment makes these paints a delight to work with. These colours are ideal for glazing techniques and can be poured, sprayed, splattered and applied by brush or any other innovative way you can think of. Not only are fluids great on their own but they can also make a great base for a mixed media painting.

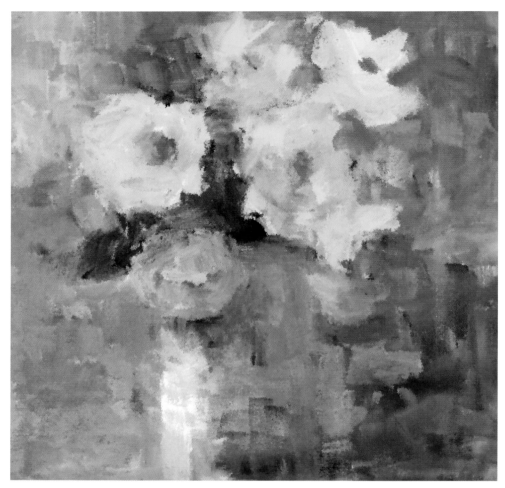

Yellow Roses *(Golden Open acrylics).*

Comparing the drying time of Open and standard acrylics – heavy body (on the left) and Open acrylics (on the right). Both paints are still wet after half an hour and one hour; the Open remains wet long after five hours.

Blending with Open acrylics; you can see the smooth transition of one colour to another, which is ideal for blending techniques.

Acrylics with extended open time

The quick-drying nature of acrylics is not ideal for artists who use blending techniques and those who wish to move the paint around the support for longer periods of time. Open acrylics produced by Golden Artist Colors stay wet for extended periods to allow for the manipulation of paint on your paper or canvas. However once you wish to dry the layer you can use a hair dryer, as the paints dry by evaporation and not by oxidization as in oil colours. They can be mixed with the standard acrylics of any viscosity, but this cuts down their drying time according to the amount of standard acrylic used in the mix. For instance, a 50:50 ratio cuts down the drying time to half. Open acrylics have their own media so that you can retain the same rate of drying time. They can be mixed with other gels and pastes to create a different surface quality.

This type of acrylic is ideal for *en plein air* painting and travelling abroad, especially in hotter climates where the standard acrylics may dry too quickly. For this type of acrylic you can use any palette as they tend to stay wet without any special treatment. However, by using a stay-wet palette or spraying the paints from time to time you can extend the drying time even further. You will find that some pigments stay wet longer; this is to do with the individual characteristics of each pigment. They have a creamier consistency than standard heavy body acrylics. These paints can be successfully used in mono printing instead of oil colours as they stay wet long enough for the process and are far less messy. Open acrylics are ideal for subtractive techniques where the paint is added and the desired shapes are lifted out. This is a really fun way to experiment with this versatile medium.

A handful of colourful soft pastels.

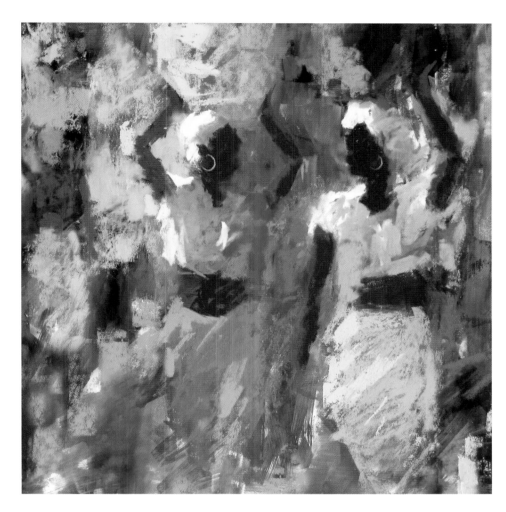

The Water Carriers *(soft pastels).*

Soft pastels

A drawing and painting medium in one, artist-quality soft pastels are probably the closest you will get to working with pure pigment. These magical sticks of colour begin as pure pigment as with any other medium; then they are mixed with a binder such as gum tragacanth or gum arabic and a small amount of precipitated chalk as filler and rolled into a stick and left to dry. For many years they were regarded as just a drawing medium, but they have now found their rightful place alongside all other painting media. Painting in pastels makes a great introduction to painting for the beginner as you can learn to paint while you also hone your drawing skills and can rectify mistakes to a great extent, which makes an easier learning process.

Soft pastels make an invaluable contribution in mixed media painting. The jewel-like colours are great for adding highlights, or enhancing the colours in dull areas of the painting. They can create attractive random marks when applied over textured areas to create beautiful passages singing with vivid and vibrant colour. The dry and powdery nature of the medium makes it prone to smudging; therefore, paintings with soft pastels should always be displayed behind glass. Like other media some pastels have a higher tinting strength and can stain the support, while some colours have greater covering power than others, and the nature of the pigment also has a great bearing on how hard, grainy or soft the pastel feels. One of the great advantages of pastels is the lack of any colour shift. The fabulously vibrant colours retain their brilliance without getting lighter or darker.

Round shaped pastels are usually softer; the square pastels have a harder consistency and can be applied with more pressure. Artist quality soft pastels have a higher ratio of fine quality pigment to the binder and just enough filler, as opposed to the chalk-filled student quality versions that contain inferior pigments and can be rather scratchy and disappointing. You can start by getting assorted boxes of pastels in colours suited to your work and adding to them as you feel more confident about their use. If you are using them just for mixed media painting then a small collection of colours suited to your style of work will be enough as a starter kit.

Oil pastels

In comparison to watercolours and oils, oil pastels are relatively new and perhaps it is fair to say slightly underused in their pure form. It could be that there are not many books or literature dedicated to this medium, therefore, many artists are not familiar with its properties and techniques. Oil pastels should not be confused with oil bars which basically contain oil paint and behave accordingly. Oil pastels contain inactive or non-drying oils plus mineral waxes as a binder, which makes the pastel stay supple and usable for many years. Once applied to a surface, however, the oil pastel tends to harden with the passage of time.

There are some beautiful colours available in oil pastels; the colours and consistency varies a great deal from each brand, so shop around to find your favourite. The cheaper brands may look bright but tend to be rather waxy and do not seem to impart much colour, so can be rather disappointing.

Oil pastel resists washes of colour, be it inks or watercolour and gouache, but it can be painted over with heavy body acrylics. As part of a mixed media painting, they can be used to highlight or enhance a passage or create resistance for washes of colour and add interesting texture. To move the colour around, you can add a touch of solvent to a brush or a rag and apply it to the oil pastel area; this creates an effect similar to a colour wash. Oil pastels can be used in sgraffito technique, meaning they can be layered on top of one another in two different shades and scratched into to reveal the underpainting. They are a useful addition to the mixed media art box.

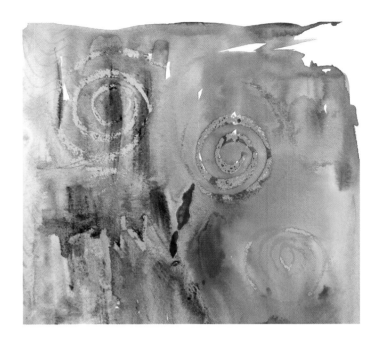

Oil pastel resist; on the left the oil pastel is resisting a watercolour wash, on the right it is resisting high flow acrylic inks.

Gouache

Gouache is also referred to as body colour; it is basically watercolour with some white pigment added to make the colours more opaque. Some manufacturers use the word 'designer' on the tubes of gouache, which creates the misconception that its use is restricted to the graphic design industry. However, it can be used for fine art, either in watercolour-style applications or in its opaque form. Gouache can be diluted to resemble watercolour, but it can also be used in a much heavier consistency with light colours over the darker ones. The colours have an attractive matte and flat finish which can enhance certain subject matters.

It is a great medium for painting outdoors, as it has a much more forgiving nature than watercolour and can be light and compact to carry. Once the paint dries, unlike acrylics it can be disturbed and reopened. Gouache is available in pans and tubes. It works extremely well as a base for mixed media work and its matte surface is quite receptive for all types of pastels.

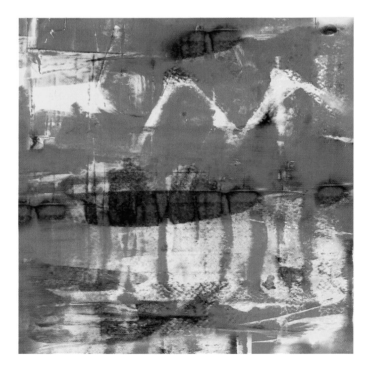

Abstract layers (gouache).

Watercolour

Watercolour is perhaps the most romantic of all painting media and universally loved by millions of artists and art lovers. A mixture of pigment with gum arabic results in this beautiful medium which depends on freshness and transparency of colours for its success. Once a watercolour painting gets muddy and loses the quality of light, it fails badly and is almost impossible to resurrect successfully. However, there is a kind of nostalgic romance attached to watercolours, and its universal popularity has not diminished despite its unforgiving nature.

It is a one-shot medium and known as the hardest of all media to master. As part of a mixed media painting however, it can be really valuable for early washes of wet into wet to tint the support or for glazing purposes. I often use glazes of watercolour to knock back an area over thicker applications of acrylics, as the watercolour washes can be removed easily if necessary.

Watercolour in its pure form relies on the white of the paper to magnify the light and its glowing transparency. The white is preserved for areas of highlight either by careful consideration or the use of masking fluid. Today many of our avant-garde master watercolourists use the medium in a different and exciting way which reflects the times we are living in. They prove that the medium can be used to its full potential, and without too much fuss and trepidation. Bursting with strong colour, vitality and energy these watercolours are a far cry from the insipid watercolours of bygone days.

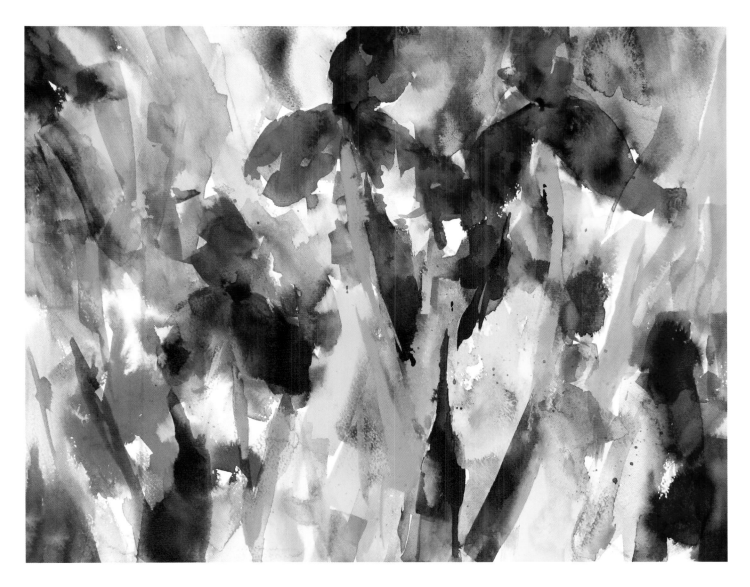

Dancing Irises *(watercolours).*

Other mark-making media

If like me, you are always tempted to buy yet another new box of pencils, crayons or any other weird and wonderful new product that you see in the art shop, only to relegate it to the back of the art materials cupboard, then it is time to delve deep and get all those boxes out and put them to good use. Every type of medium has its own unique mark-making capability and can bring something fresh to your work. Pure wax crayons, art bars and other water mixable wax crayons, tubes of gouache, graphite, charcoal, spray paints, acrylic marker pens – all these can be used to create a certain linear mark or area of broad colour.

Make little swatches of these media mixed together and you have a useful library of images that can be referred to and incorporated in a mixed media painting. For example water mixable wax crayons and aquarelle pencils are great for splattering purposes and far less messy than using diluted paint with a brush. Pens, markers and pencils are great for linear marks and fine details. Water mixable wax crayons can be used wet or dry and light on dark. With a little thought and imagination you can employ them to take your work towards exciting new heights.

Mark-making exercises

Random and incidental marks give the painting an intriguing quality. Some of these marks happen by chance during the course of applying various media in a mixed media painting and are considered happy accidents. However, it is also important to learn how to create marks that seem to be random using different media and mark-making tools. These examples are a fraction of possible techniques, use your imagination and experiment with different combinations.

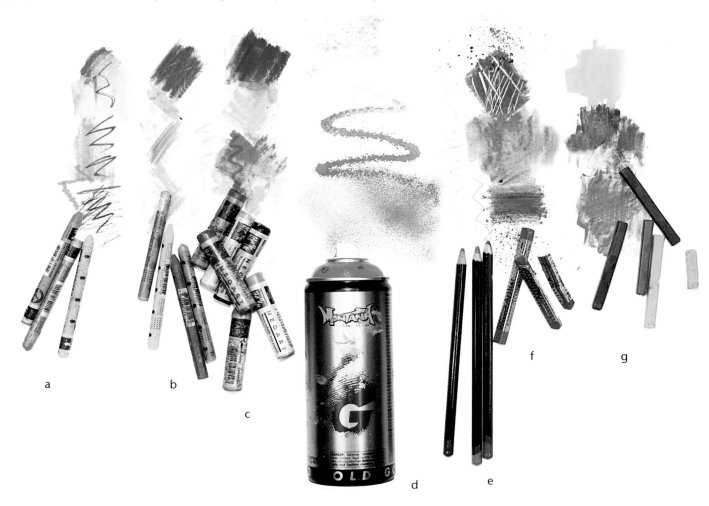

a b c d e f g

A variety of mark-making materials: (a) water mixable wax crayon, (b) pure wax crayon, (c) artist quality water soluble crayons, (d) solvent based spray paint, (e) Aquarelle pencils, (f) Derwent art bars, (g) Derwent ink blocks.

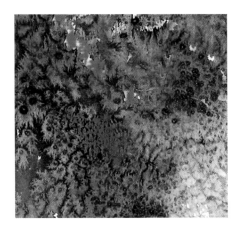

The effect of salt on watercolour washes.

Bubble wrap dipped in ink and imprinted over a magenta ground.

Using a metal comb on partially dry acrylics.

Oil pastel swirl with an ink wash.

Using sequin relief as a stencil.

Candle wax resist with a wash of watercolour.

Applying paint with a roller to achieve a hit-and-miss effect.

Vibrant pastel over a matte gouache.

Opaque splattering of colours in multi layers.

Grounds

Gesso

Gesso is an acrylic primer which creates a barrier between your support and the paint. Shop-bought canvases are always primed with gesso. When you are using watercolour paper gesso becomes optional, but it can be used to improve the quality of a surface such as a piece of MDF board to make it into a much more suitable support to paint on and ensure the longevity of your painting. It can be applied roughly with a bristle brush to create a textured surface. However, if you are after a much smoother finish then you can use a type of gesso that can be sanded down to create an even and mirror-like surface.

Gesso varies in consistency across different brands and it is available in black, white, clear and even in a variety of colours from a few manufacturers. It is also possible to tint the gesso yourself by adding a dab of any colour. With the heavier type gesso it is possible to make a certain amount of texture before applying the paint; this can be quite effective as the textures are revealed through the paint layers and add to the surface quality of the finished painting.

Details of a painting done on a ground primed with gesso brushed on roughly.

Imprint of bubble wrap on tinted gesso.

Priming a support with gesso is necessary when painting in oils, but it is not required for acrylic paintings unless you are using wooden or similar supports or you like the effect of painting on a primed ground.

If you are using MDF board to paint on it is good to note that this type of material may have chemicals in its makeup, which could react with your paints in the long term and create discolouration. To prevent this I normally use a size such as GAC100 made by Golden to prepare the board prior to priming with gesso.

Gesso first

In my experience it is better to use gesso in the early stages of painting to prime the support and create texture if necessary and paint over it. Gesso is thinner than heavy body paints and has a self-levelling ability. If you use it as white paint you will find that it may not hold your brush marks. If you use it thick in top layers you may find that it will crack as it dries, so it is best to use it under the paints to avoid these issues.

Other types of ground

Apart from gesso, there are a few other types of grounds available, each providing you with a different sort of tooth or grip for your paints and drawing media.

Watercolour Ground by Daniel Smith and Absorbent Ground by Golden create a watercolour type surface which is absorbent and great for watercolour applications. You can turn the surface of a canvas into one suitable for watercolour painting by applying a couple of coats of either of these grounds. Acrylic ground for pastels creates a surface with enough tooth and sufficient grip for your pastels. You can turn any surface such as a smooth card into a suitable ground for pastel painting. Fine pumice gel is another ground with a similar quality to acrylic ground for pastels. Micasecous iron oxide is also suitable for this purpose, especially where a darker surface is required.

All these ground preparations are suitable for both drawing media and wet media such as acrylics and gouache and watercolours. Experiment with the grounds and your chosen media to see what works best for your application techniques and the finish you want to achieve.

As well as grounds, there are numerous types of gels and pastes each with unique qualities for making a certain type of texture, creating tactile and lively surfaces (*see* Chapter 3).

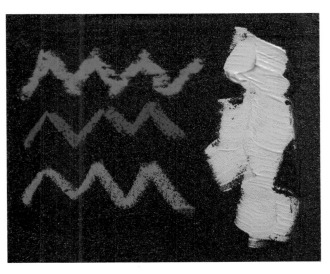

LEFT: Absorbent ground, which works well in thin layers over a ground primed with gesso, such as a primed canvas and creates a watercolour like absorbent surface ideal for staining or painting with inks and watercolour.

Micaceous iron oxide, which creates a sparkling and gritty surface which is perfect for both drawing media such as pastels or for acrylics. It is ideal when you need the subject to be painted on a dark background. You can also mix it with your acrylics for some amazing colour effects.

Acrylic ground for pastels, which can be applied either roughly or smoothly on a piece of mount board or card or any type of watercolour paper to prepare a perfect ground for pastels or other drawing media. It is also great as a base for acrylic painting.

RIGHT: Fine pumice gel, which can be painted on any absorbent or semi absorbent surface to create a fine tooth for both drawing and painting media.

Project: Getting to know each medium

The success of a mixed media painting is in discovering dynamic combinations of various media and the unusual ways in which they affect one another when used in one painting.

Experiment by making these swatches which can also help you discover more about the compatibility of various media. Finding the mark-making capability of each medium will help you decide which to employ when you need a certain mark or texture in your painting. You will not be creating a finished painting, but these sessions are invaluable and an important part of the learning process of painting in mixed media. Eventually, through this process, you will learn how each combination and technique suits some particular subject matter more than others. This is a subject you will read more about in chapters to come.

Cut up small square pieces of reasonable quality paper or pieces of card or mount board, and use them to make small sample pieces of mixed media combinations, for example, swirls of oil pastels with washes of acrylic ink or watercolour, or soft pastels over thicker applications of heavy body acrylics or gouache.

Making these small swatches is a great way of familiarizing yourself with each medium's properties and its potential in a mixed media painting. Make a library of these little gems for future reference.

As well as these experiments I often cut small sections of unwanted larger paintings that I find interesting and stick them on the studio wall. They are not only pleasing to look at but very useful to refer to when the inspiration runs dry and I cannot instantly think of a particular technique.

b

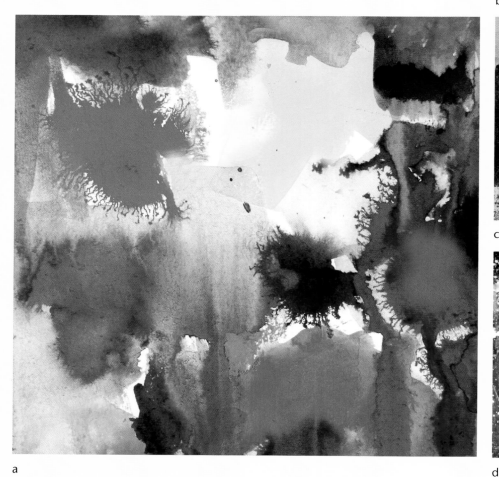

a

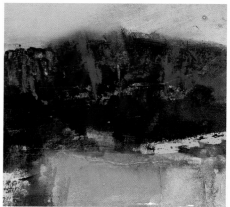

c

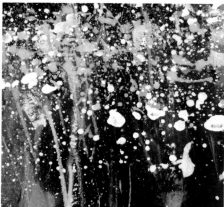

d

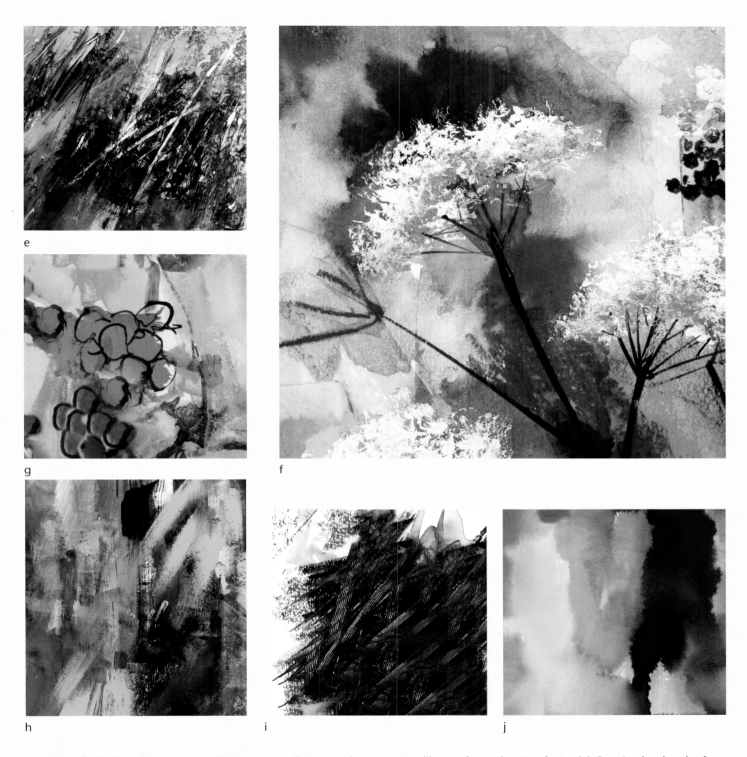

Swatches of mixed media and cropped images; I use these samples to create a library of swatches to refer to. (a) Creating hard and soft edges with wet-into-washes of inks and watercolour and water spray, (b) Water mixable wax crayon used on acrylic paint on a NOT surface watercolour paper, (c) Soft pastel marks on a tinted acrylic ground for pastels, (d) Splattering inks on an oil pastel and acrylic ground, (e) Sgrafitto: scratching into oil pastel and semi-dry acrylic paint, (f) Using a sponge to apply thick acrylic paint on flower heads over a watercolour background., (g) Using the pipette of FW acrylic inks to draw uneven linear marks, (h) Mark-making: dragging matte gouache with the edge of a credit card over acrylic washes, (i) Wax sgraffito: Scratching into the layer-upon-layer of Derwent Artbar (water soluble wax crayons), (j) Wet-into-wet watercolour washes to create soft edges.

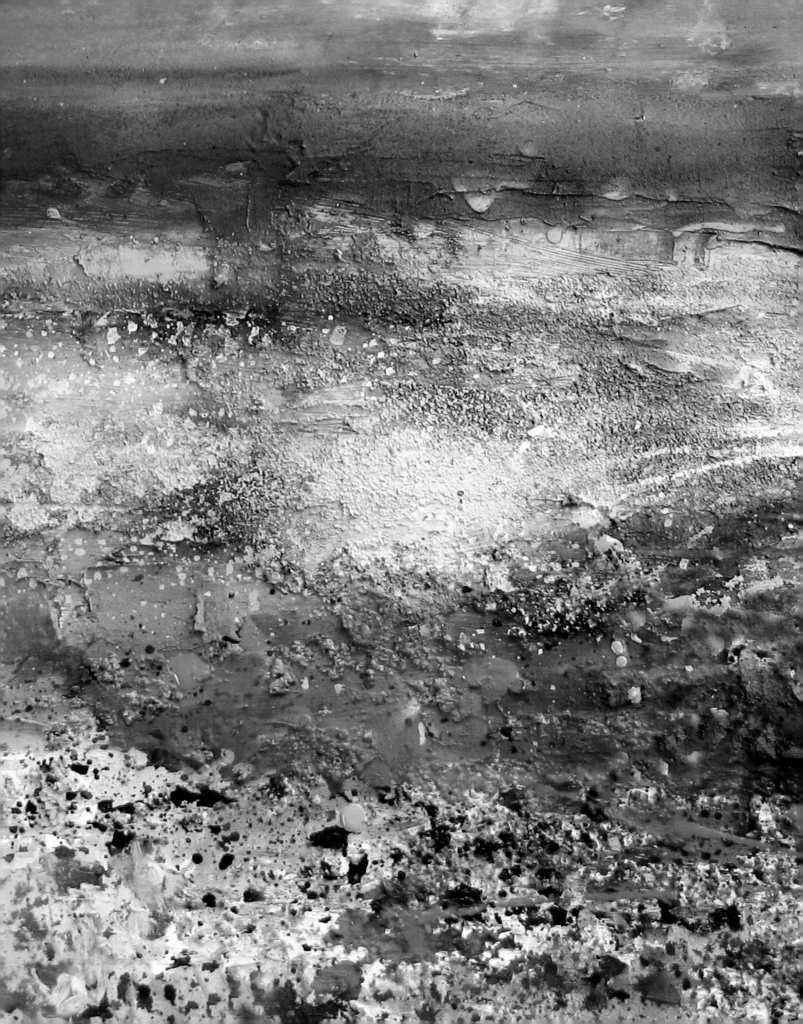

TANTALIZING TEXTURES

In this chapter I am introducing you to a number of products which will open up new horizons and help you enhance your paintings in ways that are either not possible to achieve with pure paints or perhaps not economical to do so. They should not be used to disguise a lack of drawing experience or a good compositional balance, but rather used thoughtfully to create tantalizing textural effects and an interesting surface quality in your painting. In the past many avant-garde artists resorted to

using natural sand, grit and dirt to produce texture and took a risk with the possible long-term interaction of the impurities in such materials with their paint, thus compromising their efforts. The archival quality of the gels and pastes in this chapter will ensure the longevity of your art work.

In the process of seeking these enhancing materials it is good to remember not to lose sight of the painting process and not to let the products become the purpose of the painting itself. So be frugal and do not overwhelm the painting with too many products; less is more. The overuse of texture materials can sometimes ruin what could have been a good painting.

The sheer number of these products can be rather confusing for artists new to the world of mixed media and painting in acrylics. Through books, and extensive available information online, you can narrow down the products that will be relevant to your work. A little time spent experimenting will open up a whole new world of creative possibilities. True to the easy nature of acrylics, all the following products give you a lot of freedom.

OPPOSITE: Seascape (acrylic inks and fluids on pumice gel, gesso and heavy gel matte).

BELOW: Late Afternoon Sun (acrylic inks and fluids on pumice gel and extra heavy gel matte).

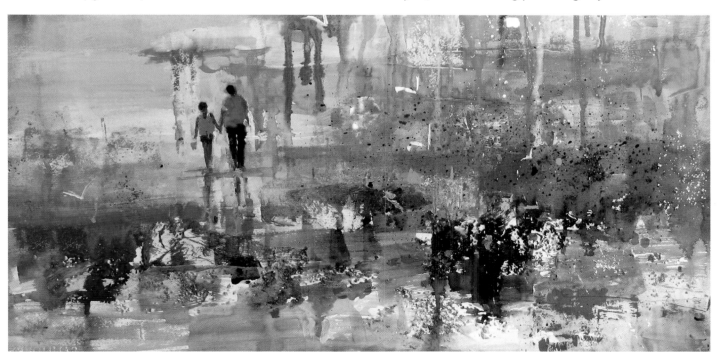

There are very few dos and don'ts and as ever, common sense prevails.

Remember, suggestions shown in this book, manufacturers' leaflets, online or any other place, are all other people's ideas. Be creative and experiment to come up with your own version of utilizing these tools and your own unique vision to move forward with your painting.

Surface quality of a painting

As one of the main elements of design the texture and surface quality of your painting plays a crucial role in the success of the image. To put it in perspective, it is the way the artist handles the paint and prepares the ground to paint on. An interesting surface finish of a painting can make the most mundane subject matter come to life. The factors that come into play are the liveliness of brush strokes and the creative application of seemingly random marks using alternative implements to brushes.

Another important factor is the support that the image is painted on, in other words, the ground preparation. In the materials chapter we have already touched on the subject of priming with gesso, watercolour ground, absorbent ground, acrylic grounds for pastels, colour fix and so on. As well as these, there is also a wide choice of texture-making products on the market that help you prepare your support or mix with your paints to achieve interesting effects in the final finish of your painting.

I am introducing a selection of these materials to familiarize you with their application and help you make an informed decision about acquiring the right product relevant to your work. To begin experimenting you can choose one or two of the gels that appeal to you. A starter set of six products is a sensible way to start. You will find that the range of texture pastes and gels is now so extensive that you can pick and choose from brands and types to suit your own budget.

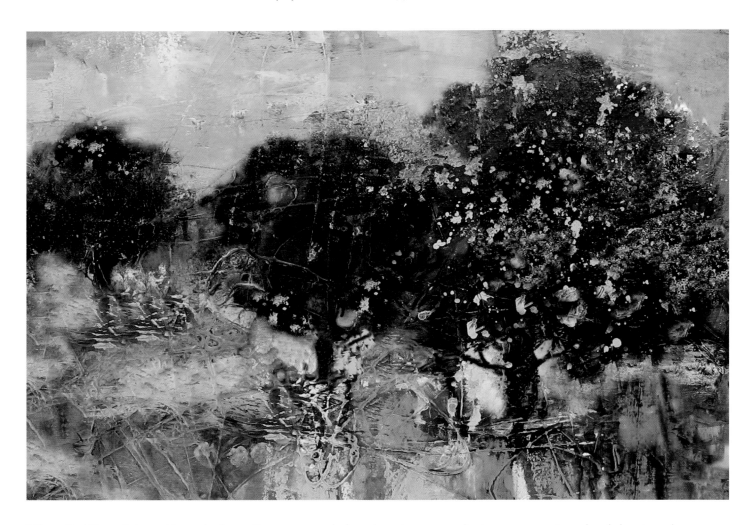

Silhouetted Trees *(inks and heavy body acrylics on a ground of regular gel, coarse and extra coarse pumice gel and clear tar gel.*

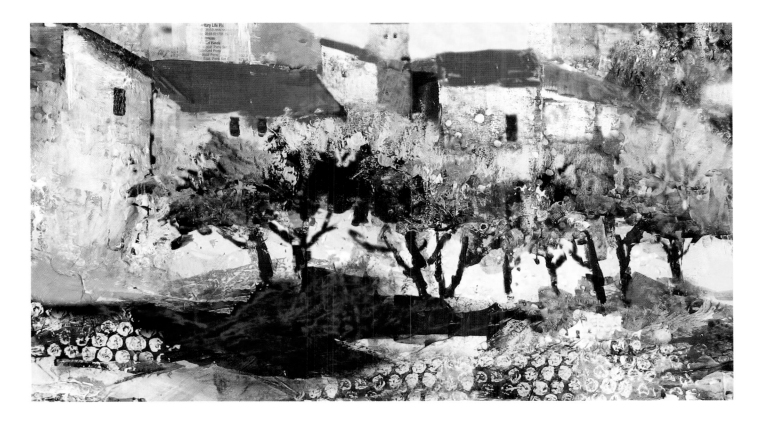

French Village *(heavy body acrylic and pastels on moulding paste, light moulding paste and fibre paste with imprints of bubble wrap).*

Dry or wet?

Always make sure that all the gels and pastes are completely dry before you start painting unless you intend to mix them with the paints. Always keep the lid on the pots to avoid the gel drying up.

Gel mediums

One of the joys of painting in mixed media is the ability to create a variety of tactile textures. Gel mediums are the products that you can either mix with your paints or use to build your texture prior to painting. You can also use the gels as a ground to paint on.

Gels are basically colourless acrylics and are composed of 100 per cent acrylic polymers just like the paints but without the pigments. In certain brands such as Golden you will find gels of various consistencies from pourable to mouldable, which allow you to achieve a specific texture or indeed extend your paints without changing the viscosity. You can also use gels for glazing as adding them to the paints makes the colours more translucent. They are available in matte, gloss and semi-gloss finishes.

Some gels have added particles such as bits of pumice, glass or acrylic granules that help you create reflective, absorbent or rough surface qualities. Gels are just like glue and can be used in mixed media paintings to adhere your collage pieces and can create a barrier to protect the collage from water, chemicals and ultraviolet rays.

Using gel to provide texture

Soft gel is the consistency of yogurt and will not hold peaks or brush marks. Regular gel is the same consistency as heavy body paint, while heavy and extra heavy gels will allow you to build up much more substantial textures.

Heavy gel has a thicker consistency than Golden heavy body acrylic colours, so you can blend it with your acrylic paints to further increase volume. It holds brush and palette knife marks well. It can also be used to build up the surface of your paper or canvas with any texture effect that you wish to achieve and can then be painted over.

The gloss version of the gel dries translucent, and the matte version is rather milky when it dries. You will notice the difference between the matte and gloss gels when you mix them with your paint; as the paint dries the gloss gel gives the finish a deep shine which suits some subjects, while the matte gel will allow the paints dry to a more attractive matte finish.

If you have used the gels in preparing your ground, then you will notice a difference if you have a wash of acrylic ink over them: the inks will run off the shiny and lustrous finish of the gloss gel while they may slightly sink into the rather more spongy surface of the matte gel. Gloss gel is also more suitable for adhering collage to your support as it will dry clear and will allow the collage to show through.

To add even more body to your paints for impasto style paintings you can opt for extra heavy gel, which is also available in matte, gloss and satin.

Gels such as heavy and extra heavy have what we call short rheology, which means they retain their shape. To maintain your brush marks you should mix your paint with gels that have short rheology.

You can create wonderful sculptural effects with both heavy and extra heavy gel, but be careful you do not turn your paint-ing into a relief sculpture; keep the painting surface just thick enough to express texture.

High solid gel

High solid gel is thicker in consistency than heavy body acrylic colours; it is very similar to extra heavy gel and offers more or less the same functions, but it shrinks less and touch dries quicker than most of the other gels. This gel is ideal for holding peaks, and when mixed with the paints you can successfully employ most oil painting techniques. You can choose from matte or gloss according to the finish you are after.

High solid gel tinted with ultramarine blue.

1	2	3	4

Gel medium consistencies: (1) soft gel, (2) regular gel, (3) heavy gel matte and (4) extra heavy gel gloss. All these gels have been tinted with different blues.

Apple and Pear in Impasto Style
(heavy body acrylic paint mixed with extra heavy gel matte).

Impasto

In impasto style painting, the brush or palette knife marks are retained and the paint is used in a highly textural and heavy manner. This means using quite a lot of heavy body paint, and is an economical nightmare, especially where the more expensive pigments are concerned. This is where using an extra heavy or high solid gel mixed with the paints can save the day. It is useful to remember that using acrylics in this way extends the drying time. Your paint might feel touch-dry but the thick layers underneath may take seventy-two hours or longer to dry fully.

more transparent. Every time you add clear gels to your acrylic paint, you are essentially adding transparent cells into the pigment, simply making it bulkier.

Using gels to extend the paints

Apart from providing texture, another useful function of the gels is to extend your paints and make the colours go further. Initially you may think that you have made a tint, but the milky white of the gels dries to a clear finish and will retain the full value of your colour. If you try to make the paint go further by diluting with water, first of all you loosen up the paint film, making it weaker, but you will also thin the consistency. By extending the paint with the appropriate gel you can make the paint go further while retaining the viscosity. You will be surprised at how much paint you save by extending your colours with the gels, especially for really expensive pigments such as cobalts and cadmiums.

You can add as much gel as you wish but be wary, as although the consistency and colour will remain the same, the pigment gets diluted by this process and the paint becomes more and

Extending your paint

To make your own top quality student colours you can mix your artist grade paints with Golden's soft gel. This way you are using great artist quality paint but making it go so much further.

A small amount of paint can be extended much further with soft gel or a heavier gel for impasto style painting.

Pouring gels

Self-levelling gel

Self-levelling gel is designed to produce an even film with excellent clarity. When this gel dries it creates a high gloss flexible film. It can be very useful for pouring techniques as it gives the colours a self-levelling quality. It dries clear so there is no change of colour when mixed with paints. It can be successfully blended with acrylic colour for glazing techniques. Self-levelling gel is ideal for making acrylic skins for collage work.

In the same way as making acrylic skins you can make interesting and irregular shape stencils. Using one of the pouring gels such as clear tar gel you can make the patterns you wish to create over a piece of plastic sheet. Allow the gel to dry and peel off gently to use as a stencil with high flow acrylics or acrylic inks.

Clear tar gel

Clear tar gel is a unique and highly resinous and stringy gel. This gel can be used on its own or in conjunction with acrylic colours. However, to retain its tar-like quality it works best with fluid acrylics. You should also regulate how many drops of colour you add to the gel to avoid losing its consistency. It can flow from a palette knife continuously and drip onto the surface of your support to generate fine detailed lines. These could be merely abstract marks or could be suggesting a particular texture such as ropes, fishing nets and other similar shapes.

Making stencils with self-levelling gel on a sheet of plastic.

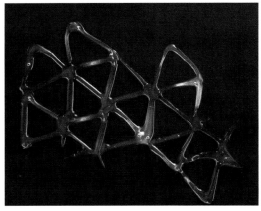

The dry ready-to-use stencil.

Just like self-levelling gel, clear tar gel is also useful for making acrylic skins to be used in collage work.

Both self-levelling gel and clear tar gel have long rheology which means that they level out and do not stay in a fixed state. If you wish to extend your paint and not see any visible brush marks then you can extend with either of these gels. Both gels can be mixed with colours for dripping, drizzling and pouring techniques.

Clear tar gel tinted with teal on a vivid orange background.

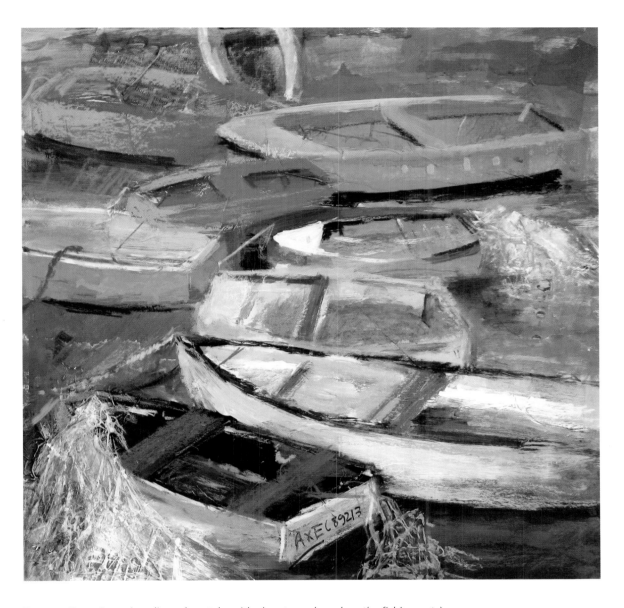

Boats at Pont-Aven *(acrylic and pastels, with clear tar gel used on the fishing nets).*

Detail of clear tar gel applied to suggest the texture of fishing nets.

Gels with granules

Some gels have different types of granules in them which enable you to imply certain types of textures in your painting. Here we will have a look at some of the most popular of these gels.

Pumice gel

Pumice gel is one of my favourites. As the name implies, it contains pumice granules. Fine, coarse and extra coarse are three different consistencies of pumice gel to help you achieve the right kind of texture in your painting. For example, using both coarse and extra coarse gels in a painting of a sandy beach will help you create recession by using the coarse gel at the back and extra coarse gel in the foreground. You can mix this gel with the paint, or you can use it to create a textural effect and paint over it. With imagination this gel in all its consistencies can enhance your painting no end. It is highly useful in both landscape and seascape paintings, but can be applied imaginatively to enhance other subjects too.

Fine pumice gel is good as a ground to draw or paint on. It creates a certain amount of tooth which provides enough grip for any drawing material such as charcoal, crayon and a variety of pastels. It is wonderful to be able to take a smooth and economically priced piece of card and turn it into a highly suitable surface for pastel painting or charcoal and pencil drawings. Acrylic paint also behaves in a certain way over this surface which gives it a nice finish quality.

I often use coarse pumice gel to suggest foliage of trees; I really like the absorbency of the gel and how the inks sink into it. Extra coarse pumice gel is fabulous for suggesting pebbles in a beach scene, as mentioned previously, or the texture of a rough ground in a landscape.

Used cleverly and with caution these products can enhance and liven up a painting.

Fine pumice gel tinted with teal and brilliant red pastel marks.

Coarse pumice gel tinted with green gold.

Extra coarse pumice gel tinted with quinacridone red.

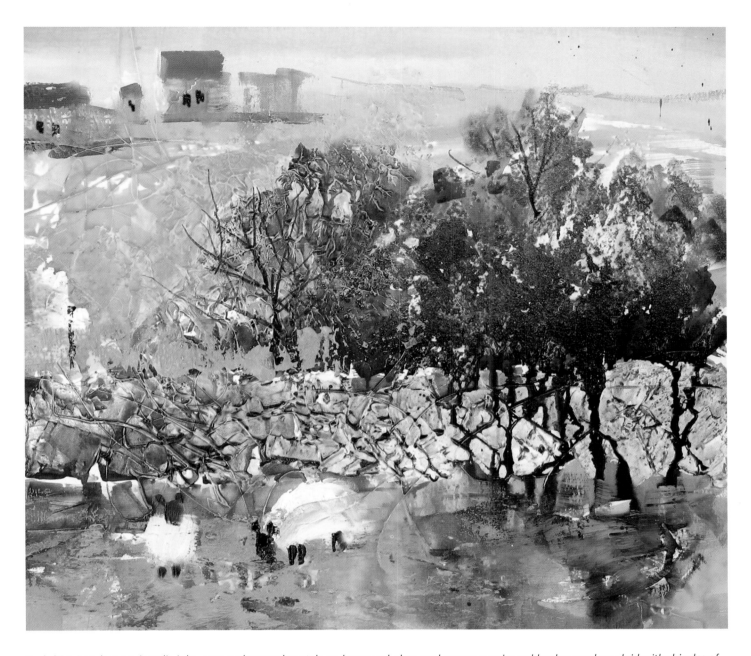

Yorkshire Landscape (*acrylic inks, watercolour and pastels on heavy gel gloss and coarse pumice gel background overlaid with drizzles of clear tar gel*).

Detail showing coarse pumice gel; this surface is quite absorbent so the washes of colour sink into it.

Detail of heavy gel gloss overlaid with clear tar gel.

Clear granular gel tinted with quinacridone magenta.

Clear granular gel

This gel contains particles made up of acrylic plastic; it dries clear with a reflective surface. It can be mixed with colour or used on its own and painted over. Transparent washes of colour will enhance the reflective quality of clear granular gel.

Glass bead gel

Glass bead gel contains actual pieces of glass. Once this gel dries it creates a beautiful reflective surface which can be effectively enhanced by washes of transparent colour. For example the centre of a flower in a mixed media painting can be created using either glass bead gel or clear granular gel.

Sparkling

Transparent and translucent washes of colour make both clear granular gel and glass bead gel sparkle. Many of the gloss gels, including glass bead gel, can be painted over a painting or print to create interesting visual effects.

Glass bead gel tinted with bright gold fluid acrylic; the opaque paint gives the gel a much more solid look.

Glass bead gel with a wash of phthalo blue high flow acrylic.

Pastes

Pastes are yet another set of tools for creating a variety of textural effects. Pastes are different from gels in as much as they are opaque and contain substances such as fibres, marble dust, clay or other types of fillers. They are often white or in colours similar to clay. Like gels, they can be mixed with the paint either to change the appearance and feel of the paint or to prepare a ground prior to painting. Used with some imagination they can really liven up the surface quality of your work. Examples of a few useful pastes are as follows.

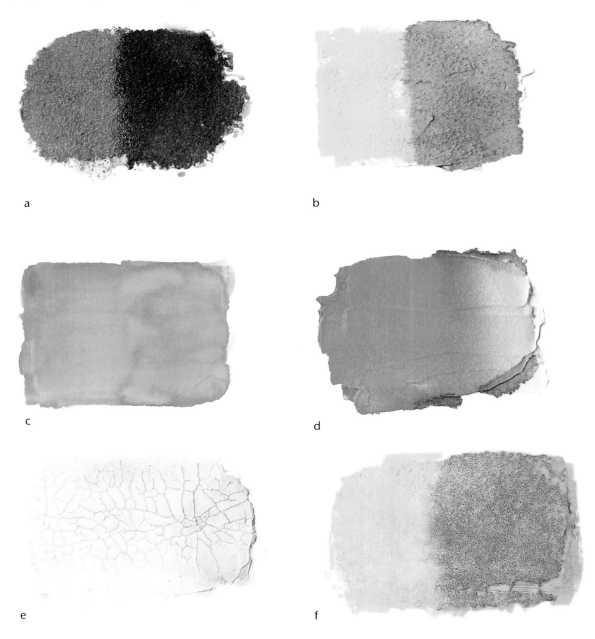

a

b

c

d

e

f

A variety of gels and pastes with washes of colour: (a) coarse pumice gel with washes of quinacridone red and Prussian blue, (b) fibre paste with washes of hansa yellow light and cobalt green, (c) absorbent ground with washes of quinacridone magenta and yellow ochre, (d) light moulding paste with quinacridone magenta and mangansese blue hue, (e) Crackle paste with washes of Teal and raw sienna (f) Glass bead gel with washes of hansa yellow medium and cadmium orange hue.

Regular moulding paste

Regular moulding paste is a great product for preparing surfaces and also for creating interesting textures. It is the same consistency as heavy gel. It is an opaque paste and remains flexible after drying. You can blend moulding paste with all types of acrylic paints to change their consistency and working property. As moulding paste is not 100 per cent transparent it will tint colours to an extent when mixed with them. They apply best to absorbent surfaces such as wood and canvas and will not stick to slick oily surfaces.

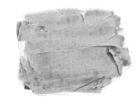

Regular moulding paste tinted with green gold.

Hard moulding paste

As the name suggests this paste dries to form an extremely hard, durable and opaque surface. It can be used for creating both smooth and textured grounds. The paste was originally developed for artists to be able to sand down the painting surface in order to create an ultra-smooth, almost glass-like finish. It is great for embedding objects for extra texture. It also works well with stencils for creating patterns and can be shaped using heavy duty tools such as knives, carving tools, electric sanding equipment and even drills. High peaks are best achieved with the light moulding paste, as the hard paste as a long rheology and peaks will settle as it dries. It can be applied directly to the canvas, paper or any support or made into a skin to be adhered to as collage. It does form a brittle film and is less flexible than other pastes so should be used on a stiff surface. Like all other pastes and gels it can be mixed with any type of acrylics to create a thicker viscosity.

Hard moulding paste tinted with light green.

Light moulding paste

Light moulding paste dries to an off-white opaque and matte finish. As the name implies this is a light paste considerably lighter than the hard moulding paste. Because of its lighter weight it can be used to build up very effective thick textures on larger canvases or paintings on paper without the problem of, literally, creating a heavy painting.

The foamy consistency is designed to hold stiff peaks to create a highly textured surface. As is the case with all other pastes it blends well with all types of acrylic colour. This paste is highly absorbent and works really well with water media. Light moulding paste, along with the regular moulding paste, can both be used on rolled canvases without cracking, unlike heavy moulding paste which will crack.

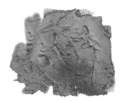

Light moulding paste tinted with ultramarine blue.

Coarse moulding paste

Coarse moulding paste is quite a thick paste which remains translucent up to $\frac{1}{8}$ in appliction, while thicker applications dry to a warm off-white colour. It dries to a fine sandpaper-like surface which is highly receptive for both wet and dry media. You can mix this paste with any acrylic viscosity and get a lovely malleable thick paint that holds palette knife peaks and brush marks. You can choose from matte or satin finish.

Coarsemoulding paste tinted with naphthal red and raw sienna.

Applying gels and pastes

The best way to apply gels and pastes is with any implement that can be cleaned easily. You can use a palette knife, plastic spatula, a piece of card, your fingers or colour shapers. A brush on the other hand makes for clumsy application and is difficult to clean afterwards.

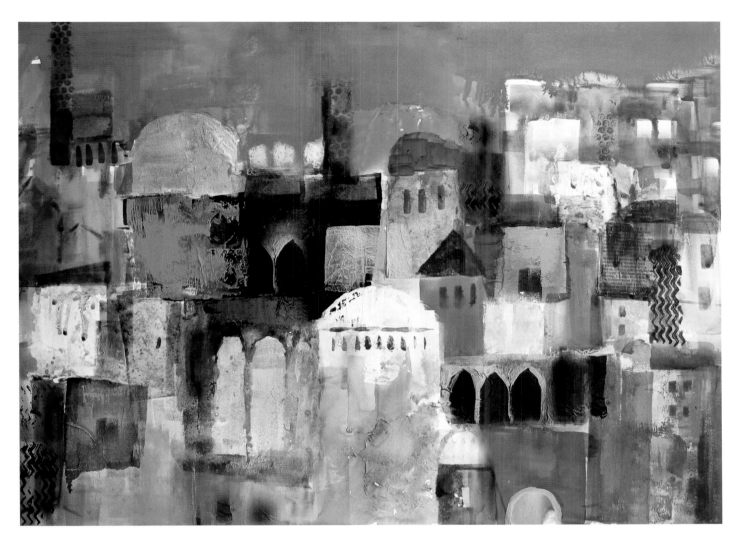

Eastern Cityscape *(acrylic inks, gouache, watercolour and pastels on a variety of moulding pastes).*

Detail showing the texture of regular moulding paste.

Applying gel with a palette knife.

Fibre paste

This is one of my favourite pastes. Fibre paste dries to resemble a very rough hand-made watercolour paper. You can apply it thickly to suggest a certain rough texture or you can skim it with a wet credit card or palette knife to achieve a smoother finish. Fibre paste dries to an off-white colour and is highly absorbent. I like the way washes of colour sink into it. You can apply fibre paste to a clear plastic sheet, allow it to dry and then peel it off to use as a piece of handmade paper.

Crackle paste tinted with flame orange ink.

Pink Anemone *(painted over a ground of fibre paste with a wash of green gold).*

Crackle paste

This is a lovely and unique lightweight opaque paste that develops fissure-like cracks as it dries and cures. The thicker the application, the bigger the size of the crackles that form on the surface. This is also dependent on environmental conditions, such as temperature, humidity and air flow during the drying process. One of the most fascinating but labour-intensive techniques with crackle paste is to paint individual sections to build the composition. This way you can create a mosaic-type finish as every small piece resembles a randomly cut piece of mosaic. To finish this look you can apply a coat of gloss gel or varnish which can be very effective for certain subject matters.

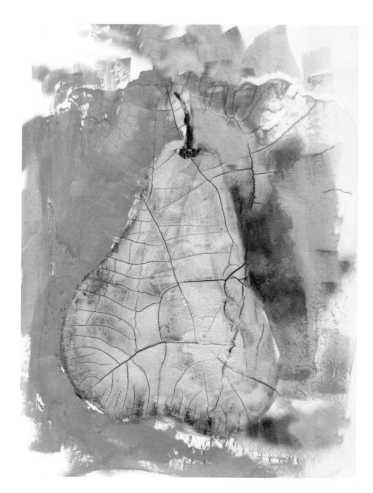

Golden Pear *(painted on a ground of crackle paste).*

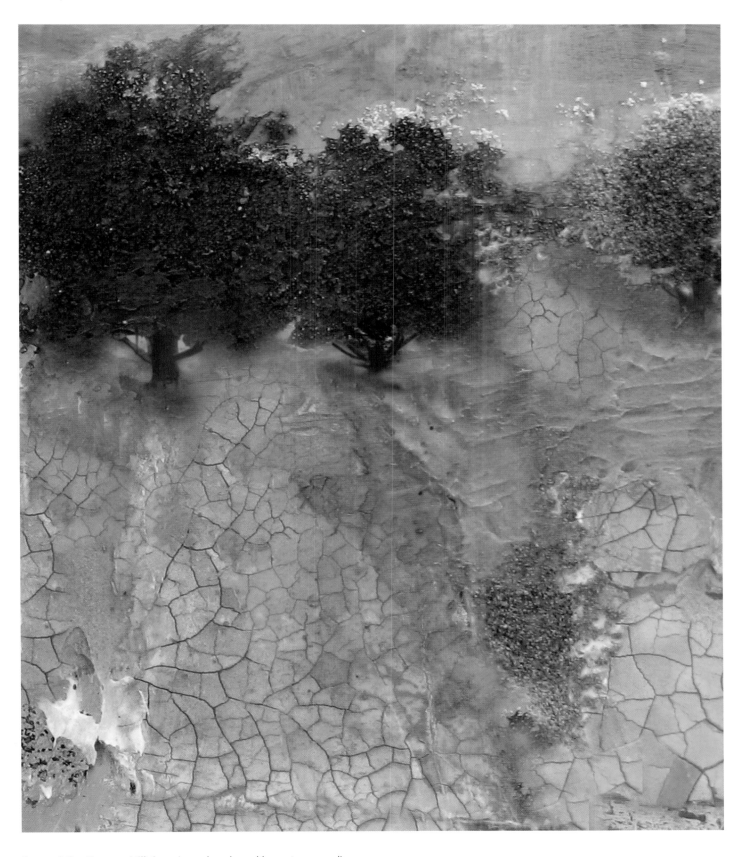

Beyond the Orange Hill *(pumice gel and crackle paste ground)*.

Project: Different ways of using gels and pastes

Both gels and pastes can be used as a ground to alter the surface quality of a painting. For example if you use coarse pumice gel as a ground the whole painting will have the rough textured appearance of the pumice gel. Every type of gels and pastes mentioned in this chapter will offer a different feel and look to the finish of your painting.

Gels and pastes can also be mixed with your paints to extend the volume, change the appearance and the finish quality of the paint. For example, if you mix and extend your paint with heavy gel gloss, the painting will have a lustrous and glossy finish. The added gloss and shine makes the colours appear deeper and richer in tone.

For this project, try a few paintings with two or three types of gel or paste that you may have.

For your first experiment mix the paint with the gels and for the second piece make the desired textures prior to painting, and note the differences in each technique.

Dragonfly *(painted over light moulding paste). This is one of my favourite pastes; I love the mottled effect it creates as the inks sink into the surface in an irregular manner.*

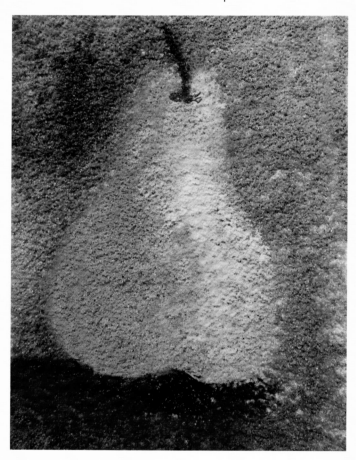

ABOVE: The Green Pear *(painted over a whole ground of coarse pumice gel, which creates an interesting and unusual visual texture).*

RIGHT: Sunflowers. *For this experiment I added acrylic ground for pastels to Open acrylics; this gives a much grittier texture to the soft and creamy Open acrylics. Try different gels with your acrylics to change the workability of your paints.*

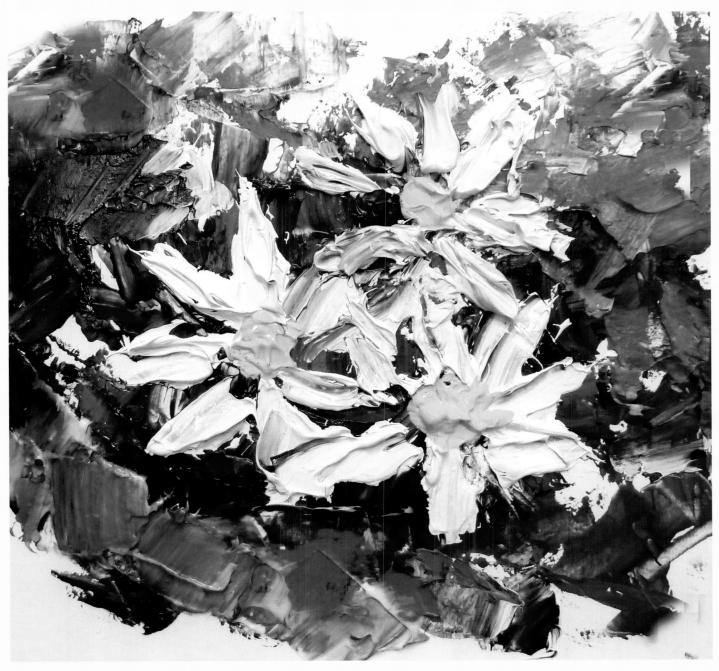

Daisies *(heavy body paint mixed with extra heavy gel/moulding paste). This is a perfect mixture for impasto style painting. You need to leave the painting to dry for quite some time; it may be touch dry but the underneath layers take a few days to dry.*

White turns clear

Gloss gels are white when wet but will dry clear, so will not alter the value of your colours.

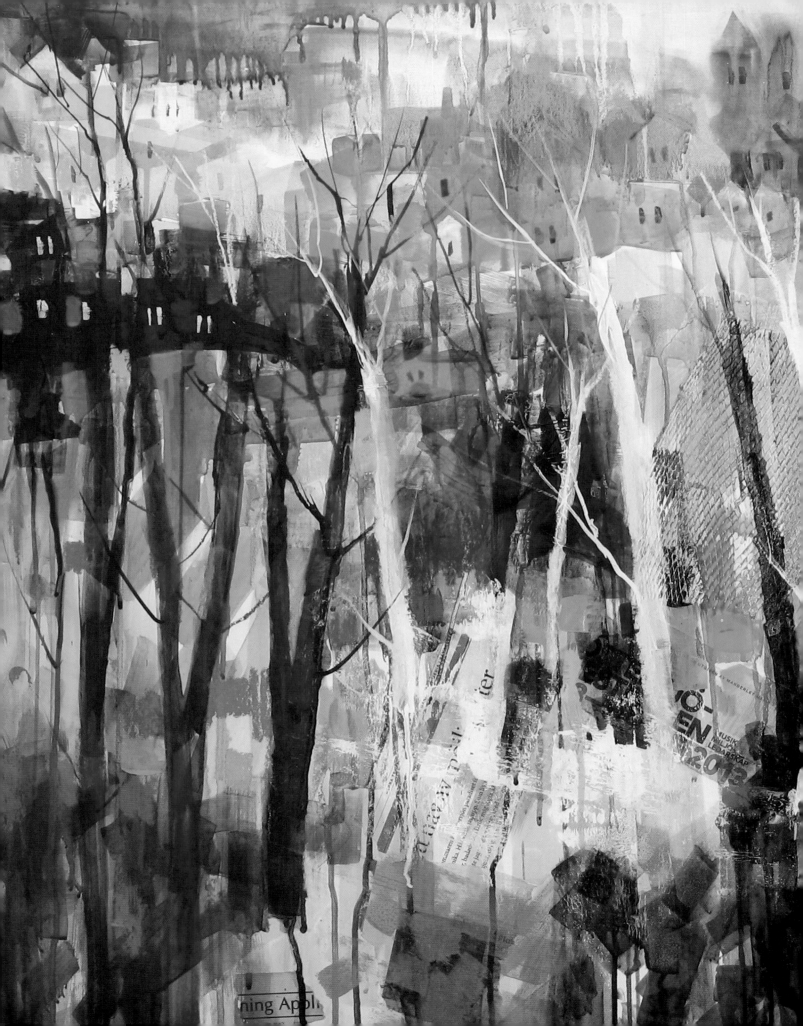

COLLAGE

Inclusion of collage in a mixed media painting creates added visual interest and an intriguing quality otherwise not possible to achieve with pure painting media. The word collage derives from a French word *coller* meaning to glue or paste. Although there is evidence of the earlier use of collage in artwork, it was not until the early part of the twentieth century with the modernist movement that Braque and Picasso brought this art form into the fore. Today, working purely in collage is an accepted art form and for some prominent artists worldwide remains their principal form of expression. In the context of this book, however, collage is used as part of a mixed media painting and is applied to enhance the painting.

OPPOSITE: **The City Beyond** *(collage, inks, heavy body acrylics, oil and soft pastels).*

Autumn Forest *(acrylic skins, fluids and water mixable wax crayons).*

Collage breaks up the white of the paper and is the ideal way to introduce less literal forms in your work. Washes of colour flow over various types of material such as tissue paper, handmade paper or newsprint, found objects and so on to create a variety of totally different and interesting visual effects. This exciting process creates some wonderfully random shapes and patterns which help you towards abstraction. This in turn brings a feeling of ambiguity which forces the viewer to use their imagination to make up the full story.

In general, subjects with multiple shapes or heavy textures, such as urban landscapes, harbour scenes, or rugged landscapes, are more suited for the inclusion of collage. Not every subject lends itself to collage; moody and atmospheric paintings require a softer and more gentle approach. With experience you will be able to judge the kind of subject matter that will benefit from the inclusion of collage, enabling you to find new and exciting ways to enhance your painting.

Although using collage is not a new concept, it is fascinating

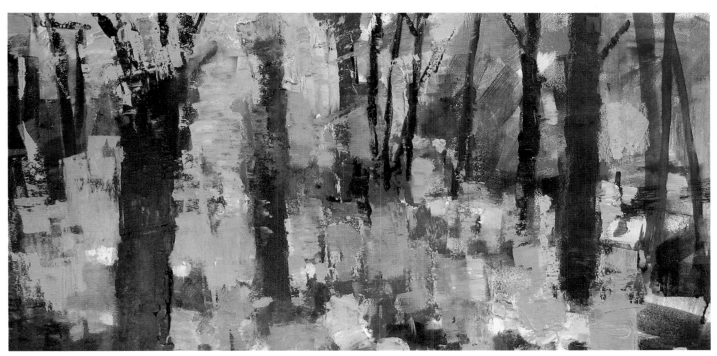

how in each era a new twist is added by innovative artists who revamp the old ideas and make them even more exciting and relevant to today's art scene.

As in the other mixed media combinations, there are many diverse approaches to working with collage, which are all valid. I enjoy the way including collage encourages me to think outside the box and helps me explore new and unusual materials and methods often with exciting and unexpected results.

Collage materials

The process of working with collage can become quite addictive and can also turn you into a hoarder of all types of materials that once upon a time you would have happily assigned to the dust bin. Other people's junk becomes your little pieces of treasure. Collage materials can be made up of pieces of handmade paper, different types of coloured and white tissue paper, Japanese rice paper and even printed texts of newspapers and Sunday supplements, glossy magazines, doilies and the netting that your

fruit comes in, can all be incorporated in some way to suggest a certain texture or colour. My personal preference is merely to enhance the painting with collage and avoid the surface becoming a relief sculpture instead.

It is remarkable the way discarded items take on a new identity by being transferred as collage into a piece of art work and used in a new context.

If, like me, you worry about the amount of waste that junk mail creates, recycle these by using them as collage as they are usually produced using good quality printing materials with interesting fonts, designs and patterns that can potentially add quite valuable interest to your painting.

Collage pieces with nostalgic value such as travel tickets, theatre tickets of a favourite show, letters from a loved one and meaningful printed texts are also popular choices for some artists. Try to use them tastefully and don't let the painting become over sentimental.

Being selective is key to producing paintings that have a good balance between the collage and the painting media, much the same way that you balance other elements in your painting, such as the ratio between busy and quiet areas.

A selection of collage pieces in their dry form.

Collage pieces with washes of ink: washes of colour over the collage pieces create wonderful varied effects, as each piece has its own unique reaction to the inks.

Using text and letters in collage.

Applying collage to your support

I personally prefer to use collage on paper rather than canvas, however, you can also use canvas if you prefer. Collage pieces can be glued to the support of your choice with either PVA glue, slightly diluted to the consistency of double cream, or better still, using any acrylic medium or gels which additionally have archival quality. The gloss products are usually preferred for this purpose, since they offer the greatest transparency; however, the other sheens work just as well as a glue. You need to make sure that the collage is adhered properly and is not left untreated by your means of adhesion. Collage pieces are quite fragile when wet, but become quite tough and hardy when dried. Although you can speed up the drying process by using a hair dryer, where possible, it is best to leave the collage to dry naturally. I quite often prepare collage backgrounds when I am not in the mood for painting, and leave them to dry naturally.

Every artist approaches collage differently. You can be quite contrived about where to apply a certain piece of collage to imply a type of texture, for example, scrunched up tissue paper to resemble the creases of flower petals or the texture of a rough wall. Alternatively collage pieces can be applied randomly so that after the washes of colour you can decide on the subject matter that can be successfully applied to the collaged paper. The unpredictability of this method is more exciting and there is always a certain amount of anticipation and an element of surprise. Collage can be absolutely magical where a pattern or texture or text can visually tease and attract the viewer, but at the same time it can be a total eyesore if it happens to be in the wrong place. Most of the time this can be reversed, either by carefully removing the collage where possible, or by covering the culprit with opaque media or applying a more appropriate piece of collage to cover the original piece.

Collage can be added at the beginning to break up and prepare the painting surface or after the initial washes of colour, or indeed at any time during the painting process where you think a certain colour or texture can improve the painting. It is best to glue pieces onto a dry surface.

Stuck-down collage pieces.

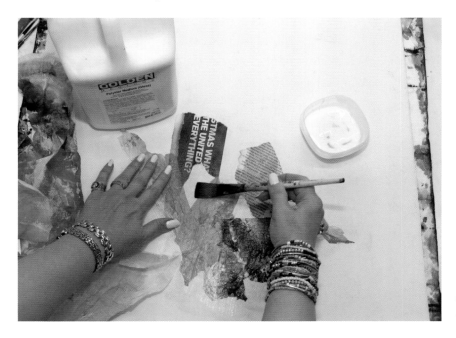

Applying collage with polymer medium gloss – the best option as it dries clear.

A very small selection of my extensive collection of stencils, stamps and all manner of objects to help create interesting patterns.

Skeleton leaves on tinted moulding paste; these make a great addition to abstract floral paintings.

Embedding sequins and beads in gel medium (for these light items I used regular gel but for heavier objects you need to use higher viscosity gels).

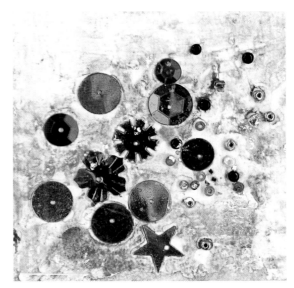

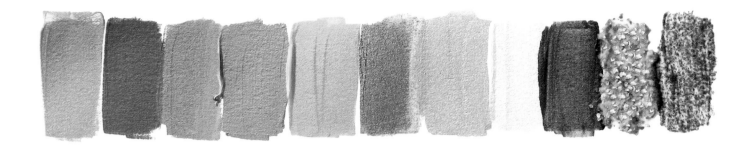

Swatches of iridescent colours, from left: iridescent gold deep (fine), copper (coarse), bronze (fine), copper light (fine), bright gold (fine), stainless steel, silver (fine), pearl (fine), micaceous iron oxide, gold mica flakes (large), coarse alumina.

Achieving exciting effects

Iridescent colours

Iridescent colours are synthetically produced in such a way that their reflective properties mimic natural phenomena such as the pearlescent qualities found in the wings of a dragonfly or butterfly and fish scales. Iridescent pearls are derived from mica platelets and then coated with extremely thin layers of titanium white; reflection and refraction of light on the titanium white layers produces the beautiful pearlescent effect.

Iridescent gold, copper and bronze are also derived from mica platelets but have an iron oxide coating which creates hues as well as a pearlescent effect. They all create fascinating effects when mixed with acrylic colours, in particular with fluid colours, and can be made into wonderful acrylic skins to use as collage material. The more that light reflects on iridescent colours the more they show their brilliance. Adding glossy gel or gloss medium will increase their iridescent quality as will a top coat of gloss varnish, but using a matte gel is not recommended as this will reduce their shine.

The iridescent quality magnifies when these colours are applied on dark surfaces or on top of darker tones in the painting.

Stainless steel, micaceous iron oxide and gold mica flakes are examples of another group of colours containing reflective colourants including highly metallic pigments. This group can truly enhance parts of the painting with their sparkly presence.

Using these colours in the right place can give your paintings extra pizzazz. They may contribute to representational paintings, but they really shine in more abstract work. These colours do not photograph well, but you can really appreciate them close up, especially under appropriate lighting.

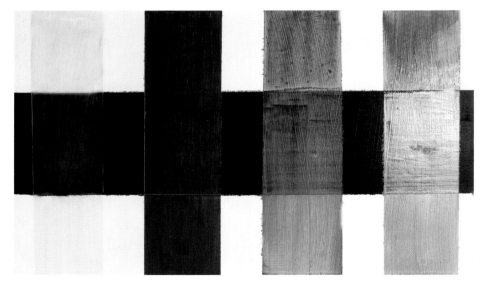

Iridescent and interference colours mixed with other colours. On the left-hand side I applied pure interference violet over the black strip; as you can see the violet is only apparent on the top of the dark strip. At the top you can see the flip effect colour which is the violet's complementary yellow. Next to this I added some black to the interference violet, which makes the violet apparent. The third strip is interference blue mixed with phthalo green which emphasizes its vibrancy. The last row is a mixture of iridescent bright gold with manganese blue hue which yields a beautiful iridescent green gold. You can jazz up your mixed media work by incorporating these unusual colours.

Interference colours mixed with clear tar gel. In this exercise I mixed the clear tar gel with interference green and interference violet and drizzled over strips of dioxazine purple, manganese blue hue mixed with coarse alumina and Prussian blue.

Interference colours

Golden's Interference acrylics are a group of utterly fabulous colours; their interplay with light and the change of hue is simply mesmerizing. These colours are made from mica platelets with an extremely thin and almost transparent coating of titanium dioxide. What you see when you apply these colours is through the reflection, refraction and interference of light. When you apply them over a white surface you can see a faint version of the colour and as you move the support you will notice its complement, so each colour flips back and forth between its own hue and its complement. When painted over a dark surface the actual colour becomes quite obvious with a beautiful opalescent effect. Alternatively, by adding a drop of fluid black or high flow black to an Interference colour you can bring out its actual hue and make it richer and deeper in tone.

These colours are relatively transparent, so are ideal for glazing techniques. They are absolutely great for abstract painting but can also enhance representational work. For example thin glazes of Interference blue and green are great for livening up seascapes and landscapes and ideal for depicting the wings of butterflies and dragonflies.

The colours included in this range are Interference red, green, blue, violet, orange and gold. You can add them to gels for impasto applications or thin them with glazing medium for layering colours. The more light that goes through the layer of Interference colours the more shine you will get, so if you blend them with a gloss medium you can increase their luminosity, and for this reason combining them with matte gels is not quite as effective. They blend well with all other acrylic colours for great combinations. You will find, however, that when you blend them together they neutralize each other and lose their effectiveness. There are no set rules for the use of Interference colours, so get creative and use your imagination.

Techniques with collage

Customizing your paper

Coloured tissue paper comes in a wide range of light to dark colours. Some of the colours are absolutely beautiful, but unfortunately as these materials are coloured with natural dyes they may fade in time. Plain white tissue paper can easily be stained with acrylic inks or fluid colours to create tissue paper with archival quality. Staining the paper with the inks helps retain the delicacy of the tissue paper, but if you need slightly more body you can use the fluid colours. Be inventive about staining the tissue or handmade paper. For example, by applying the colour with a roller you can dramatically change the texture and look of the paper. Splattering different coloured inks or diluted paints on the paper, newsprint or tissue paper creates wonderful and random effects. These can be cut up and used as pieces of collage in the painting.

Colourful circle on Interference green and blue background.

All kinds of craft stamps dipped into various colours can create wonderful patterns on the tissue paper. Iridescent and Interference colours can be particularly effective for this method especially when stamped on darker papers. There are many ways you can utilize tissue paper to make your very own unique and customized collage papers. You can splatter, stamp, stain and pour inks and fluid colours for accidental and unique colour combinations.

I sometimes cut up sections of failed paintings which have a pleasing colour combination and use them as collage in another painting. You can be creative with this – whether using an abstract section cut into random or specific shapes, or cutting out sections of a representational composition such as trees, figures, or a skyline, be as creative as you like to combine and create new images. These elements may not have worked in your original piece but may really shine in a new context.

The Lemon Seller *(using printed paper for the African woman's dress).*

Although collage is mostly regarded as a shortcut device to bring a certain colour, texture or pattern into your painting, you may prefer to use archival materials as collage, in which case you would be taking a longer route. For example, you can take your own photo and print it by using archival papers and inks to increase the longevity of your work. This process is quite satisfying as you are responsible for the creation of every part of the painting including the collage material.

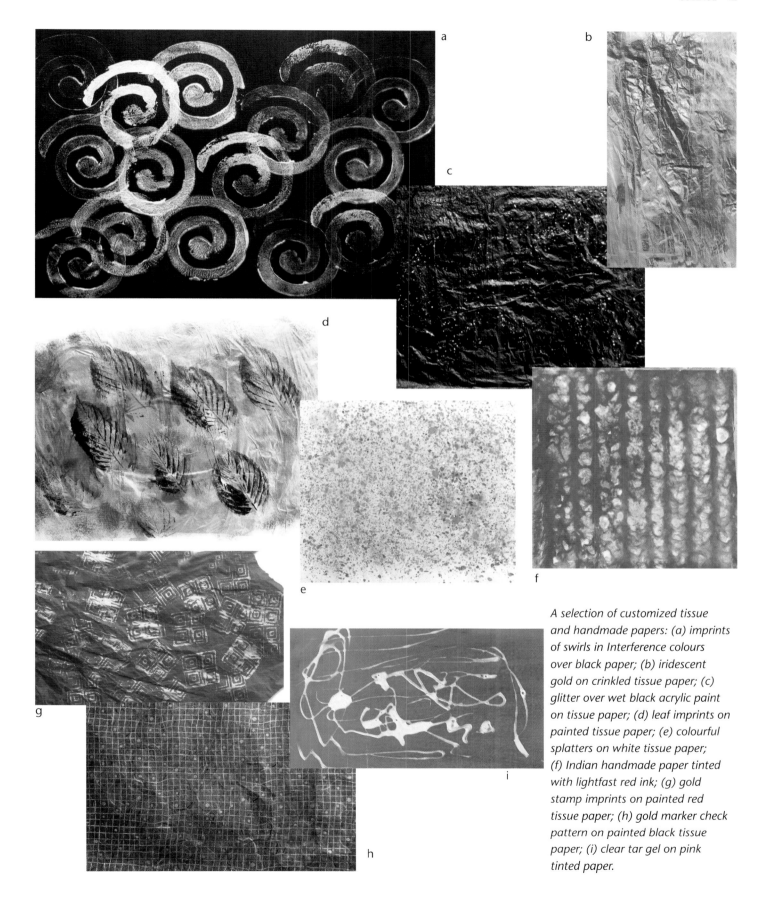

a

b

c

d

e

f

g

h

i

A selection of customized tissue and handmade papers: (a) imprints of swirls in Interference colours over black paper; (b) iridescent gold on crinkled tissue paper; (c) glitter over wet black acrylic paint on tissue paper; (d) leaf imprints on painted tissue paper; (e) colourful splatters on white tissue paper; (f) Indian handmade paper tinted with lightfast red ink; (g) gold stamp imprints on painted red tissue paper; (h) gold marker check pattern on painted black tissue paper; (i) clear tar gel on pink tinted paper.

Making acrylic skins

As acrylic paint dries it turns into a plastic film which can be peeled off if painted over a shiny and smooth surface such as a plastic sheet. These are known as acrylic skins and can be incorporated into your painting as collage material.

For this process it is best to use a type of acrylic that spreads easily, such as the soft body or fluid acrylics – I usually use the Fluid colours made by Golden. This kind of acrylic colour has a runny consistency and a self-levelling ability and can be spread easily over a piece of plastic sheet or acetate and left to dry. Once dried the skin can be peeled off to use as collage. You can work with a variety of interesting colour combinations, especially by mixing metallic or the Interference range of colours, such as gold and copper with other colours, or give the paint a pearlescent effect by mixing iridescent pearl with a colour of your choice. To apply acrylic skins you can use any of the acrylic mediums and gels or even acrylic paint itself as they all have adhesive quality. In the absence of any of these you can always use PVA glue to apply your acrylic skin.

All gels and pastes can also be made into skins, either mixed with paints or on their

Pouring self-levelling gel to make acrylic skin.

own, as well as being added to the paints for special effects.

Self-levelling and clear tar gels

The pourable consistency of both these gels makes them ideal candidates for creating acrylic skins and stencils. Both gels are designed to produce an even film with excellent clarity. The consistency of the gels is resinous and stringy, and it dries to a flexible and high gloss film. You can increase the transparency and sheen of acrylic paints by mixing them with the self-levelling clear gels or clear tar gels, which also gives the paints a self-levelling quality. These gels are also ideal for blending with other colours to produce beautiful glazes.

Moving the plastic sheet to spread the gel evenly.

Colourful Pebbles. *This painting was done on a board primed with gesso using inks and heavy body acrylics built up layer by layer. I incorporated quite a few bits of acrylic skin to build up the foreground. The pieces add texture and colour at the same time and are so much fun to use. It makes a great change from mixing colour and using a brush with wet paint.*

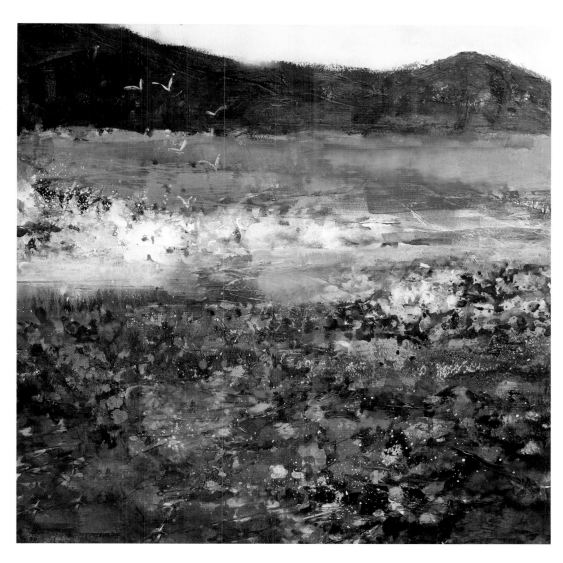

Pealed off fragments of acrylic skin.

Making a skin with fluid naphthal red light.

Adding extras to the acrylic skin

During the process of making acrylic skins, while the acrylic paint or gel is still wet, you can add other materials such as scrim, cheesecloth or other similar textured fabrics to the paint. The dry film will take on the texture of the cloth plus the colour. This material is great for collage, and colours such as copper, gold and silver work particularly well for this process. Glass bead gel and coarse alumina are also quite effective in acrylic skins. Tiny pieces of gold leaf and glitter add sparkle and can be useful in certain paintings as collage. Marbling patterns can be made by pouring two or three different fluid colours on a sheet of plas-

tic and moving the colours in a swirling motion with a pointed object. Leave to dry once you have created the desired pattern.

These are just a few ideas, the sky is the limit of how you can combine these media to produce numerous, exciting and effective patterns.

Stacking skins

Do not stack acrylic skins on top of one another; always have a protective sheet in between layers.

Different acrylic skins; be patient and leave the skin to totally dry naturally before peeling it off the plastic sheet.

Adding scrim to the skin.

Straightening the scrim before adding it to the gel.

Adding glitter and gold leaf to half-dry red acrylic skin.

Gold textured acrylic skin; I made this skin with iridescent gold fluid colour on a piece of cheese cloth. I dragged some glass bead gel over the dry skin for added texture.

Close up of the textured gold acrylic skin.

Acrylic skin with drizzles of clear tar gel at the half-dry stage.

Digital ground

You can put almost any kind of paper through your printer, but you cannot expect good results on every type of paper, as some may make the image appear dull, faint or blurry. If you ever put a non-porous surface such as acetate or kitchen foil through your printer you may find that all the inks mix and mingle and create a smeared and messy surface. For perfect results in inkjet printing every droplet of ink needs to be embedded and held in place by your surface.

A few years ago Golden Artists Colours created a fluid called Digital Ground. By applying two coats of this fluid you can make any surface with the right texture and thickness for your particular printer into an ink-jet printable surface.

So, in order to make a truly archival piece of collage, you can make your acrylic skin using colours or gels of your choice. By applying a coat or two of digital ground fluid you can make the skin viable for inkjet printing. For ease of printing, try to keep the layer very thin, ideally $1/32$–$1/16$ in. Rather than using acrylic skin, you may have a special type of handmade paper or a paper with a non-porous surface that you wish to print on. All these materials can become viable for printing with two coats of the appropriate digital ground.

For example, instead of using newsprint directly, you can take a digital image of the printed text and print it directly onto your acrylic skin or a special paper using archival inks. This also gives you more possibilities for finishes – in the graffiti example shown here, the printed words appear directly on the acrylic skin I have created. This is quite an effective and interesting process, and the collage will integrate with the rest of the painting and I can be sure of its longevity.

In order to print on your acrylic skin or special paper you need to use either an A3 or A4 paper carrier. For this purpose you should lay your acrylic skin or paper on top of the carrier (which could be a normal piece of printing paper) and tape it to the carrier on two sides. Experiment by using a series of porous and non-porous surfaces through the printer.

There are three types of digital ground available, giving you the freedom of choosing the type of surface you wish to print on, rather than being limited by what is available for inkjet printing.

Digital ground white matte is a porous, opaque and white ground which can be used on a wide range of surfaces; it dries rapidly and is a good starting point for your first foray into inkjet printing.

Digital ground clear (gloss) is a clear and glossy ground which is appropriate for most absorbent surfaces. This ground dries more slowly, so be patient and wait.

Digital ground for non-porous surfaces is similar to the clear digital ground but has an increased adhesive quality and works well on non-porous surfaces such as aluminium or plastic. For example, a piece of kitchen foil can become suitable for printing.

Applying digital ground to acrylic skin with a wash brush.

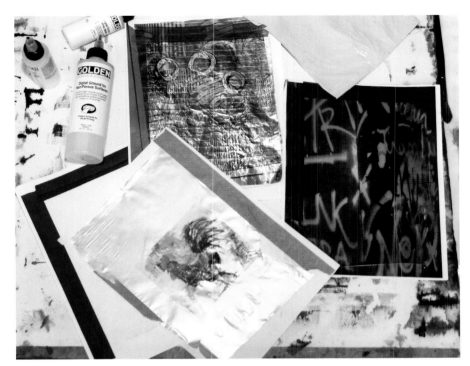

A selection of printed acrylic skins. The graffiti is printed on fine pumice gel skin, the cockerel is on pearlescent fluid skin, and some abstract doodles on the non-porous kitchen foil.

Printing on acrylic skin: acrylic skin attached by tape to an A4 paper carrier is being put through the printer.

Close-up of my graffiti photo printed on acrylic skin. I will be using this as collage in a future painting.

Demonstration: Semi-abstract passages with collage

Collage is an ideal technique for helping to take some of the passages in your painting towards the abstract. You can still have recognizable subject matter but parts of the painting will take on an ambiguous quality and encourage viewers to use their imagination.

Stage 1

I added pieces of collage in areas where I felt they could suggest the texture of the flowers. I found a piece of stripy paper for the awning and for the flower seller's apron. I made sure that all collage materials were securely stuck to the board.

This is a more contrived way of adding collage so that you can suggest a certain colour or texture of one or several components of the composition. However, collage does not necessarily have to be added at the beginning and can be brought in right up to the last minute if you feel another area would benefit from its contribution to enhance the painting further.

Flower seller

Materials

Support
Mount board 14 × 14in

High flow Acrylic inks
Lemon yellow
Quinacridone magenta
Light green
Indian yellow
Indigo

Oil pastels
Light green
Lemon yellow

Heavy body acrylic paints
Hansa yellow light or lemon yellow
Light blue violet
Titanium white
Quinacridone magenta
Phthalocyanine blue
Burnt sienna
Buff titanium
Ultramarine blue

Acrylic matte medium or PVA glue

Collage
Black, hot pink, yellow tissue paper, stripy paper, newsprint

Flower Seller *stage 1*.

Stage 2

The interaction of the inks and collage can potentially create lots of delightful and accidental shapes which can be manipulated to represent an element within the painting. I started with the lightest colours to set the scene and kept the colours fresh and vibrant. Washes of lemon yellow and light green were applied over most of the surface, leaving some of the areas of collage pieces free of colour.

When using standard coloured tissue paper, I always make sure that by the end of the painting, all paper is covered by the appropriate colour washes of ink to reinforce the colours and ensure against fading.

LEFT: Flower Seller *stage 2.*

BELOW: Flower Seller *stage 3.*

Stage 3

Prior to adding the darker tones I applied dabs of light green and yellow oil pastel to various parts of the painting where I thought the marks could enhance the colour of the ink and also resist the subsequent washes of colour. Then I added washes of indigo ink to introduce depth and structure to the painting by turning the shapes into forms. The areas of oil pastel resist the inks and create some lovely textures.

This stage can look quite chaotic and you have to learn to look ahead and be imaginative about how to organize the chaos into order. Ideally I aim for abstract shapes that read as the mass of flowers, but I always bring a few flower heads into focus by adding a recognizable detail such as the centre of the sunflowers in this particular painting.

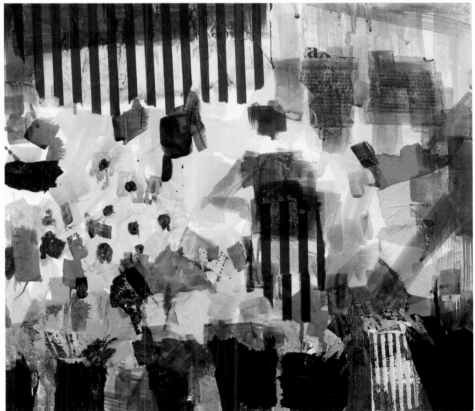

Stage 4

I started bringing in heavy body paint to describe the shapes of the sunflowers, then mixed a dark green with phthalo blue and lemon yellow and applied it to the areas where the mass of the flowers' foliage meets the pots. I then defined the flower seller by bringing colour onto his face, and painted the arms using a mix of burnt sienna and buff titanium for the skin tone.

I glazed the background using dark indigo blue ink behind the flower seller and underneath the awning to make the awning more prominent. I also painted the darker values for the white flowers using light blue violet paint. The pink flowerheads were dabbed with a mixture of quinacridone magenta and white after being covered by a wash of quinacridone high flow ink. By this stage almost all collage pieces have got some form of glaze of inks and paints on them to ensure their permanence.

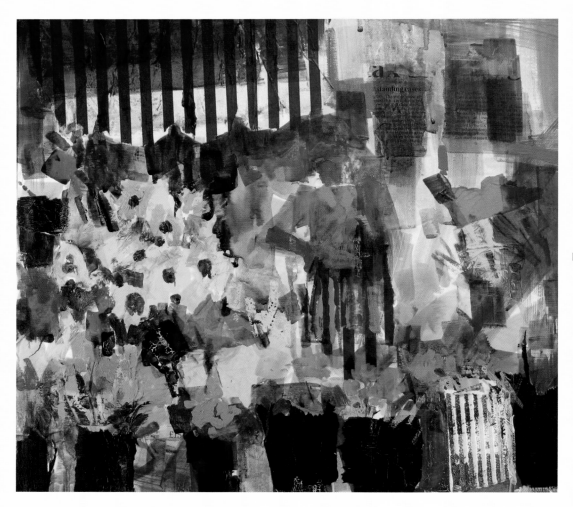

Flower Seller *stage 4.*

Skin tone

For skin tone you can use a red such as cad red light or quinacridone magenta or burnt sienna, a touch of yellow ochre and adjust the colours with either titanium white or buff titanium. Change the proportions to get a variety of tints. Make a darker version for shadow areas. This is a general mix, as depending on the light source there are all kinds of nuances of colour on human skin, and you also have to take into account the skin tone of different races and nationalities to make the colours lighter or darker.

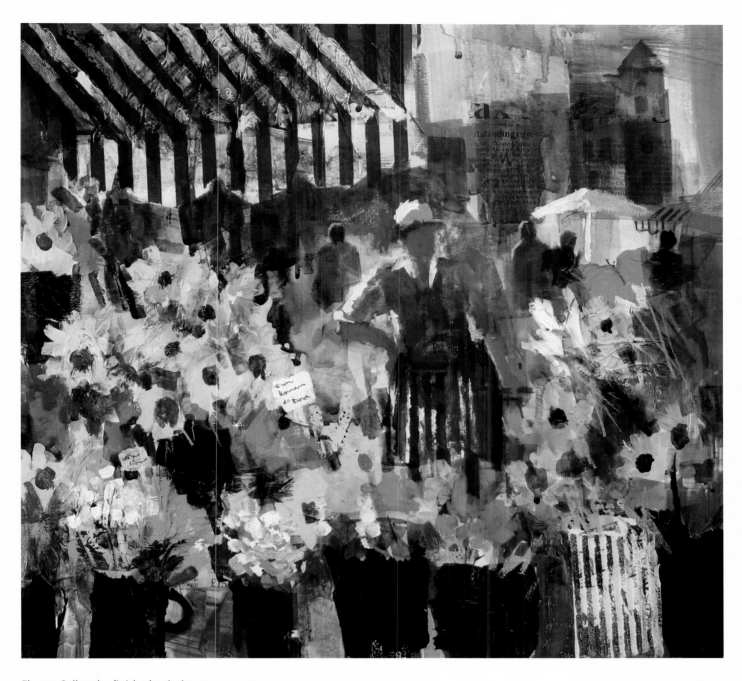

Flower Seller *the finished painting.*

Stage 5

I painted the flower seller's hat with light blue violet to indicate its shadow side. By painting a series of negative shapes I brought out a few figures from the washes of the background. I added the white umbrella and a further much smaller awning to suggest activity within the market place. The collage pieces at the back suggest distant buildings.

I finally came to my most favourite part of the painting – adding the finishing touches with all the highlights, to bring the painting alive. I feel that the painting has reached a good stage to be considered finished.

THE LANGUAGE OF COLOUR

Colour is a vast and multidimensional subject. As one of the key elements of design the colour scheme of a painting is absolutely vital to the overall success of the image. It is the element that conveys the mood and atmosphere of a painting and evokes an immediate emotional response from the viewer. It is by far the most seductive part of the painting process and one that many artists get most excited about.

There is a lot to get excited about with colour, but unfortunately enthusiasm and love of colour alone cannot guarantee you success with colour choices and applications. An instinctive understanding of colour is a truly rare gift bestowed upon few; for most of us it comes down to a little hard work. For most people a world without colour is unimaginable, yet our perception of colour varies a great deal from one individual to another; it is important when choosing your colour scheme to respond to your natural preference towards certain colours without the influence of new trends or public demand.

In mixed media you have a wide range of colours at your fingertips, giving you the opportunity to push the colour boundaries to their limit and find your personal signature through the colour scheme of your paintings. The same pigments respond differently in different binders making each medium's contribution to a mixed media painting unique and worthwhile. From the flowing transparency of watercolours and inks, to the powdery and jewel-like colours of soft pastels and coloured collage papers, you have a wealth of hues to choose from.

Too many colours, however, can be confusing and do not necessarily make you a better painter. The structured colour schemes in this chapter will help you narrow down your colour palette. The deeper you delve into the fascinating world of colour, you will realize how much more there is to learn, but the journey is full of wonderful and magical adventures. Colour in painting can be applied in an objective or representational

OPPOSITE: Persian Folk Dancers.

BELOW: *Gold fragments on red.*

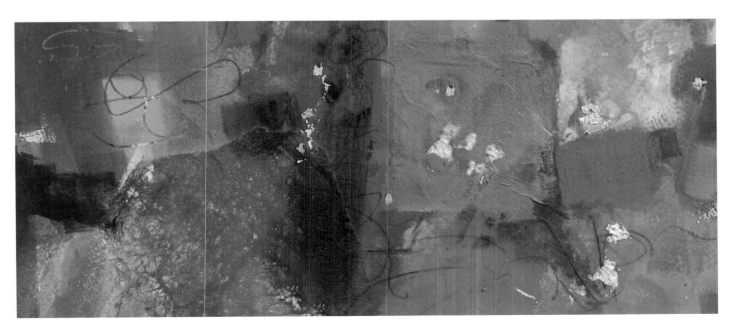

manner, where the colour of the components of the subject matter are described as they appear in reality or more expressively in a subjective and non-representational manner. In this chapter we will be exploring the basics of colour theory and useful tips regarding colour mixing to help you become more confident with colour.

CHARACTERISTICS OF COLOUR

To build your confidence with colour mixing you need to understand the three main attributes of colour: hue, saturation (chroma) and value.

Hue simply describes the colour of something such as blue, red, green and it can also be a shade of a colour. For example, lime is a hue of green. Hue and colour are general terms whereas the names of pigments are quite specific. Within each spectrum there are numerous hues, for example within the blue 'hue' there is a wide range of colours, and to distinguish between these, manufacturers give each distinctive pigment a different name. Cobalt, ultramarine, phthalocyanine are examples, but the list is long. In turn, each pigment has an index number. For example the hue of French ultramarine is blue, the pigment name is ultramarine, and the colour index number for this pigment is PB29.

We do the same in everyday life to describe a particular colour; terms such as pillar box red and raspberry red immediately give you an idea of the type of red hue being described to you.

Hue.

Saturation or **chroma** is the measure of vividness of a colour; in other words, how bright or how dull a colour is. For example, the colour red at its highest saturation appears pure red. The chroma can be greyed down by adding a little of its opposite colour, in this case green or a touch of grey. With the addition of each dab of grey the colour becomes less saturated and more subdued until it becomes totally grey.

Saturation (chroma).

Value refers to the lightness or darkness of a colour regardless of its hue. It is one of the most important elements in the design of a painting. The visual impact of a good painting is in its correct tonal value structure.

Value.

USEFUL COLOUR TERMINOLOGY

Staining power

The degree of the pigment particles embedded in the paper determines the colour's staining power. It is important to recognize this quality in your pigments if your technique relies on lifting colour. Some pigments have a high degree of staining which means the small particles of the pigment get embedded into the paper and are hard to lift. Below I have used phthalo blue; as you can see the colour still stains the paper after my attempt at lifting some of it. Conversely cobalt blue, which has a moderate to low staining quality, is much easier to lift, leaving cleaner areas of the paper. In general most modern synthetic pigments have a higher staining power than the earth colours and inorganic pigments.

Cobalt blue (less staining power).

Phthalo blue (high staining power).

Opacity/transparency

It is absolutely crucial to get to know this characteristic of your colours in order to be able to make the right decision about which two or three colours to combine together. Even though most top quality brands have this type of information on the tube of colour, you should ideally be able to recognize this property in your colours without referring to the tube. Both acrylics and watercolours have a range of transparent and opaque colours.

When unsure you can make your own test by simply applying a strip of colour over a patch of either black or another strong colour; if the colour underneath shows through then the colour is transparent; if it totally covers the colour underneath then the colour is opaque; and if it partially shows through it is semi-transparent.

Remember that every opaque colour used thinly can become translucent and any transparent colour used in its mass tone straight out of the tube can appear opaque.

Granulating ultramarine blue.

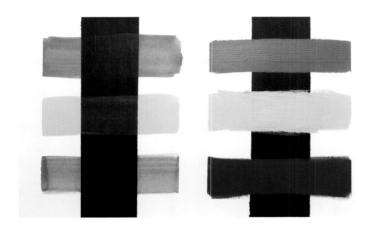

Transparency/opacity test.

Granulation

Sometimes particles of the pigment settle into the fibres of the paper and create a mottled effect known as granulation. This quality can create beautiful passages in a watercolour painting, and many watercolourists take advantage of this characteristic to create an interesting visual texture. Some of the earth colours and inorganic pigments have this quality in varying degrees, but as a rule modern synthetic pigments do not granulate. Ultramarine is a fine example of a granulating pigment.

Tinting strength

Tinting strength in simple terms is the measure of the ability of the pigment to impart colour to whatever material it is dispersed in, or its ability to change the character of another colour. Many synthetic organic pigments such as phthalo blue or quinacridone magenta have a high tinting strength. A little drop goes a long way when these pigments are mixed with another. To test this quality you can add the same amount of titanium white to each colour. Colours with high tinting strength make darker mixtures than the ones with the lower tinting strength. Most inorganic and earth pigments have a lower tinting strength.

Comparing the same amount of smalt hue with low tinting strength and phthalo blue on the right with very high tinting strength.

Warm and cool colours.

Warm ultramarine towards cool cerulean.

Warm cadmium red light hue towards cool quinacridone magenta.

Warm cadmium yellow deep hue towards cool lemon yellow.

Colour temperature

Colour temperature describes whether a colour is cool or warm. When we talk about warm colours our mind immediately conjures up images of yellow, orange and red and for cool colours, blues, greens and violets come to mind. If you look at the colour wheel you can see the side of the colour wheel that contains yellow, orange and red appears warm and the blue, green and violet side seems cooler. However, within each spectrum there are warm and cool versions. For example, within the red spectrum, an orange red is warm and a violet red such as magenta is cooler.

Cooler colours recede and warmer colours come forward, so colour temperature is especially important in describing distance and creating recession in your paintings. It can also help to a great extent towards your understanding of colour mixing. Temperature, as with other attributes of colour, is a relative concept, and a colour that appears cool in isolation or next to a warmer colour may look warmer when placed next to an even cooler colour. In other words, colours impact on one another, and changing the colour in one area of the painting often leads to having to alter other areas to retain the balance.

Colour temperature is also important in creating light and shadow; a warm light casts shadows that are slightly cooler, and conversely a cooler light has a slightly warmer shadow.

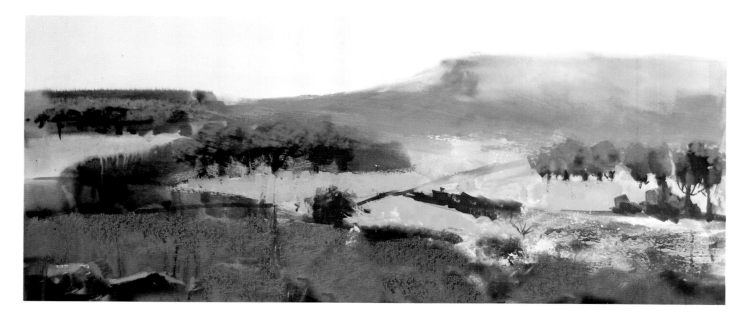

Hampshire Countryside. *The warmer greens in the foreground turn to cooler blue greens in the background to create recession.*

Tonal value

Value is the degree of lightness or darkness of a colour, and it is the element that turns the flat shapes into forms. Value is the attribute of colour that makes the most impact in composing your painting; however for most newcomers to painting it is also the most difficult aspect of colour to get to grips with. A painting that lacks the correct tonal values can appear flat, lifeless and boring. You can ignore the local colour of objects, and as long as you gauge the correct tonal values the viewer can engage with the painting.

So often by focusing intently on getting the correct local colour of the components of our subject matter we might totally overlook the application of correct tones. We can only see objects when they are lit up. A three-dimensional object lit from one angle will have a lighter side, partially lit areas and a shadowed side. Failing to apply the correct tones will result in the object looking flat and one-dimensional as shown in the orange disc. The key is to learn to read and interpret a subject tonally; this comes with practice and by improving your observational skills. It is also helpful to learn how to darken a colour and have a number of beautiful and interesting darks at your disposal that you can employ in the appropriate areas of your painting.

There are a number of steps you can take to help you get to grips with tone. Study the subject through half-closed eyes eliminates the unnecessary details and breaks down the subject into light, dark and mid tone shapes. Set up a still life lit up from one angle and observing the light and shadow areas and drawing or painting what you see.

Turning your source material upside down or sideways can help you to concentrate on tonal pattern rather than the subject itself. Taking a black and white copy of photographic reference material will also help you to concentrate on tone. Similarly, painting a subject monochromatically is a great way of focusing on tonal values. In the absence of too many colours it becomes easier to recognize the tonal structure of your subject.

When painting in watercolours you must allow for a certain amount of colour shift as the colours usually dry lighter. Conversely in some acrylic colours there is a shift towards a darker tone as the white polymer dries clear.

Orange flat disc: totally flat in the absence of tone.

Tonal sphere: the tonal structure turns the disc into a sphere.

Ten-step grey scale: This is a very helpful tool for gauging your tonal values against.

It's all relative...

Tone is a relative concept. A colour that looks light next to a dark colour can look dark when placed next to an even lighter tone.

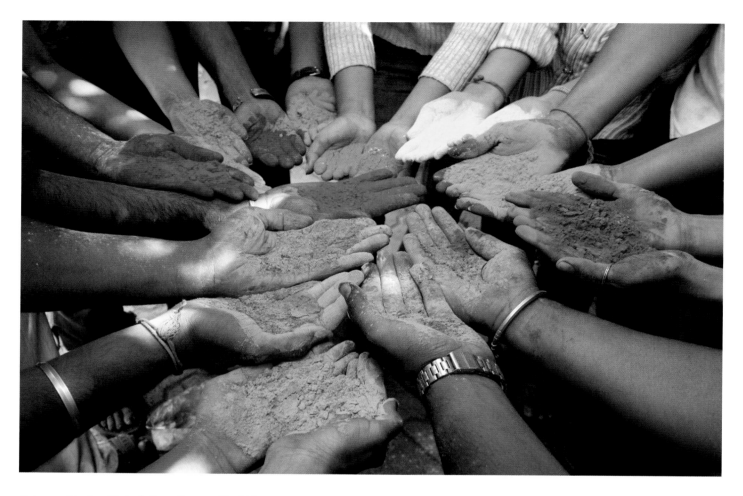

Colours of India. (© Amit Dave/Reuters/Corbis)

Understanding pigments

The world of colour theory is a minefield of contradictions and exceptions. Over many decades various colourists have brought forward their views of how colour should be understood and used. Most painters require a guide in simple terms to help them mix the right kind of colours together in order to achieve the desired hues in their paintings. To be able to mix the right colours together you need to understand the nature of pigments that go into making the colours you will be using. Pigments are divided into two categories, organic and inorganic.

Inorganic

Inorganic pigments are derived from minerals and ores. Natural inorganic pigments are obtained through the grinding and washing of clay rich in iron oxide, or the grinding of stones such as lapis lazuli. These are amongst the oldest pigments available to man and are also known as earth colours. Earth colours range from yellow to green, red and brown. Examples of these pigments are raw sienna, terra verte, red ochre and raw umber.

Although natural inorganics are highly permanent they lack consistency and producing them is a long and tedious process. Today we use the superior synthetic versions of these pigments such as Mars red and yellow oxide, and many of the earth colours such as burnt sienna and umber are made synthetically.

Another group of inorganic pigments are the synthetic inorganic pigments which are made through chemical manufacturing, such as cadmium pigments, cobalt and titanium white. Most earth pigments are of low intensity, have low tinting strength and are moderately to highly opaque, with the exception of zinc. It is important to know that mixing these low chroma pigments gives you low intensity colours which have great opacity and permanency.

Organic

Synthetic organic pigments are produced through complex carbon chemistry from petroleum, acids and similar substances under intense heat and pressure. Most organic pigments are of high intensity and offer high tinting strength and a great degree of transparency. In the majority of these pigments, the molecules have a crystalline formation which can resemble a small piece of stained glass, which allows the light to go through; therefore, these colours make mixtures with amazing clarity. Examples of these colours are phthalocyanine, quinacridones, azo and hansa. They are the high performance wonder pigments that we are so lucky to have at our disposal today.

Natural organic pigments are derived from animal oils or plants and unfortunately are prone to fading, so most of these have now been replaced by their more permanent synthetic versions. Crimson and genuine madder are examples.

Pigment test chart

It is important to try out your different tubes of paint and test the pigments for the degree of opacity, tinting strength, granulation (watercolour), transparency and opacity. Make a chart to refer to until such a time as mixing your colours becomes second nature.

Inorganic pigments from the left: cadmium red, cobalt blue and cadmium yellow medium make much denser secondary colours. The red and the blue make a very muted violet which is almost brown.

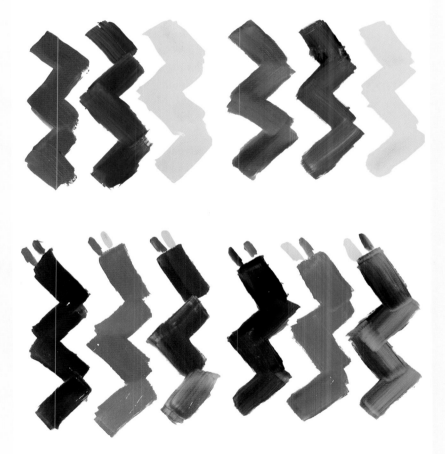

Modern organic primary colours, from the left: quicacridone red, phthalo blue and hansa yellow light; they make more vibrant secondary colours that have more clarity.

Comparing organic and inorganic primary colours.

Painting media

All artist quality wet and dry media start with a colourant or pigment which is then mixed or dispersed in a medium to make a specific type of paint. For watercolours it is gum arabic; for oils it is linseed oil, poppy oil or walnut oil; and for acrylics, acrylic polymer is used. In other words it is the binder that separates each medium; the pigment is the same.

Getting to know the physical properties and characteristics of the pigment is highly important in order to be able to use it properly. For example trying to cover a strong colour with a transparent yellow pigment is a hopeless exercise as the transparent colour lacks the covering power needed to complete the task.

We must remember that although there are times when we can make a general statement about certain inherent qualities of some pigments, different manufacturers may produce their own unique version of some paints and pigments and there are always exceptions.

Choosing your colours

Qualities to look for

Longevity. It is important to choose paints made up with light-fast pigments that can stand the test of time as opposed to fugi-tive colours; this should be the top of your list, especially if you are selling your work.

Quality. Choose brands where the proportion of fine quality pigment to binder is high, it is a joy to work with paints that do the job properly. Student grade paints are often made with low quality pigments and are padded out with extra filler and binder making them weak. However, if your budget is really limited then choose a student grade made by a reputable brand.

Budget. Which make you choose is your personal choice and needs to fit your budget, as long as it is a long established reputable manufacturer. Buy fewer but good quality paints. See my notes on a suggested basic palette that will help you narrow down your palette but still make an infinite range of hues.

Transparency/opacity. Get to know your colours in terms of transparency or opacity, a transparent colour is not going to cover an area if that is what you require. I cannot emphasize highly enough how important it is to know this quality in your colours in order to mix the right colours together and not make mud. Most good quality brands have this information on the tube.

Effect. Finally get to know your colours intimately, so if you know a colour is highly staining and you rely on lifting colour then use a colour with a lower staining power. If you like to have a granulation effect then choose granulating pigments such as ultramarine and burnt sienna or cerulean blue. Reputable manufacturers such as Golden and Daniel Smith give you this type of information clearly on their colour charts so you can make an informed decision.

Remains of the day.

Suggested basic palette

In the world of subtractive colour mixing there are no pure hues and each primary contains a certain amount of other colours. For this reason it is best to have two versions of each primary colour.

My suggestion for a basic palette consists of six single pigment colours based on a split primary colour system which I personally find extremely useful and clear. This includes two blues, two yellows and two reds, plus a tube of white in your acrylic palette.

Although you can mix your useful earth colours from these hues, for consistency and convenience you can add a tube of yellow ochre and burnt sienna. This simple palette should enable you to make your secondary and tertiary colours, plus a range of coloured greys, neutrals and clean and sharp near-black lively darks. Ultimately as an artist the choice is yours; when you become familiar with your colours, you do not need to be told not to use black, white, Payne's grey or umber, as all these colours can be useful in the right hand, the right amount and in the right place.

In the context of this book we are dealing with paint and pigment so we are using subtractive colour mixing. To start with, try to mix all your colours from this basic palette. As you gain more experience, if you need a colour in a hurry add ready-mixed colours to the palette.

Suggested basic palette: lemon yellow or hansa yellow light, cadmium yellow deep hue or hansa yellow deep, ultramarine blue or cobalt blue deep, phthalo blue or Winsor blue, quinacridone magenta or permanent rose, naphthal red light or cadmium red light hue, plus titanium white and zinc white.

Extra useful colours: burnt sienna, yellow ochre, buff titanium, dioxazine purple, manganese blue hue, parchment, Prussian blue, Payne's grey and light blue violet.

Project: Mixing vibrant colours

In order to mix vibrant secondary colours, both primary colours should be biased towards the secondary colour you wish to mix. In this exercise mix the two colours that are good carriers of the secondary colour you wish to mix.

Looking at the twelve-segment colour wheel:

- You can see the two primary colours closest to each other; mix the most vibrant secondary colours.
- To mix a slightly more subdued secondary colour, choose one good and one poor carrier of the secondary colour.
- To make an even more muted secondary colour choose the two poor carriers of the secondary colour.

Swatch library

In this exercise make a swatch library of all the different possible mixes.

For example:

phthalo blue + hansa yellow light = vibrant green

phthalo blue + cadmium yellow dark = slightly muted green

ultramarine blue + cadmium yellow dark = quite muted olive green

Phthalo blue + hansa yellow light = vibrant green.

Twelve-segment colour wheel.

Cadmium red light hue + cadmium yellow deep hue = vibrant orange.

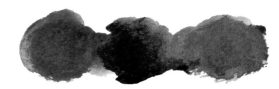

Ultramarine blue + quinacridone magenta = vibrant purple.

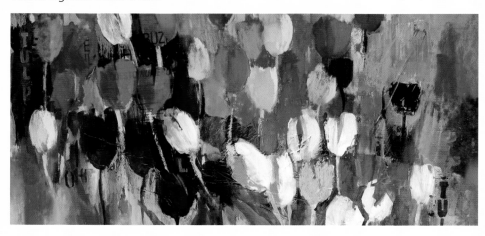

Colourful Tulips, *a mix of vibrant colours.*

Project: Mixing neutrals

I call the neutrals the backbone of the painting; they are the elegant, quiet and unassuming colours that hold all the brighter hues together and make them shine. Paintings that are predominantly made up of vibrant colours can sometimes become rather garish and overpowering. When all the bright colours are vying for attention in a painting, they can easily create visual noise for the viewer.
Complementary colours. When two colours that are absolutely opposite one another on the colour wheel are mixed together they tend to neutralize one another and create a grey, brown or near-black. These colours are called complementary colours. Most of the time, however, we are dealing with near-complementary colours; therefore, by mixing these colours we achieve semi-neutral or coloured greys. You can mix an infinite number of these beautiful greys which add real substance to the painting.
Chromatic. Black, white and grey are achromatic, which means they have no colour. All other colours, including beige, cream, brown

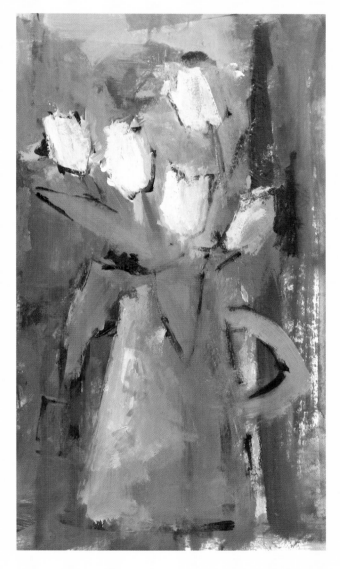

and coloured greys are chromatic. Mixing a grey from black and white can be rather cold and flat, though still acceptable in the right painting.
Semi-neutrals. Ideally, to ensure unity and harmony, mix your semi-neutrals from the primary colours that already exist in your painting rather than introducing yet another set of colours. Semi-neutrals are not to be mistaken for muddy colours, which are the result of too many incompatible washes of colour on top of each other. Skilled watercolourists often have puddles of beautiful subtle greys forming on their palette as a result of mixing all three primary colours together.

Greys and browns chart

In this exercise choose different sets of primary colours or a pair of complementary colours plus white and make a series of coloured greys and rich browns .

A set of naturally muted earth colours, from left: burnt sienna, yellow oxide, raw sienna and burnt umber.

Colourful greys or semi-neutrals: mixing neutrals from quinacridone magenta, cobalt blue and hansa yellow light. All three colours mixed equally makes a dark grey which can be lightened by white. Changing the proportion of each colour makes chromatic red, blue or yellow grey. Pick any three primary colours or a set of complementary colours to make colourful greys and rich browns and near blacks.

White Tulips. *In this painting there are a number of subtle light greys and strong dark greys mixed from three primary colours of magenta, lemon yellow and phthalo blue. Some of the greys are biased towards blue and some towards magenta. Also note the subtle warm browns mixed with complementary colours green and red.*

Project: Mixing greens

In nature a myriad of the most beautiful greens comes together to tease and caress our senses. Recapturing these amazing hues can be a challenging task for the inexperienced artist. My best advice is whenever possible to work from life so that you are able to appreciate the subtle differences in hue amongst the many greens in nature.

Most importantly, you should avoid mixing an even green mixture and applying it all over a green landscape painting. Representational depiction of landscape and floral subject matters are dependent on these variations in tone and hue, however subtle.

The manufactured tubes of green seem like an easy solution, but they often have an artificial look about them and unless they are modified with the addition of other colours, it is best to avoid them. There are always exceptions and you may find a ready-mixed tube of green that has the exact hue you are after. There are a number of very usable greens in FW acrylic inks and the Golden High Flow colours. Hues of vivid lime green or bright aqua green in very small doses can enhance a painting beautifully. Phthalocyanine green, which can appear quite harsh when used on its own, is a great base green colour that can be made more subtle by the addition of a touch of red, yellow and blue. It also makes beautiful tints with titanium white.

To mix vibrant greens you need to mix the blue and the yellow that are biased towards green. Phthalocyanine blue and lemon yellow or hansa yellow light are both good carriers of green.

Blues and yellows chart

In this exercise take a few tubes of blues and yellows and mix them together in varying proportions and make a chart for future reference. They can all be useful in the right place.

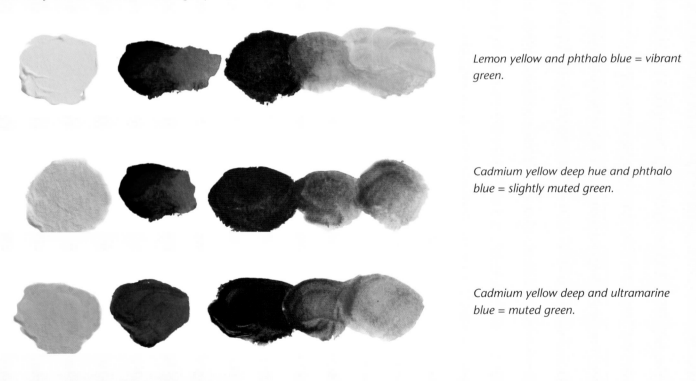

Lemon yellow and phthalo blue = vibrant green.

Cadmium yellow deep hue and phthalo blue = slightly muted green.

Cadmium yellow deep and ultramarine blue = muted green.

Ready-made greens

Modify your ready-made tubes of green by using different types of red such as cadmium red, burnt sienna or quiacridone magenta, then adding more yellow or blue to adjust the mixture into a cooler or warmer green. Then add white for a whole range of useful tints.

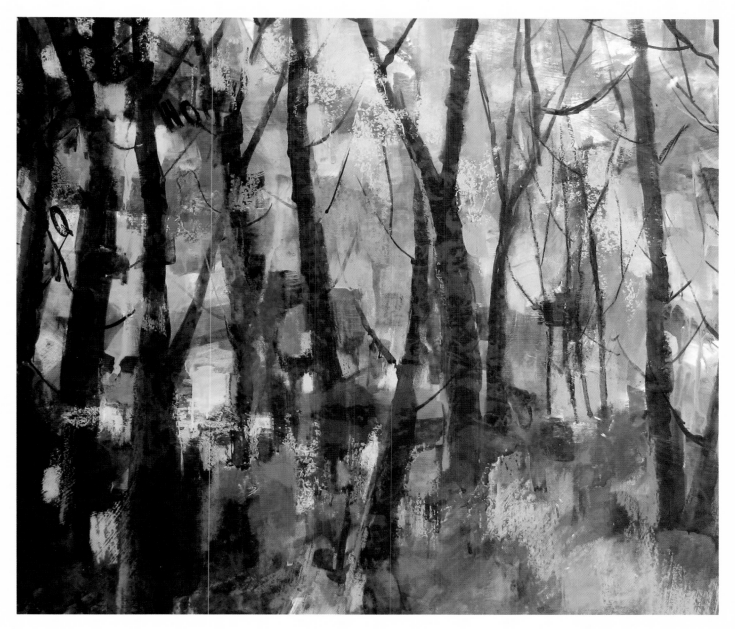

Spring Woodland. *Different greens from vivid lime green to blue green and dark green come together in this painting to convey the joy of early spring.*

Modifying a ready-made tube of green. Phthalocyanine green is a useful transparent dark green; it is rather harsh and unnatural on its own but a touch of its opposite colour red can easily modify it and alter the acidy look. Thereafter you can lighten the mixture by adding more yellow, or darken it by adding blue and make numerous useful greens. By adding white you can also make beautiful tints.

Project: Mixing darks

Many beginners to painting are afraid of dark colours, especially in pure watercolour painting. Creating dark colours that are not dull and boring can be quite problematic for newcomers to painting. The darker tones bring depth and structure to the painting; a lack of the correct tonal values can make the painting appear lacklustre and lifeless.

Colour plays a big role when composing your painting, and harmonizing the colour scheme is an important design principle. In order to create harmony it is best to mix your darks from the same primaries that already exist in the painting rather than introducing yet another colour.

The natural tendency to darken a colour is by adding black to it, however although you can darken the tone in this way, it can easily lead to murky and muddy colours. By far the best option is to darken a colour by adding a small amount of its complementary colour. The result is more subtle and effective. To darken yellow you have no option but to use a small amount of its complementary violet, as black turns the yellow to green.

The more experience you gain in painting and colour mixing the less you become concerned with the local colour of each object and instead you naturally learn to see colour in terms of tone rather than the local colour. For example, you can really see the yellow-ness of a banana properly where it is lit up by either natural or artificial light, but overall it is a mixture of all different shades of yellow from light to mid-tone and dark.

Whether you are a representational or a non-objective abstract painter, the contrast of light and dark creates the element of drama and a rhythmical pattern for the viewer's eye to travel around the painting. So do not be afraid of the darks; add depth and substance and create maximum visual impact by including them in your painting.

When using watercolour, to achieve the intensity you require you may have to build up several washes of the same colour. Allowing each layer to dry will help you achieve cleaner and deeper dark tones.

Complementary chart

In this exercise experiment with sets of complementary colours to achieve a library of swatches to refer to for future reference.

As an example, to achieve a beautiful dark green add a small amount of lemon yellow to phthalo blue, then modify the mixture by adding a small dab of a red hue such as crimson, magenta or burnt sienna. You can also get a slightly different dark green by using Prussian blue.

Mixing darks with complementary colours: (top row) phthalo green and quinacridone magenta, (middle row) dioxazine purple and cadmium yellow medium hue, (bottom row) phthalo blue and burnt sienna. Each set will give you beautiful rich darks, from near blacks to beautiful deep browns.

Darker first

When mixing dark colours getting the proportion of each colour right is absolutely vital. Always add the lighter colour to the darker one in small amounts until you get the mix that you are after.

Flower Stall at Salisbury Market. *The dark values give this painting depth and a feeling of ambiguity where the figures are emerging from the dark corner.*

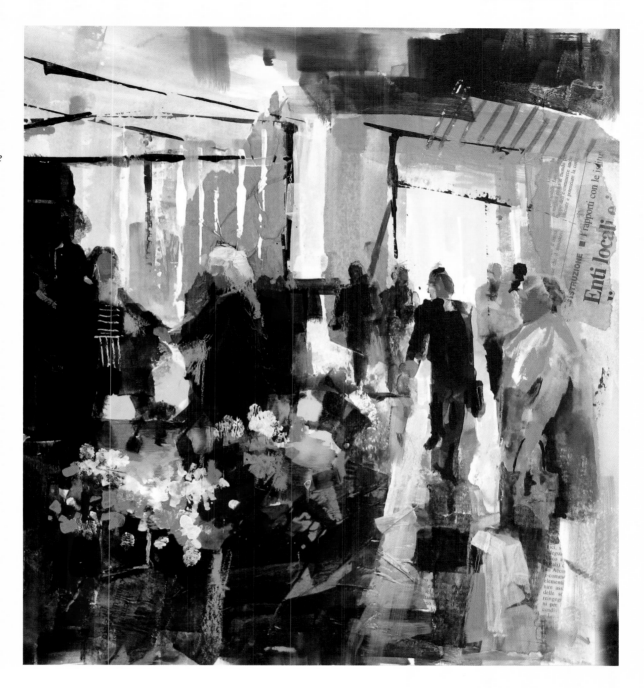

A selection of useful dark colours: (from left) Payne's grey, Prussian blue, sepia, anthraquinone blue, dioxazine purple.

Comparing two different blacks. By adding white to a black colour you can see the difference in the relative coolness or warmth of colour. Carbon black on the left is warmer than the bone black on the right. This makes a difference when you intend to use the black to mix greys with white or mix greens with yellow.

Colour harmony

Colour is the most powerful element in the design of your painting. It has amazing expressive qualities and sets the overall mood and ambiance for the painting. Above all the colour scheme needs to be consistent, and the balance and harmony are achieved by the visual contrast that exists between colour combinations. To compose with colour successfully we need to understand colour relationships. Below we can examine a few tried and tested colour schemes.

Analogous colours

Analogous colours are the colours adjacent to each other on a twelve-part colour wheel, such as green, yellow green and yellow. Analogous or neighbouring colours create a harmonious colour scheme and a feeling of calm and tranquillity. This colour scheme is particularly suitable for moody and atmospheric subject matter.

Harmonious colours have one primary colour in common; therefore, the eye makes a soft and smooth transition when travelling from one colour to another. These colours reflect the same light waves. So for instance, green, yellow-green, yellow, yellow-orange and orange would be harmonious colours. They all share one common primary colour, which in this case is yellow. If you add the sixth colour, red orange, it would no longer be harmonious. The red in the red orange is the complement to green and would reflect the opposite light, thus taking it out of harmony.

These pleasing combinations happen over and over in the natural world. For example an autumn woodland is a rich tapestry of green, yellow green, yellow, orange yellow and orange. Sometimes harmonious combinations can be a little too sedate; bringing the complement of the most dominant colour as an accent can help inject more excitement to the painting, so an autumn woodland colour scheme against a blue sky creates a striking contrast.

Striking combinations

Complementary colour scheme

Complementary colours are directly opposite one another on the colour wheel. Blue and orange, green and red, and yellow and violet are all examples of complementary colours. When placed next to each other in a painting they enhance and intensify the visual effects of one another.

The Impressionists' masterful use of complementary col-

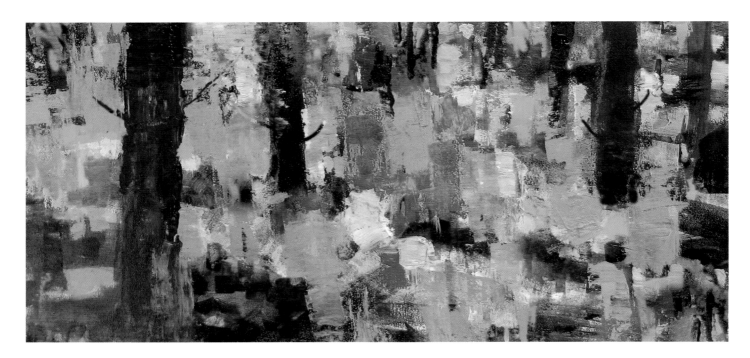

Green Forest. *In this painting, blue, blue-green and green are analogous and create a soft transition from one colour to the next. To break this up slightly I introduced a few touches of red here and there.*

Red Hot Tulips. *You can see the visually striking combination of red and green in this painting; the two colours almost vibrate with energy when placed next to each other.*

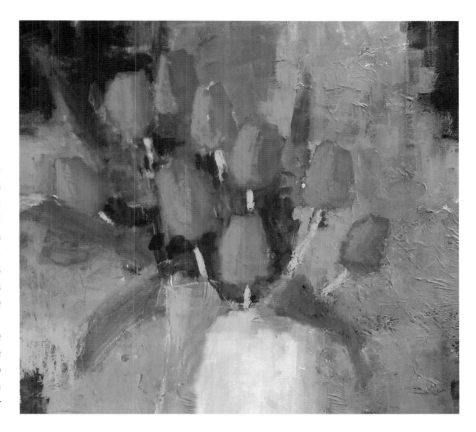

ours brought their paintings alive. For example they abandoned the old-fashioned ideas about how to portray the shadow colour of an object, and rather than using the object's local colour plus a bit of black they brought dashes of its complementary colour to the shadow. Many Impressionists took advantage of this striking colour contrast to produce paintings that buzzed with life and energy and a true celebration of colour.

In contrast, you can darken or lower the saturation of each colour by adding a little of its complementary colour to it. When two complementary colours are mixed together in equal proportions they neutralize each other and make either grey, brown or near-black.

Colour perception varies from one individual to another, so which two of the numerous hues of complementary colours are put together varies a great deal. A painting made up of too many complementary colours can be in danger of creating visual noise and chaos. Too much harmony can also disengage the viewer and become monotonous and boring. A dynamic image needs to find a happy medium between the energy of complementary and the respite of harmonious colours to create a visual equilibrium.

Near-complementary colour scheme

In this colour scheme we choose a colour but instead of its actual complement we use the colour either to the left or to the right of its complement. This makes a more interesting two-colour combination which is very similar to the complementary colour scheme but with a little twist. For example instead of pairing red with green you can combine it with blue green. These colours enhance each other when placed next to one another, but unlike the true complementary colours they do not totally de-saturate each other when mixed. They do make grey but still retain some vibrancy; their combination looks much brighter and cleaner. Near-complementary colours make a series of coloured greys together which are fabulous to work with.

Red Poppies on Turquoise. *The near-complementary combination has the visual contrast but a slightly quieter disposition than the complementary colour scheme.*

Split complementary colour scheme

A split complementary colour scheme features three colours. It is a variation on the complementary colour scheme. In this colour combination we choose a colour and two other colours, the ones on either side of its complementary colour. For example, if you choose red as the main colour, then you would go for a yellow green and a blue green which are on either side of its complement which is green. You can in fact go round the colour wheel finding a dozen different combinations.

I find this colour scheme more balanced and visually intriguing with less tension than the complementary colour scheme. By adding a little of the main colour to the other two colours you can then create more muted versions of each colour. The whole scheme can become quite sophisticated and harmonious. For successful composing with this colour scheme it is best to have one dominant colour with the other two colours as accents.

Monochromatic colour scheme

In this colour scheme you can choose a single colour from around the colour wheel and use it in all its different shades, tints and tones. For example you can choose Prussian blue and

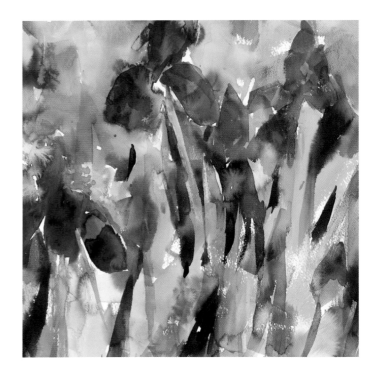

Irises. *An example of a split complementary colour scheme, a popular colour scheme as it is so easy on the eye.*

make it lighter, darker or mid tone to create all the values in your painting from this one single colour. This colour scheme does not have to be boring, and if you gauge the tonal values correctly you can make quite an impact with this tranquil and easy-on-the-eye colour scheme.

It is a brilliant exercise for helping you to get to grips with assessing the colour values in your painting. Inherently dark colours such as Payne's grey, dioxazine purple or sepia are great for painting monochromes, or you can use white to lighten, grey to decrease saturation and black to darken if need be, as this process changes the tone but does not alter the hue. Monochromes send a simple, direct and powerful message to the viewer and can be just as effective as any other colour scheme.

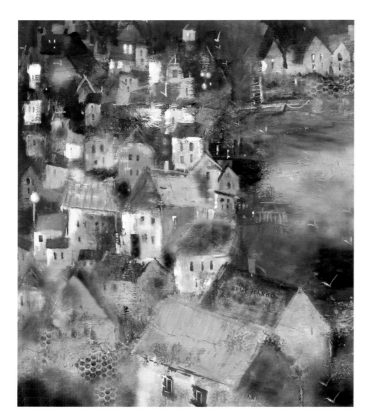

Blue Harbour. *In this painting I used ultramarine blue (green shade), darkened by adding a little black and lightened by adding white. I used it straight from the tube and diluted it to get all the tones in between. For one or two of the rooftops I added a touch of neutral grey to slightly tone it down.*

Triadic colour scheme

Triadic colour harmony consists of three colours that are equally spaced on the colour wheel. This traditional colour scheme is one of the most basic and frequently used colour schemes. Triads will allow strong visual contrasts while remaining balanced and harmonious. Colour triads are not restricted to pure and saturated colours; they can be secondary, tertiary or near-neutrals. The only criterion is for the three colours to be equidistant on the colour wheel.

The three colours I have chosen here are quinacridone red, phthalo blue and hansa yellow light. To make the most of triadic colour scheme, always choose one of the colours as the most dominant, and to harmonize add a little of the mother colour to the other two colours, plus small accents of pure colour for more visual contrasts. You can go round the colour wheel to find and experiment with other colour triads.

Triad of red, yellow and blue: the three chosen colours are equally distant from each other on the colour wheel.

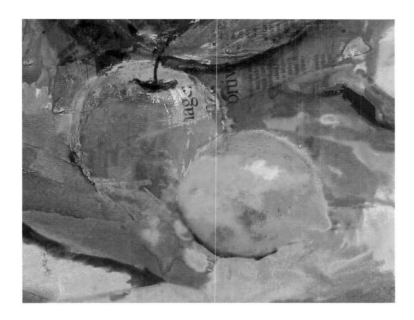

Apple and Lemon Still Life. Red is the most dominant colour in this triad; the darks are a mix of all three colours and for some of the more subtle tones a little of the red is added to both yellow and the blue. You can also see accents of both yellow and blue in unequal proportions for variety.

Hansa yellow light, quinacridone red and phthalo blue.

Just a fraction of mixtures possible with this versatile triad of modern pigments. The green is vibrant, as the yellow and blue are both biased towards green. The purple and the orange are both slightly muted. You can also mix an infinite number of chromatic greys and rich browns.

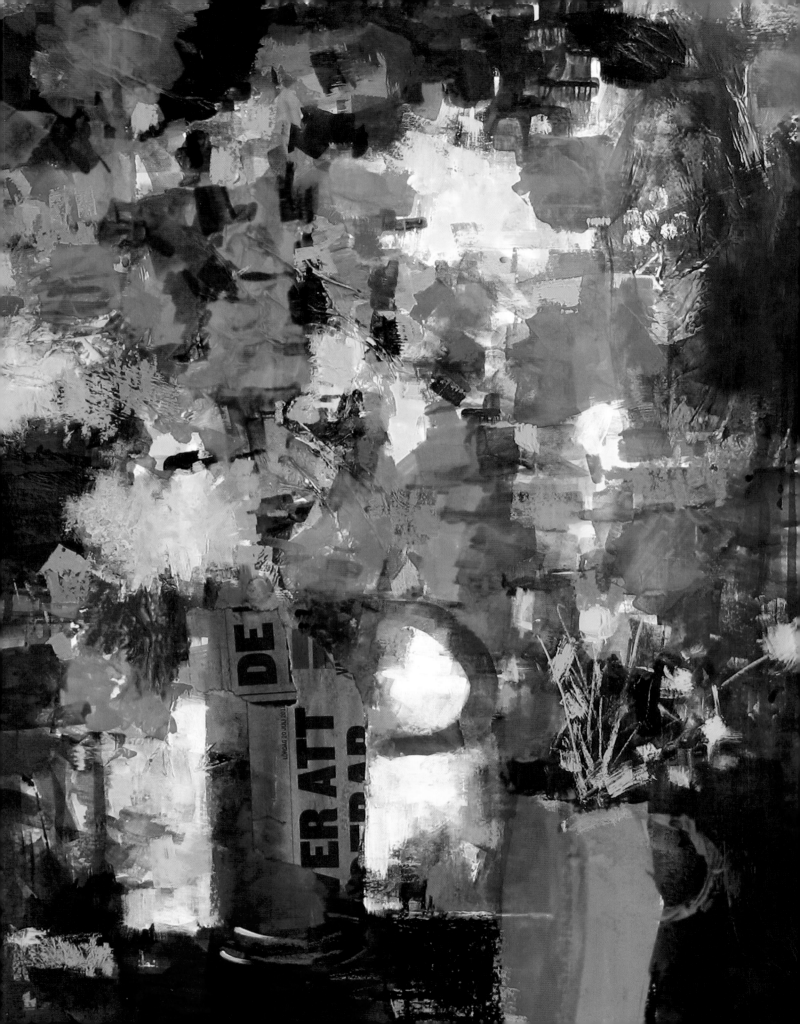

EXPERIMENTAL FLOWERS AND STILL LIFE

The intrinsic beauty of flowers makes them one of the most painted subjects throughout the history of art. The shear variety of shapes, colours and textures gives the flower painter a lifetime's worth of subject matter. As for still life, you do not have to go far to find your inspiration; you are practically surrounded by numerous possibilities in everyday life. However, through my teaching experience I have found that for many artists neither still life nor flowers are a popular choice of subject. Flower painting is sometimes perceived as a feminine subject matter, yet although this may be true to some extent amongst the male leisure painters, throughout history some of the most magnificent flower paintings have been depicted by male artists either exclusively or alongside their other subject matter.

OPPOSITE: Hot Pink Flowers *(collage, inks, heavy body acrylics, collage and pastels).*

BELOW: Hogweed in Summer Hedgerow.

The complexity of floral subjects gives you opportunities to assess the relationship between the myriad of intricate shapes and about the play of light as it falls on many different twisted and turned petals and foliage. Subjects such as life drawing, still life and flower painting will sharpen your observational skills and drawing ability as well as helping you to get to grips with gauging the correct tonal values.

Flowers are one of the best subjects for developing free expression and exploring colour relationships. Water media techniques are specially rewarding, and the delicacy of transparent colours is ideal for describing the fragile nature of the petals. Collage in the form of tissue paper and the more delicate types of handmade paper are great for suggesting subtle textures such as the creases in the flower petals.

Impressionist flower painting is a million miles away from botanical renditions, which are awe-inspiring in terms of skill but can sometimes look more scientific than artistic and lack the soul and vitality that is associated with a loose and free style of painting. Creating a sense of movement is essential to avoid static and lifeless floral images.

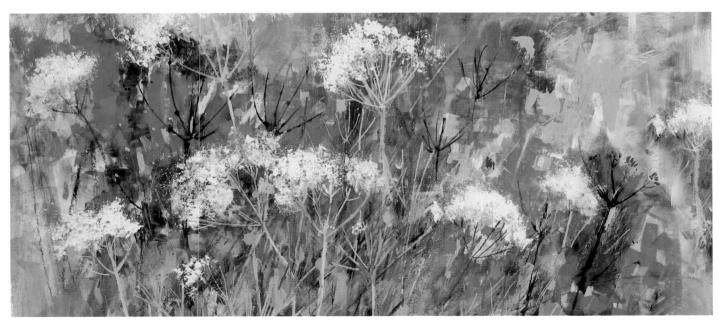

In mixed media, you will have a great choice of colours and textures in every medium and collage to help you create exciting images bursting with life and energy.

Impressionist flower painting

The Impressionist flower painter is more occupied with conveying a feeling rather than the accuracy of flower parts. However, it is crucial to get to know the structure of any flower you wish to paint, so that you can abstract the shapes convincingly and produce pleasing shapes that ring true.

Cottage garden plants, rustic and informal gardens are more enchanting as subject matter than the rigidity seen in formal gardens or the uniformity of cut flowers. Poppies, delphiniums, sunflowers and bluebells are just a few examples of flowers that create naturally pleasing shapes for painting.

In an impressionist flower painting there is a great opportunity to explore vibrant colour combinations and the interplay of light with all the intricate shapes within the petals and the foliage. Flower stems and the branches of shrubs give you the perfect shapes to create a visual path for the viewer to meander through the painting.

Informal gardens tend to provide the artist with a wide variety of rustic and interesting shapes that you can abstract within the subject matter. In a painting made up of a number of flower heads always choose an odd number and vary the sizes of the echoing shapes to create a rhythmic pattern, which in turn brings movement and energy. It is a good idea to have a number of similar shapes together, balanced by a few isolated shapes. For example, where you have multiple blooms, then choose either one large flower head or a group of blooms close together as the most dominant shape and make the others the supporting act.

Acrylic inks and oil pastels

Oriental Poppies

In this painting washes of acrylic ink and pastel work effectively together to create interesting passages in the background and stop it from becoming samey and boring. I used Saunder's Waterford hot pressed watercolour paper 200lb weight for its smooth surface as I did not want the paper to contribute to the textural effects.

The diagonal orientation makes a dynamic composition with three poppies placed on the two-thirds on the right side of the painting. I broke up the semi-abstract background by introducing a few recognizable elements such as the bud shapes. Some of the buds were added as positive shapes using an oil pastel that resisted the washes of ink, and some were depicted by painting the negative areas and brought out from the background washes of colour. By painting some of the shapes negatively you can create more depth in the painting as these passages tend to recede into the background. Oil pastel resists washes of colour so the stems and some of the bud shapes have a certain amount of oil pastel on them. I used tissue paper to imply the creases in the flower petals. The tissue paper reacts with the ink washes and creates the most delicate textures suited to the delicacy of flower petals.

Detail of Oriental Poppies. *In this close-up you can see how beautifully tissue paper implies the delicate creases in the tissue like petals of poppies. You can add the tissues either at the beginning or after you have applied the washes of colour and paint over them. Always make sure you dry the tissue before laying down the washes as it is quite fragile when it is wet.*

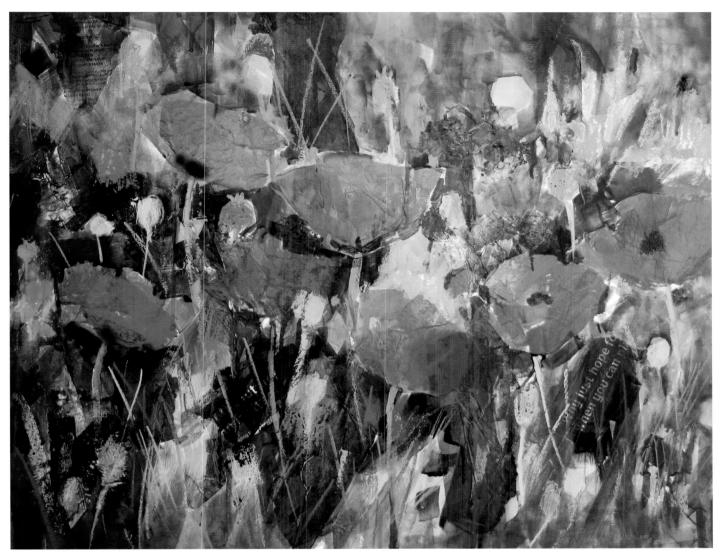

ABOVE: Oriental Poppies. *The abstracted background suggests a busy flower border without describing anything in detail. A few marks by water mixable wax crayons and oil pastels suggest more flowers in the background.*

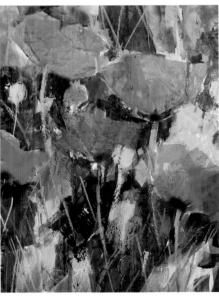

RIGHT: Close up of Oriental Poppies. *In this close-up you can see how the pastels and crayons contribute by making gestural marks to suggest stems, bud shapes and creating a busy flower border without any fine details.*

White Poppies. *In this painting I preserved the white for some of the flower heads, and one or two were painted with titanium white. The flowers painted negatively from the background washes create depth in the painting. I used wax crayons and oil pastels to paint some of the stems and abstracted details.*

Painting white flowers

In watercolour painting we tend to save the white of the paper for the white components of the subject matter. This can be achieved either by careful application of colour into the negative spaces behind the white flower shapes, or by painstakingly masking out the shapes with masking fluid prior to painting. Either method is rather time consuming and tedious and can potentially create a laboured and overworked look to the painting.

You have a choice in mixed media of either preserving the white or using titanium white to paint the whites afterwards, or better still a combination of both. If you are using pure watercolour then in effect you are painting the background or the negative spaces between the flowers to allow the white flowers to emerge from the background; however you cannot go over the washes too many times and need to get things right straight away.

In mixed media painting you can utilize the transparency and fluidity of acrylic inks with the added benefit of the titanium white ink, which can be brought in at any time to introduce more white or make a tint of any of the colours. You can be more free and spontaneous with your washes of colour, safe

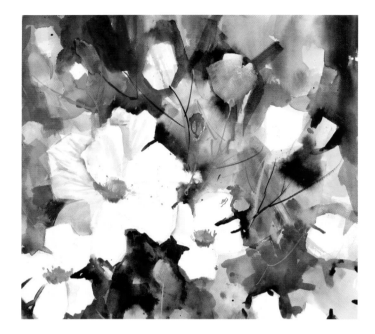

in the knowledge that any mishaps can be rectified by the opaque media. The object will only be truly white when in direct light; the shadow areas are full of nuances of colour. All white components of the subject matter need careful observation to recognize the subtle differences in tone within the white. The differences may be subtle but they make all the difference.

Painting over a gel surface

Snowdrops

These snowdrops were painted over a textured surface made up of heavy gel matte and gloss using heavy body acrylic paints mixed with some heavy gel for added volume. Rather than creating the extra body by using thick layers of paint, I built the surface up by using extra heavy gel in a random manner. By adding some of the same gel to the paint I managed to create a lively impasto surface.

The colour scheme is a tranquil combination of several blue-greens put together in close proximity for subtle changes of hue. A few strokes of soft and oil pastel gives touches of surprise colour in an otherwise quite calm colour scheme. The gels give the paint more body and avoid too much shrinkage of the acrylic paint after the evaporation of water. This helps retain bold brush strokes and creates a lively image.

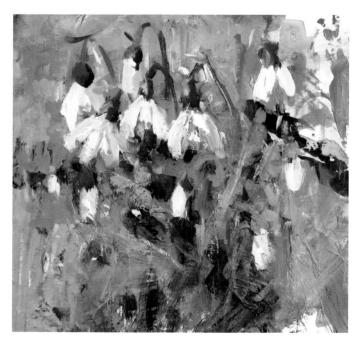

Snowdrops on a gel surface.

Fine and coarse pumice gel

Still Life with Hogweed and White Roses

The hogweed was growing in a hedgerow near the studio and I wanted to achieve a rustic look to the painting. To do this, I applied a coat of fine pumice gel to a piece of card – this gel creates a rough surface which grips the paint in a different way than just the naked surface of the card. I then added coarse pumice gel to the flower heads. I think the texture of coarse pumice gel is perfect for describing the hogweed flower heads which were then painted with a grey violet for their darker tone and dabs of titanium white in the highlighted areas.

I used a palette knife to apply some hard moulding paste to the roses to build up a certain amount of volume in the petals. This helped to create some shadow colour where the glazes of colour pooled together in the creases. I kept the colour scheme quite subdued by greying down the yellow green and purple colour scheme. To add a little liveliness to the colour scheme, however, I used some cobalt teal behind the vase.

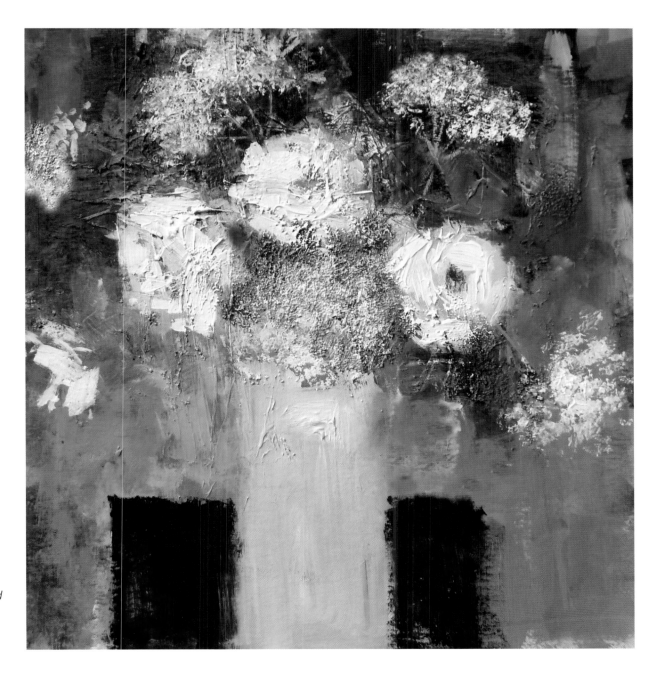

Hogweed and roses on fine and coarse pumice gel.

Demonstration: Negative shapes and the abstraction of foliage

This demonstration is a good exercise in mixing several media that help enhance one another, as well as an invaluable exercise in painting negative spaces and the abstraction of foliage in impressionist paintings.

Negative shapes are all the spaces between the positive shapes of the subject matter and also the spaces between the components of the subject against the edge of the picture plane. Painting white flowers or objects is a useful exercise to get you into the habit of addressing these spaces with equal importance and deliberation and not leaving them to chance. Sometimes taking part of an object half out of the picture plane makes a better composition and suggests that the subject exists beyond the confines of the picture plane.

Another area that needs careful attention in floral paintings is foliage. In botanical flower painting, the foliage is an integral part of the composition and is carefully considered and painted. In impressionist work however it is best if the foliage is described as abstract shapes with perhaps a handful of the leaves represented and well defined. This creates a sense of ambiguity which is all part of the charm of a loose and free style of painting. Sometimes a lot of time and effort is given to the flowers but careless treatment of the foliage almost as an afterthought can let a painting down badly. Let your viewer's imagination take over.

Daisies

Materials

High flow acrylic inks
Prussian blue, light green, quinacridone magenta, dioxazine purple, titanium white

Oil pastels
Light green, yellow, white

Soft pastels
Dark royal blue

Support
Saunders Waterford HP 1401b high white watercolour paper

Brushes
1" wash brush, Size 8 Kolinsky sable

Stage 1

As I intended to preserve the white of the paper, I used an aquarelle pencil to draw a few minimal outlines to guide me. For compositions such as this where a lot of similar shaped flower heads are vying for attention, it is best not to make them all the same size and value. So I chose a few of the flower heads to act as the main attraction, with others as the supporting act. I then used a light green oil pastel to indicate a few of the stems, hoping that they would come through the subsequent washes of ink. The linear marks of the stems create a lead-in for the viewer. I used a yellow oil pastel to suggest the centre of a few of the daisies.

Demonstration of Daisies *stage 1.*

Stage 2

With the 1" wash brush I applied quinacridone magenta, purple lake and light green ink in the areas where I felt they would be beneficial for the subsequent layers of colour. I generally use a lot of flat brushes – simply my personal style – hence all the hard edges. If you do not wish to end up with so many hard edges, then use a round brush or a filbert for a softer wet-into-wet result.

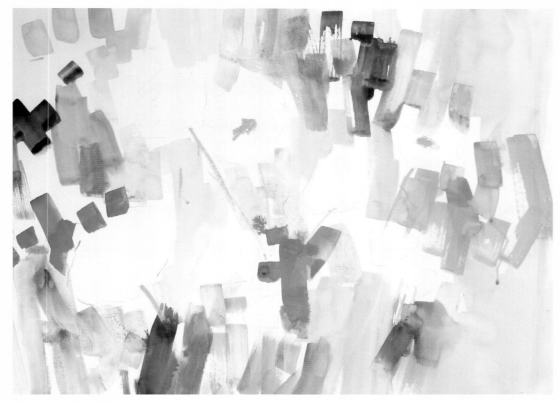

Demonstration of Daisies *stage 2.*

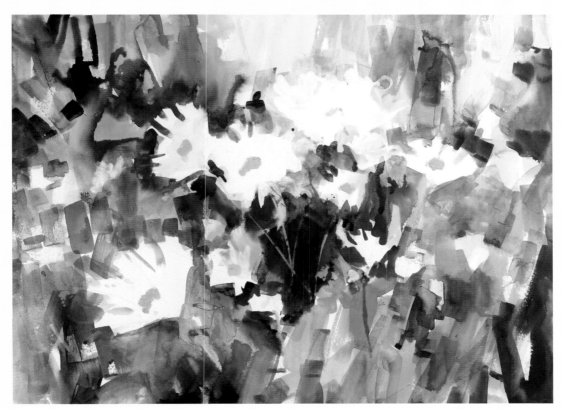

Stage 3

I applied Prussian blue ink to start bringing my darker values and create depth in the painting. I then added some titanium white in a few different areas to create more daisy heads. Note that in my composition the largest daisy is placed on the two thirds as it is the centre of attention.

Demonstration of Daisies *stage 3.*

Stage 4

I used the green pastels to make even more stems to suggest a busy border of flowers. I added lots of thin glazes of blue and purple to send some of the details into the background. The inks superimpose beautifully on top of one another and you do not need to be tentative about their application. I also started to find a few daisy shapes in the blue and purple washes of ink in the background to create depth and recession in the painting.

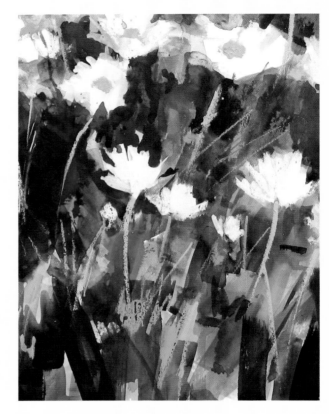

Demonstration of Daisies, *detail of stage 4. This close-up shows the abstraction of background foliage and detail.*

Demonstration of Daisies *stage 4.*

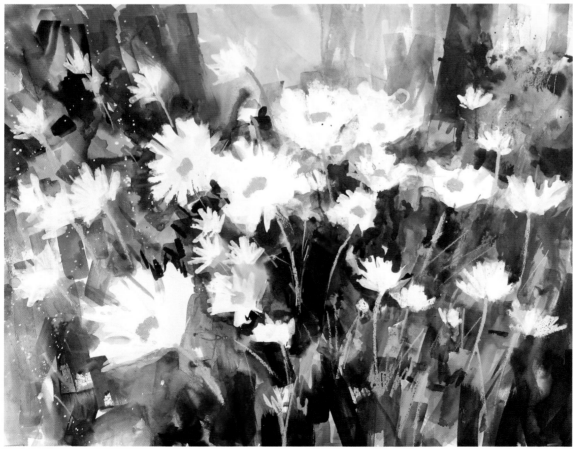

Stage 5

I continued to find even more shapes from the washes of the background. Then I added more yellow centres to the flowers and tidied up some of the petal edges. As you can see by introducing flower heads of different shapes and sizes I have tried to bring variety into the composition. At the latter stages of the painting I usually balance my colours, so I decided to apply a few thin glazes of blue and purple inks to unify the colours. I applied a little splattering of white ink to lift the top left hand corner. After a few more highlights on the flower heads I decided the painting is finished.

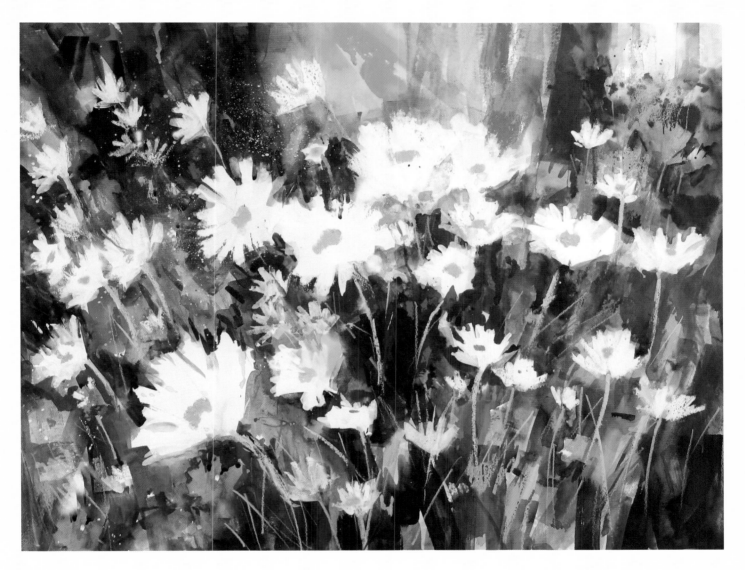

Daisies – *the finished painting.*

Stand back

By standing back from the painting frequently you can assess the progress and avoid covering some of the interesting and accidental shapes.

Project: Same subject, different approaches

One of the main advantages I find with painting in mixed media is the luxury of choice it offers me. Through experience I can decide which subject can be more effective in which particular medium or combination of media. To get to this juncture, however, you need to get some practice, and one of the best ways to achieve this is by repeating your favourite subjects using different combinations of media.

This is a very enjoyable process as the results always have little surprises in store. There are subjects that lend themselves to a variety of media while others really blossom through the surface quality or particular texture of one medium. This exercise is far from boring as the different handling properties of each medium will create quite varied textural effects. Be careful not to copy yourself, however; put the first painting away before doing the next version.

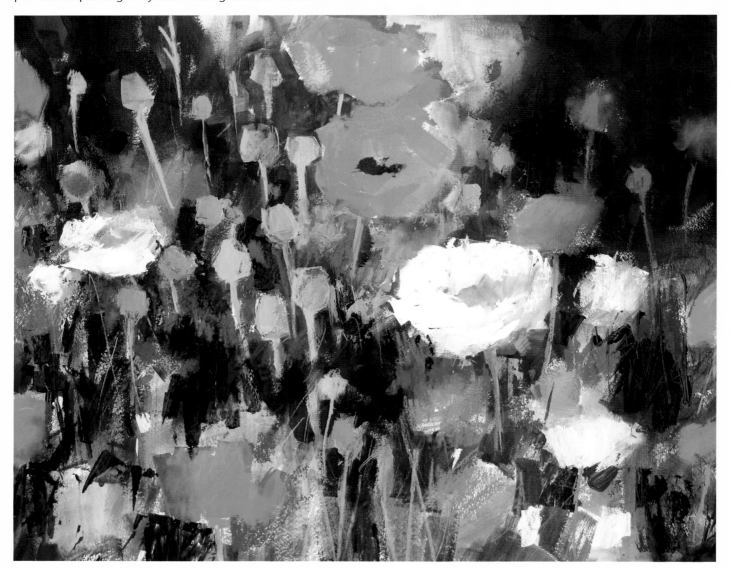

Summer Flower Border 1 *(heavy body acrylics, soft and oil pastels). I used heavy body acrylics for this painting. This technique is similar to oil painting and has a more controlled process. It is important to keep brush marks light, not too heavy and stylized. Whereas the watercolour washes run and settle to create lovely accidental marks, in this style your skill is needed to make the marks seem incidental even though you are in total control of where and how they are placed. Dabs of oil pastel and soft pastel as accents of colour here and there bring extra touches of magic. I find this style more therapeutic where you can lose yourself in the lushness of colours and enjoy the tactile addition of pastels and crayons.*

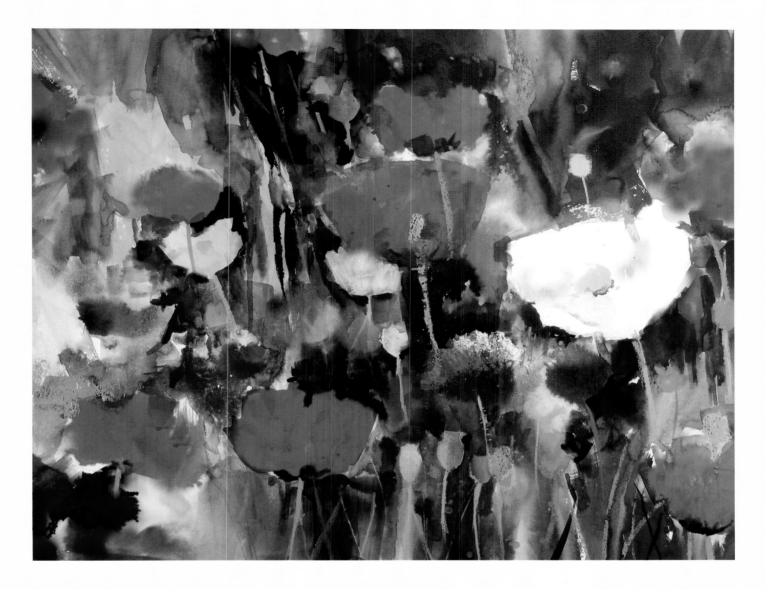

Summer Flower Border 2 *(acrylic inks, oil pastels). I started this painting with light washes of hansa yellow light high flow acrylic inks, followed by naphthal red light for the poppies and quinacridone magenta for the alliums. I then flooded the surface with washes of Prussian blue and allowed the colours to mix and mingle and create interesting shapes. Once the painting surface dried I added stems and seed heads and buds using oil pastels, and then started to bring out some of the shapes of the seed heads and buds from the washes of the background colour by painting around them into the negative shapes. I love all the contrast of soft and hard edges and the unpredictability of watercolour style washes.*

The collage version...

You can repeat this exercise with collage and have even more fun by changing not only the media but also the colour scheme of the painting. There are many valuable lessons to be learnt by this project.

Setting the background

One of the benefits of painting in mixed media is that through surface preparation, under-painting and application of collage pieces, the painter is usually already addressing the background and therefore the painting as a whole. Newcomers to painting tend to focus fully on the positive aspects of the subject matter, but there comes a time when the question 'what do I do with my background?' raises its ugly head. If you get into the habit of making the background an integral part of your composition and carrying out a few thumbnail sketches you should never come across this issue again.

Backgrounds have a huge impact on the subject matter, and those added as an afterthought may lack the necessary connection with the painting and look detached. As an interesting and useful exercise you can try and paint something with a variety of different backgrounds to see the difference in the overall feel of the painting.

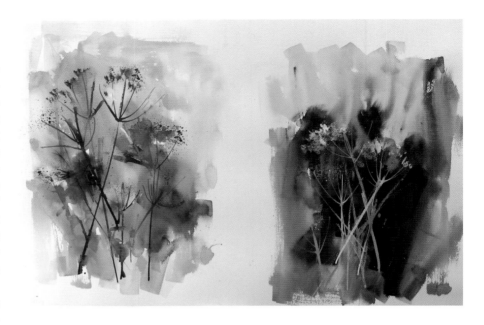

Hogweed with two different backgrounds: the colour and texture of the background has a profound impact on the mood that the painting conveys to the viewer.

French Anemones. *I used both cling film and tissue paper technique for this painting. Dragging soft pastels over dry tissue emphasizes the texture effect.*

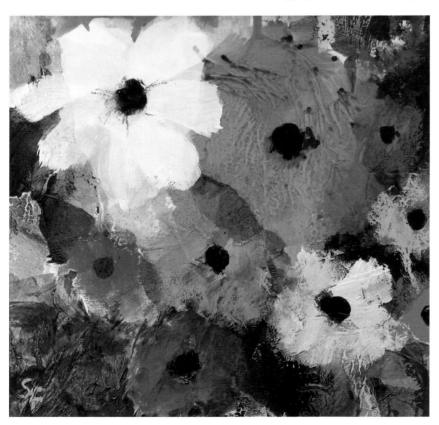

Collage for creases of flowers

Creases formed in the petals of delicate flowers such as poppies and anemones are part of the charm of these fabulous flowers. This is the kind of detail that would add to the surface quality of the painting and bring added visual interest. There are several ways of achieving this:

- By laying down plastic wrap or clingfilm over a wash of watercolour or acrylic inks and letting it dry you can create visual texture as the areas of contact with the cling film will dry lighter; this method creates a lot of wonderfully random patterns.
- To achieve a more tactile texture in mixed media adding tissue paper either with glue or acrylic medium is quite an effective way of forming textures that suggest the creases.
- Another method is by modelling a heavy gel to form the creases before painting over them as shown in the painting *Red Roses with Apples and Pears*.

Red Roses with Apples and Pears

This semi-abstract painting of roses happened at the end of a still-life painting session when some of the items were left on the table. I applied bits of dark tissue paper to create the darker tones around the flowers. Then sculpted the roses with heavy gel and layered pieces of tissue paper into the gel. By flooding several inks such as magenta for the roses, yellow mixed with indigo for the background I created a chaotic surface.

I stood back from the painting and then started cutting out leaf shapes from the colours of the background. I left a major part of the background as an abstract mass that the viewer can interpret as they wish.

My composition breaks the rule as I have placed two shapes of equal value in a fairly central position, but I think I have got away with it through the balancing of other shapes and through the colour distribution and the diagonal orientation of the placement of the roses.

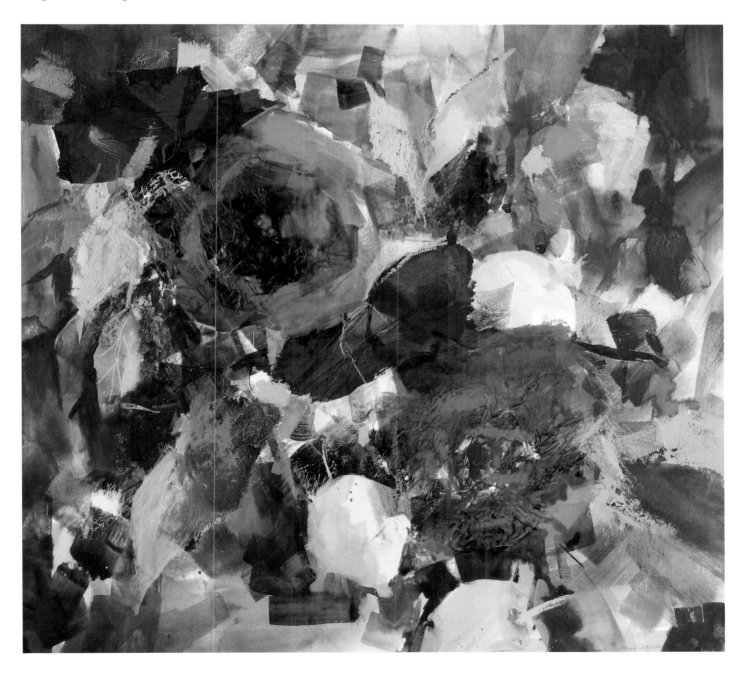

Red Roses with Apples and Pears.

Autumn Still Life with Chinese Lanterns

Autumn offers a feast of beautiful warm colours, but I always feel that I need to exercise a little restraint to stop myself from getting carried away and letting the subject become too prettified. I was going to arrange a still life with these Chinese lanterns, pumpkins and autumn berries, but in the end my impatience got the better of me and I set about painting them as I found them.

I decided to include a handful of the beautiful heart-shaped leaves by adding pieces of green handmade paper; I also added a few pieces of orange tissue paper for the flower heads and used pieces of white tissue paper over the pumpkins. To suggest the texture of chestnuts I applied heavy gel and scratched into it with a sharp tool.

By flooding the lighter colours such as the lemon yellow first I created a sunny feel to the painting. The lanterns went in sim-ply as orange shapes and then were defined through painting the negative shapes behind them. The almost black background makes a perfect backdrop for the array of more vibrant tones and is a mixture of all the secondary colours in the painting.

For the berries I wet the paper and dropped in flame red and process magenta inks and used green gold to paint the foliage. All linear marks were done using either oil pastels or water mixable crayons. Highlights on the foliage were done with a dab of light green oil pastel. Both soft and oil pastels create a lovely hit-and-miss effect when dragged across the creases of the paper.

I chose a diagonal composition with the mass of busy areas moving towards the bottom right hand corner of the painting. The bigger shapes of the pumpkins and the bottom left hand corner and top right hand corner bring areas of relief from all the busy passages in the painting. I find the end result is a real celebration of autumn colours.

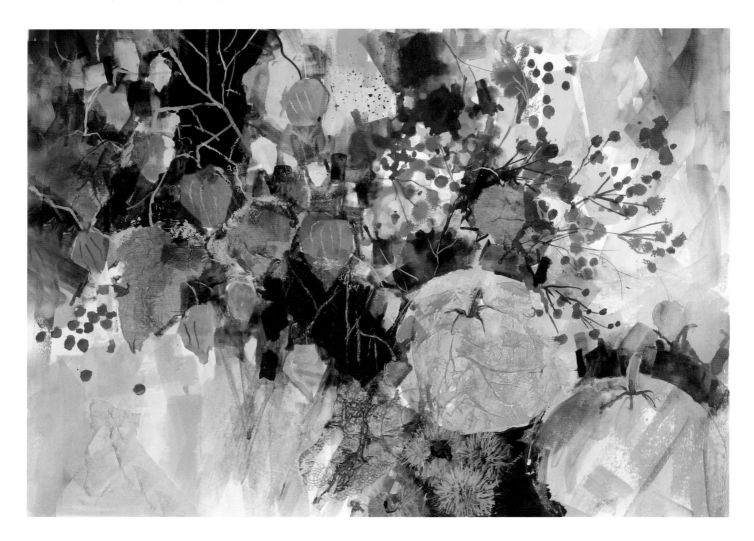

Autumn Still Life with Chinese Lanterns.

Reworking an old painting

Some failed paintings are beyond resurrection but a few can be successfully rescued with a bit of imagination and patience. This is one of my favourite things to do when I am at a loss to start a new piece of work. I have browsers and folios full of paintings that for one reason or another have not been finished.

This painting of irises was a half-finished demonstration painting. One of the best things about this exercise is that you have nothing to lose, so you can let go of all inhibitions and try out different things.

Irises

I used acrylic purple lake and indigo acrylic inks, oil pastels, handmade paper, gold leaf, bubble wrap and sequin relief to breathe a new life into a painting otherwise doomed to go in the graveyard of failed paintings. I felt it had a good background and was painted on Saunders Waterford paper that can take quite a lot of punishment and is a great base for corrections and reworking.

This is where mixed media really delivers by allowing you to add layers and liven up an otherwise dull and boring image.

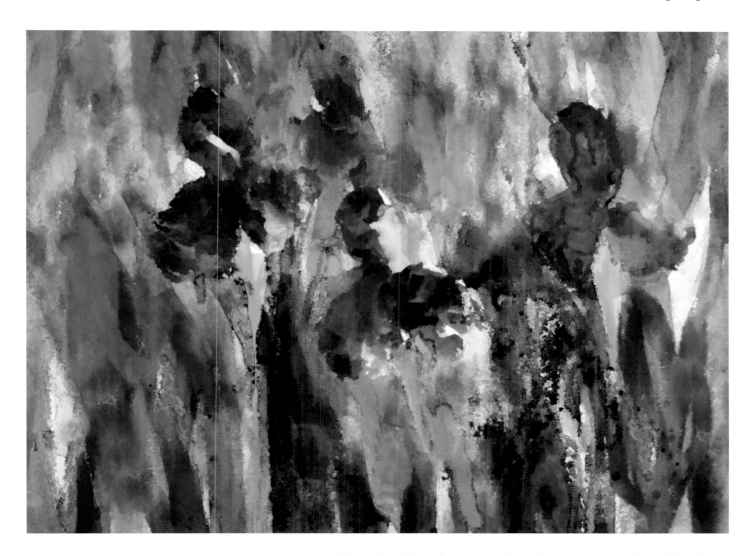

Reworking Irises. *The original image.*

Recycling

If you have used good quality paper for a failed painting and consider it beyond repair then prime the base with gesso or any of the gels for another piece of work.

Reworking Irises *stage 1. I started by adding lovely handmade tissue paper with some gold swirls and written text on it.*

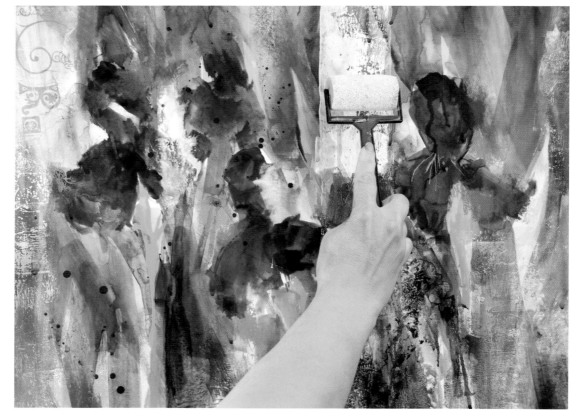

Reworking Irises *stage 2. I then applied some white paint with a roller. I added heavy gel in a few places and pressed a cloth with a pattern onto the gel, which left an interesting imprint.*

Reworking Irises *stage 3. I applied some acrylic matte medium to wet some of the areas of the painting and then laid some gold leaf onto the wet areas. With strip of sequin relief I added some pattern to a couple of areas to lift an otherwise dull and boring background.*

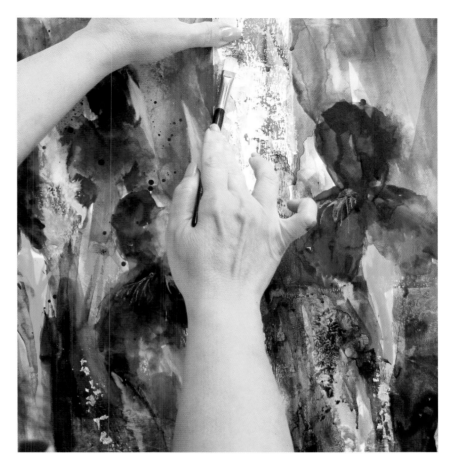

Reworking Irises. *Close-up of the gold leaf. This is a delicate operation as the pieces are so fragile. If you do not want to opt for gold leaf, there are fake versions called magic metal available in most craft shops.*

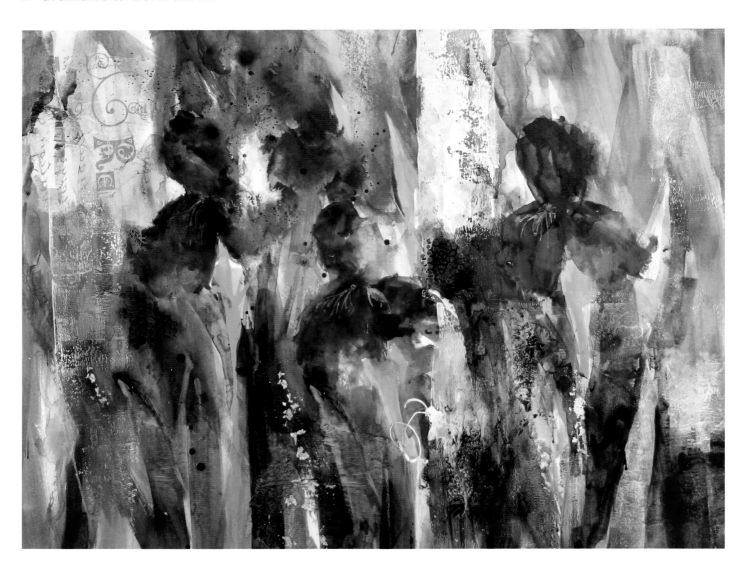

Reworking Irises, *The finished painting. I then turned my attention back to the flower heads: I flooded some more inks on the flower heads and painted the veins on the petals using bright gold fluid colour. I love the spiky shape of the iris foliage so added a few more by painting the negative spaces behind them. I applied some washes of Interference green violet to jazz up the background and finish the painting.*

Reworking Irises. *Close-up of the pattern created with sequin relief.*

Irises with lost and found edges: a balance of lost and found edges gives the painting a feeling of ambiguity.

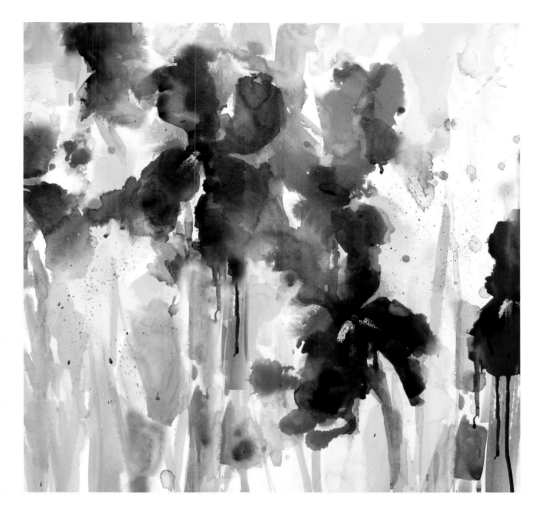

Lost and found edges

We have reached a juncture where the composition is sound, the paint application supreme, the colour balance spot on, but there is something else missing – could it be the treatment of the edges?

All the components of the subject matter are connected to one another; how they are separated is just as important as the components themselves. Edges are areas of transition from one form to another. How the artist translates this transition plays a very important role in the success of the image.

Some subjects call for a lot of sharp and crisp edges; others are dependent on lost and found areas to create an atmosphere of ambiguity and intrigue for the viewer. In most paintings there should be a good balance of both defined and diminished edges. In floral paintings this is so important as too many hard and well-defined or outlined edges in floral paintings can easily turn the painting into a design. Soft and lost edges bring a certain delicacy to floral paintings which enhances the fragile nature of this particular genre of painting.

Irises with lost and found edges: this close-up shows the merging washes of ink and some of the hard and soft edges created by the washes of colour.

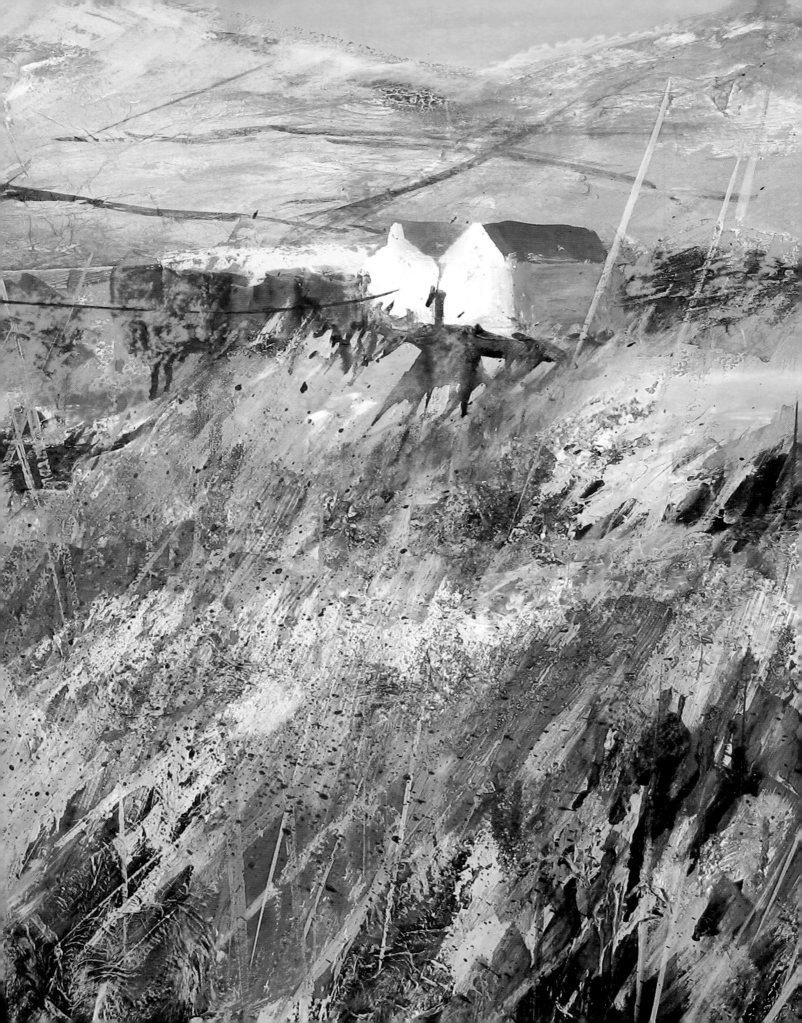

EXPRESSIVE LANDSCAPES

Mixed media is an ideal approach to painting landscapes where a myriad of shapes and textures can be explored by using a variety of texture-making materials, collage and combination of different media. The textures found in nature are often hard to replicate simply by applying paint on paper or canvas; or at best can be a lengthy process as well as an economical nightmare. In mixed media painting you can use the unique characteristics of each type of media to capture the textural effects you wish to achieve quickly, effectively and economically.

Through the experience of painting in mixed media you get to know which subject works best in a certain medium or which combination of several media. You learn to exploit certain qualities in each medium to achieve your desired textural effects.

OPPOSITE: September Fields *(heavy gel, heavy body acrylics, high flow acrylic inks and pastels).*

BELOW: Rocky Layers *(inks and pastels).*

For example a moody and atmospheric painting will benefit from the sensitivity of watercolours or soft pastels on sandpaper. Conversely for rough and rugged landscapes, collage and any number of gels together with acrylic and pastels will help you create all the tactile textures you need. It is the different aspects of a landscape that grab an artist's imagination. For one artist it may be the quality of light, for another a sense of place or a special landmark, while for another it is the elemental conditions within the landscape – the change of season, the snowy weather, expansive cloudy skies or stormy seas, the list is simply endless.

The process of your painting starts with the surface preparation. Gels are colourless acrylics and the building-up of the textures is the first step of composing your painting on your paper or canvas. If you prefer you can be completely contrived about the application of gels, pastes and paper collage, and apply them exactly where it would suggest a certain texture in a more representational painting. Alternatively, a textured ground can be built up either for an abstract piece of work or a painting

Sketching kit: A few water mixable wax crayons or aquarelle pencils and a brush pen is all you need to take out for sketching.

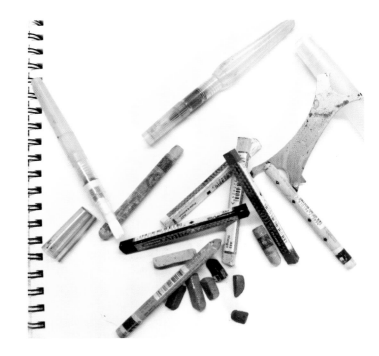

that starts with the textures and washes of colour and is then allowed to grow organically.

Aerial perspective can be achieved through the interplay of transparent and opaque media. The use of less-textured and transparent media in the background and opaque and textured materials in the foreground can create depth and recession in your painting. Water-mixable crayons, oil pastels and soft pastels contribute a great deal of spontaneity and expressive qualities.

The value of sketching

Unlike a photograph, sketches can record exactly what you require from a scene in front of you rather than recording unwanted details. Sketches often have a kind of energy and a feeling of spontaneity that unfortunately at times fails to translate onto the actual painting done from the sketch. Over the years I have come to the conclusion that I would personally rather sketch for the sake of sketching itself and getting to know my subject intimately and not particularly as a reference for a future painting. However, there is no denying that a lot of compositional issues can naturally resolve themselves while you are creating a detailed sketch. It is also great practice for improving your drawing ability and acquiring a photographic memory. Sketching teaches you to see rather than assume. Artists often become subconsciously more free and uninhabited when sketching, without the pressures of a fine and expensive piece of paper.

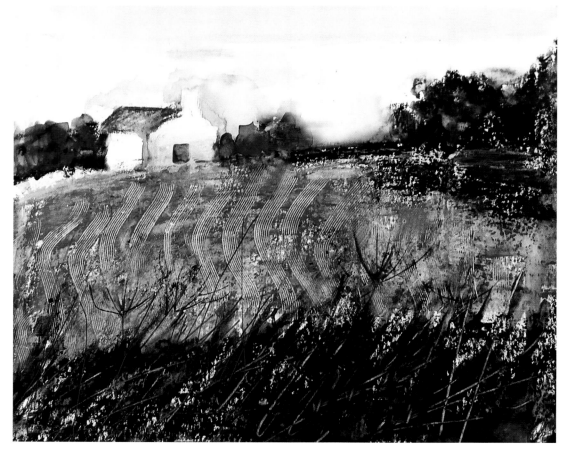

Winter Landscape. This sketch was done with artbars and a brush pen. I used the scraper to make the furrows in the field.

Thumbnail sketches

Preliminary sketches either from a photographic resource or from life before the start of a painting do not have to be on a large scale or detailed. Thumbnail sketches are a great way of helping you resolve various issues within the composition before you start the painting. They only take a few minutes but get you well on your way.

- Draw a few small boxes in a variety of shapes on one page of your sketch pad and use both line and shading to block in the major components of the subject matter.
- Within the small boxes, you can choose the format of your painting as well as deciding what to leave in or out. Apart from the traditional formats such as landscape or portrait, some paintings look better in a square format, some call for a long and narrow shape to have the most impact.

Thumbnails help you establish the areas of light and dark, and help you set the tonal value of your painting before moving onto your main support. These small-scale sketches are not as precious as a larger detailed sketch which can be quite time-consuming and might not work out, and in the process they could frustrate you as much as a failed painting.

Thumbnail sketches of the flower market. These sketches do not need to be detailed. I sort out different compositional issues in each one. If the sketch is no good I just cross it out and do another one.

Keep it simple

Regarding how much detail to include, it is better not to make a detailed drawing in order to paint it. Let the brush and the paint and the value structure do the job. A detailed drawing will confine you within its line and suffocate the painting.

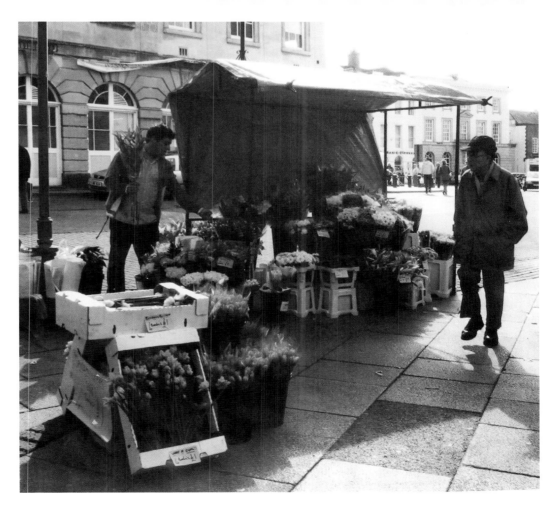

Andover flower market.

Skiathos Headland. *Watercolour sketch of a headland in Skiathos on a super windy day.*

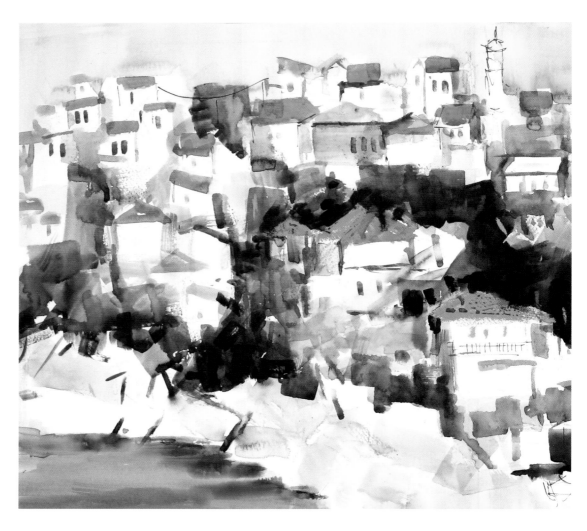

En plein air

If you are keen to explore the widest variety of mixed media it is not the easiest approach to painting outdoors – there are simply too many things to carry around. However, over the years and through teaching on location in many different climates I have pared down my painting kit so that I can use mixed media for my field studies. I quite like the raw quality of these spontaneous paintings, but I really appreciate the comfort of my well-equipped studio when I get back. For me painting outdoors is essentially about gathering ideas and drinking in the atmosphere and not about producing finished pieces of work. If you have never painted outside then try not to be too ambitious. Taking a sketchbook and a few water mixable crayons and a brush pen filled with water is enough to collect information and practise direct observation until you feel comfortable to take your easel and paints.

I cannot emphasize enough the importance of painting and drawing from direct observation and the need to get a sense of place and be able to compose a subject when faced with the great vast outdoors. If for any reason this is not possible, however, then try improvising for a similar effect by setting up a still life in the comfort of your home. You will then be much better equipped to interpret your photographic references and compensate for the shortcomings of your photo resources and naturally create more believable and lively images. You do not necessarily have to create a finished painting outside. Any of the individual media can be used to provide you with small studies to be used later on at the studio as a reference or to be reworked and made into a painting.

Painting outdoors will help you to learn how to handle and cope with the change of light, how to narrow down a small area that has more impact and how to focus without getting distracted by what is going on around you. It does wonders for honing your observational and compositional skills. I also find the challenges of working in the open, such as battling with the elements on a windy headland or the hustle and bustle of a marketplace, can help you lose inhibitions. You have no choice but to simply get on with it and do your best. This sometimes leads to more spontaneous and lively paintings.

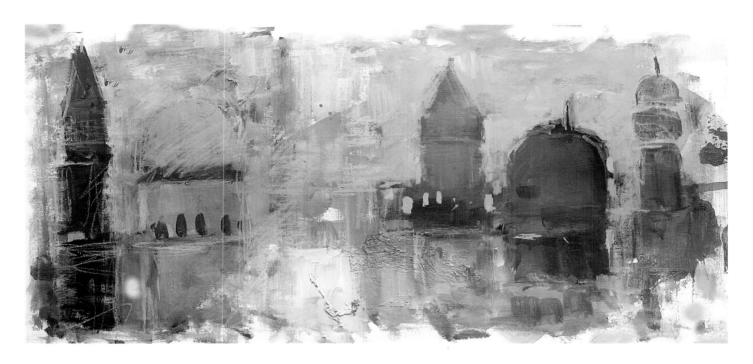

Townscape. *Mixed media sketch with wax crayons, oil pastel and water mixable wax crayons. I make textured off-cuts of mount board to take out on location for these small sketches. The larger pieces are the same size as the bottom of my suitcase. They are ideal as they are rigid and easy to work on.*

A simplified sketch of Venice buildings in muted colours on location. I used OPEN acrylics mixed with Acrylic grounds for pastels to add extra body for this study, as they stay wet in warm climates. This was done on a textured canvas.

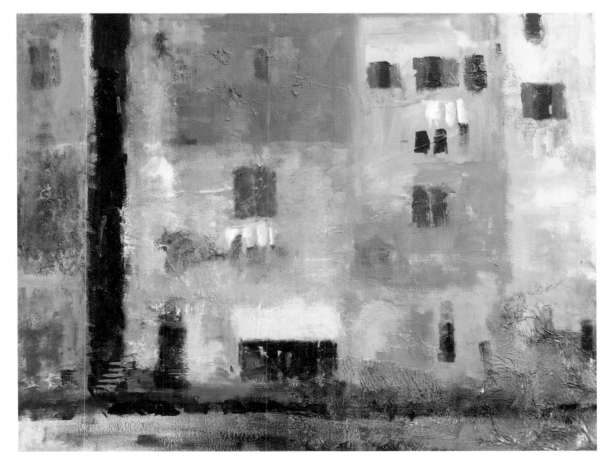

The value of underpainting

Applying a layer of colour prior to painting is known as underpainting. This is an effective way to establish a certain mood and atmosphere in a painting right from the start. For example, an underpainting in raw sienna or yellow ochre can add a warm and sunny feel to the whole image. A predominantly green painting may benefit from an underpainting of its complementary colour red. In other words the underpainting can be used either to create an ambiance or to contrast and intensify the subsequent layers of colour. Furthermore by allowing the underpainting to show through the top layers of colour you can create harmony and unity in your painting.

If you feel intimidated by the white of the paper or canvas this is the best way to start your painting.

Oil painters have traditionally used underpainting either by tinting the primer with a single colour; often burnt sienna, or by initially blocking in some of the tones in the painting. You can use the same concept in a mixed media painting.

The underpainting can consist of one colour either applied smoothly all over or used in a more patchy and haphazard way. Alternatively some of the shapes and colours of the subject can be blocked-in lights, darks and mid-tone hues as an underpainting, thereby establishing the value structure.

There is another purpose for underpainting, enabling one medium to help another; for example by applying a layer of acrylics or a wash of acrylic ink or watercolour you can not only create a certain amount of tooth, but also block in some of the initial tones prior to painting in pastels. This method is now used by many pastel artists worldwide as a valid technique. Blocking-in the initial stages with water media is not only a quicker process but also stops you from inhaling too much pastel dust. The finished painting can still have the appearance of a pastel painting without a few disadvantages associated with this wonderful and direct medium.

Careful consideration

Some thought and planning is necessary to choose the colour of your underpainting, as it will affect the colours that will be painted over the top of it.

Summer Meadow. *In this painting I used an uneven underpainting of naphthal red light acrylic paint which I allowed to show through the subsequent layers to unify the painting. Lots of layers of pastels, oil pastels and crayons added energy to the surface of the painting.*

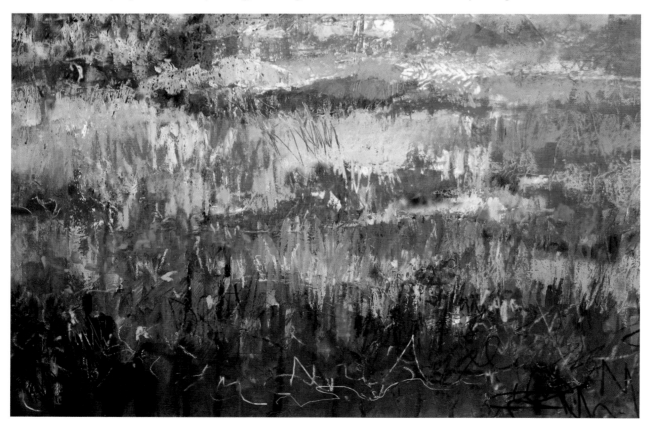

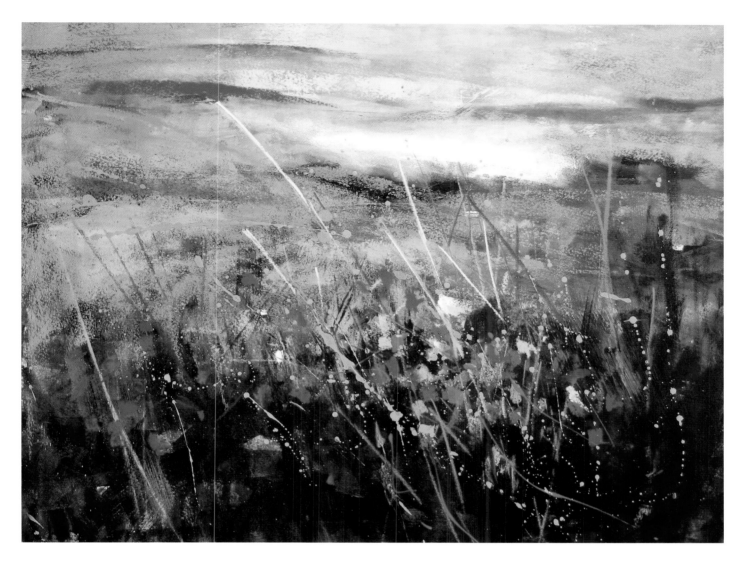

Hedgerow Fireworks. *The washes of acrylic ink and some heavy body colour blocked in all the darks and mid tones before I started applying the pastels to bring out all the vibrant colours. By changing the proportions of each medium you can change the whole surface quality of the painting dramatically.*

Some techniques for landscapes
Combining wet media with pastels

This is truly a marriage made in heaven. I find certain colours in pastels shine in a way that is almost impossible to replicate in acrylics or any other wet media. Preparing the background with a couple of layers of acrylic grounds for pastels or colour fix creates a certain amount of tooth to grip the pastels. Alternatively there are a number of artist quality wet and dry sandpapers on the market that allow for underpainting with water media before applying the pastels without compromising the tooth of the paper. Watercolours, gouache and acryl-

ic inks themselves also create a certain amount of tooth for a pastel painting. You can experiment with a number of different types of watercolour papers, each will give you a different result.

As I mentioned previously by using an acrylic heavy body or ink base you can minimize the amount of pastels you use, however, finishing the top layer with pastels still give the appearance of a pastel painting. This is especially helpful for beginners to pastel as the underpainting provides a certain degree of cohesion which is sometimes lacking in a pastel painting by a beginner to the medium. The mix of the two mediums reduces the amount of blending you need to create a more cohesive painting.

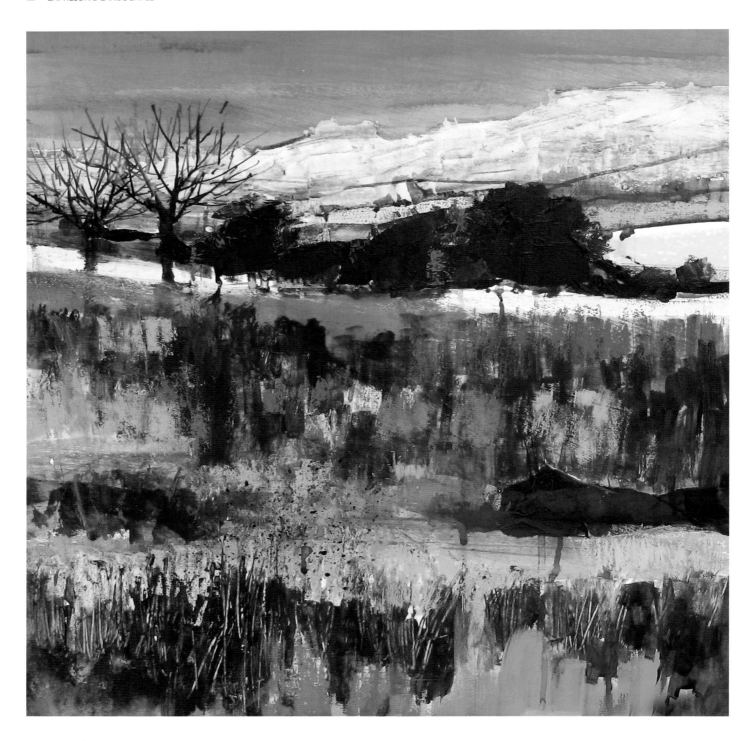

Magenta Sky *(sgraffito technique).*

Tones for sgraffito

The colours that you scratch into should be two different tones – the more contrast, the more dramatic the effect will be. This technique also works for suggesting all types of textures, such as the weave of a basket.

Sgraffito

Sgraffito is an Italian word for a scratching technique for decorating pottery, where a layer of paint or glaze is scratched to reveal the colour underneath; the term has been adopted by painters to describe a similar method in painting. This is one of my favourite methods of implying rough textures.

Magenta Sky

The surface of the painting is built up layer by layer.

- I applied a layer of fine pumice gel over the whole board as I really like the way the gel grips and reacts with the paint. Furthermore it provides a certain amount of tooth for the pastel applications.
- I chose process magenta ink as an underpainting colour to harmonize with all the rough purple heather in the foreground.
- I applied a generous amount of gloss heavy gel over the hills in the background, as the inks tend to run off the surface of gloss gel and just leave a pale impression of colour which was what I wanted. The gel can also mimic the roughness of the hills.
- Small pieces of dark blue paper collage in the foreground and over the dark trees on the two thirds gave me a head start towards creating the dark values needed to add depth to the painting.
- Dabs of light green oil pastels were applied over the distant hills. The oil pastel areas resisted the subsequent washes of inks and came through. I followed washes of magenta with light green inks and then flooded high flow dioxazine purple, which is a lovely strong purple. Washes of ink tend to find their own way on the support and mix and mingle and create drips and dribbles which can all add to the chaotic surface I wanted to achieve.
- I let the surface dry and then started going over various areas with layers of soft pastel followed by heavy body paint in darker tones.
- While the paint was still wet in the foreground I took a sharp tool and started scratching the surface to reveal the lighter tones underneath to suggest the texture of grasses in the foreground. This is a very effective technique for suggesting textures and can be done with layers of wax over acrylic, watercolour or gouache. You can make very thin and intricate patterns with sharp objects.

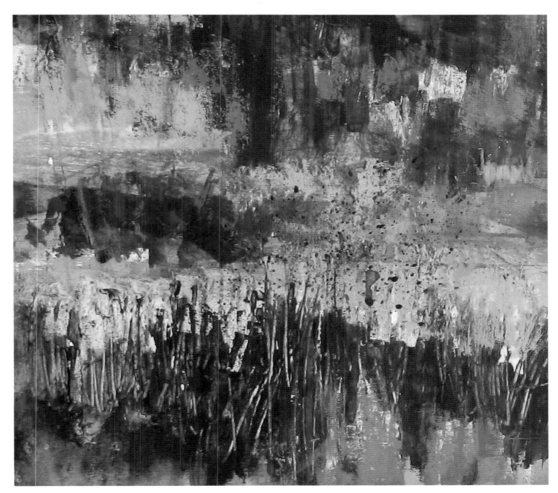

Close-up of sgraffito technique showing the scratches into the top layers of colour to reveal the colours underneath.

Demonstration: Sgraffito

The sgraffito technique is the ideal method of suggesting a variety of textures in landscape, and is also useful for implying the textures of woven objects such as baskets and hessian.

Furrowed fields

Materials
Acrylic inks
Prussian blue
Raw sienna
Burnt sienna
Light green
Yellow oxide

Acrylic paint
Prussian blue
Light blue violet
Titanium white
Light green
Cobalt teal
Naples yellow

Support
Recycled piece of 16×16in mount board

Texture products
Gesso
Light molding paste
Regular gel
Pumice gel

Stage 1

I prepared the recycled board with two coats of gesso, but you can still see the faint colours of the painting underneath. Once the surface dried, I spread regular gel with a palette knife in the direction of the furrows over the area of the fields. Before the gel dried I used a catalyst comb like tool to create the furrows in the fields. You can use any sharp object or the end of a brush to do this. I used a tool with wider teeth for the field that was further away and one with smaller teeth for the larger field. I covered the trees in coarse pumice gel to suggest the foliage. I created a more absorbent foreground by applying a layer of light molding paste. I like the way the inks tend to sink into this absorbent surface and create interesting and random shapes.

Demonstration of Furrowed Fields *sgraffito stage 1.*

Demonstration of Furrowed Fields *sgraffito stage 2.*

Stage 2

At this stage of the painting there is a feeling of freedom about applying the inks. I flooded washes of high flow yellow oxide and burnt sienna and light green to create the background colours and tint the board. You can see how the inks run off the gel surface but sink into the absorbent surfaces of the light molding paste and the pumice gel.

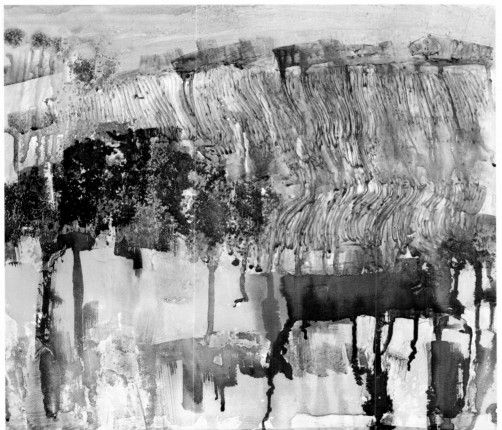

Demonstration of Furrowed Fields *sgraffito stage 3.*

Stage 3

Washes of Prussian blue were added to all the trees and hedges. I was standing at my easel for this painting; hence there were a lot of dribbles of ink running down the support. If you are quick you can wash away the unwanted drips; otherwise they can be covered by opaque media or better still incorporated into the painting. I also strengthened the washes of burnt sienna over the fields.

Stage 4

I used a roller to add light blue violet to the cottages and the sky area. Then I applied Prussian blue to the foreground over the light moulding paste and scratched into it while wet with the point of the palette knife. Then I incorporated some of the drips as the trunks for the trees and added some Prussian blue in the foreground and to the dividing hedge between the two furrowed fields.

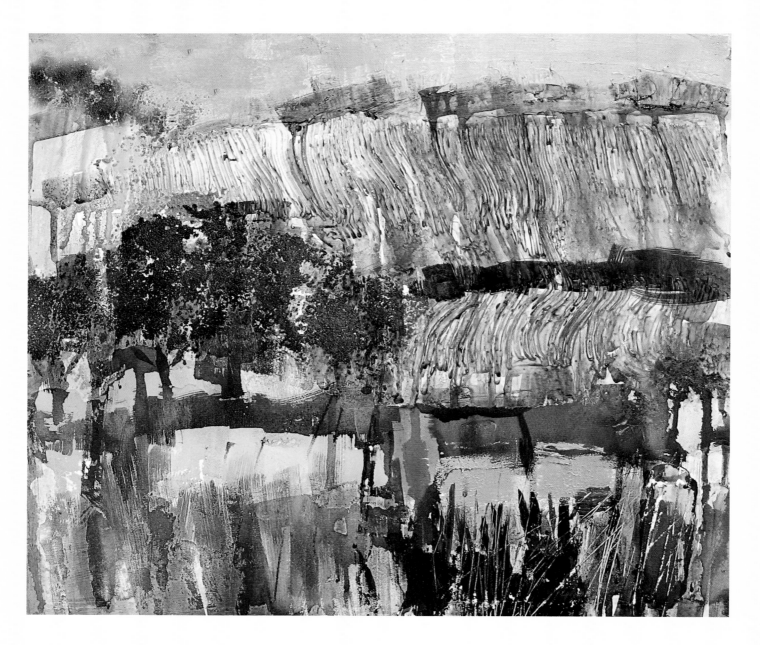

Demonstration of Furrowed Fields *sgraffito stage 4.*

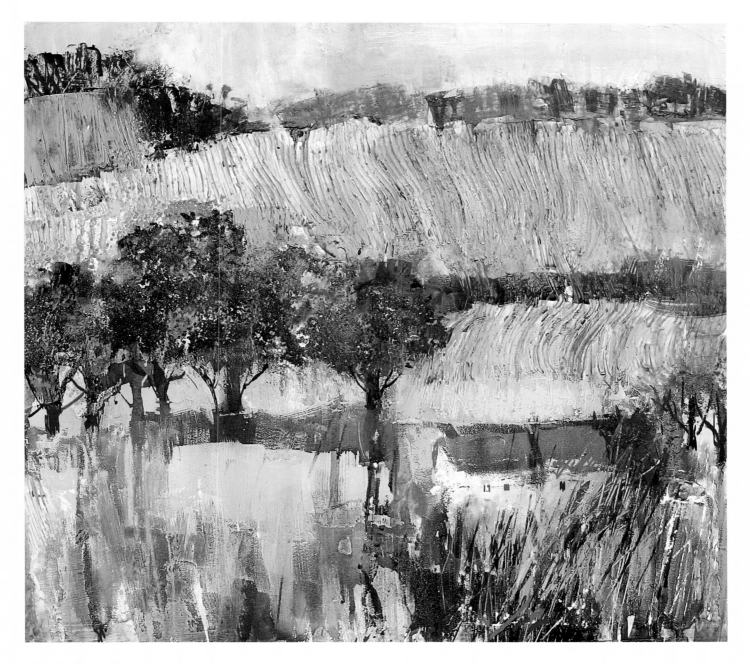

The finished painting

I started to bring in the heavy body colours and painted the fields with a mix of yellow ochre and Naples yellow. Using a sharp tool I scratched into the furrows and painted the field on the top left hand corner with cobalt teal. A royal blue pastel helped lift the trees in the distance and between the two fields. I then applied a third colour to the sky by diluting the burnt sienna and adding it to the sky, letting a little of the blue and the yellow ochre to show through. I added a few highlights to the trees and decided the painting is finished.

Demonstration of Furrowed Fields *sgraffito. The finished painting.*

Project: Experimenting with colour, format and surface texture

Changing the colour scheme and the surface quality of a painting can have a profound impact on the end result. For this project you can use either a photograph or a sketch as your reference and create two or more paintings from the same source material, but change the colour scheme and the format to see the dramatic change in the overall feel of the painting.

Composing your source material

Combined with the experience of painting from life, photographs can be a great aid to your painting. This time the process of your painting begins with the composing of the photograph as a first step in the creative process. If you are in front of the scene then you must be able to acquire a sense of place; later on you can compensate for the shortcomings of the photos.

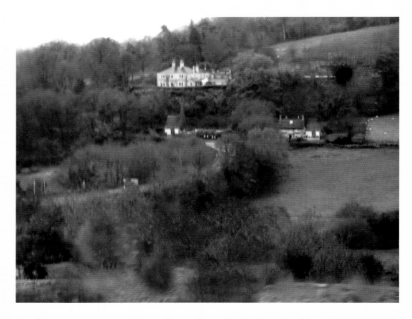

West Sussex countryside photo reference (© Soraya French).

Alternatively you can use one of your sketches. There are many reasons why we take photos rather than sketching: inclement weather, lack of time and your own inclination can get in the way of the extra time and effort needed to sketch rather than click a button.

My photo references are usually composed with the intention of being my primary source of material and are used to back up and refresh my memory. I use the viewfinder to assess the image, already thinking about the best composition and the process of turning it into a painting.

The task of turning the image into a painting carries on back at the studio with thumbnail sketches, doodles and trying different ways until I can see the way forward to start the painting. This process can take anything from a few minutes to several days or more.

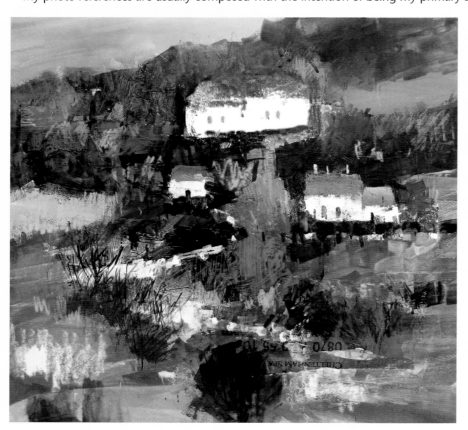

West Sussex Countryside 1. *For this painting I used heavy gel matte brushed on vigorously to allow the marks to come through the layers of paint. I also used molding paste on the cottages and some printed text as collage in the foreground. I chose a double complementary colour scheme of orange and blue plus purple and yellow. Lots of soft and oil pastel marks created a lively surface. The darks are a mix of all the colours together. I opted for a more contemporary square format for this painting.*

RIGHT: West Sussex Countryside 2. *I used mainly tissue paper for the texture of this painting and a triad of hansa yellow light, phthalo blue and quinacridone red. I opted for a portrait format so it elongated the image. The same source material has produced a totally different image. Soft and oil pastel marks bring more vibrant violets and greens as accents of colour.*

BOTTOM LEFT: Close-up of West Sussex Countryside 1 *showing the roughly brushed-on gel for texture effects.*

BOTTOM RIGHT: Close-up of West Sussex Countryside 2 *showing the texture of the tissue and how different the two paintings are.*

Revisit the past

From time to time revisit your old source material and see how your views have changed. Find out how you might tackle the same subject now, or even whether you are still interested in the subject.

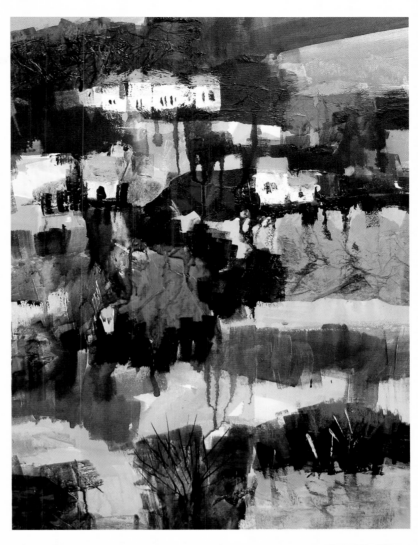

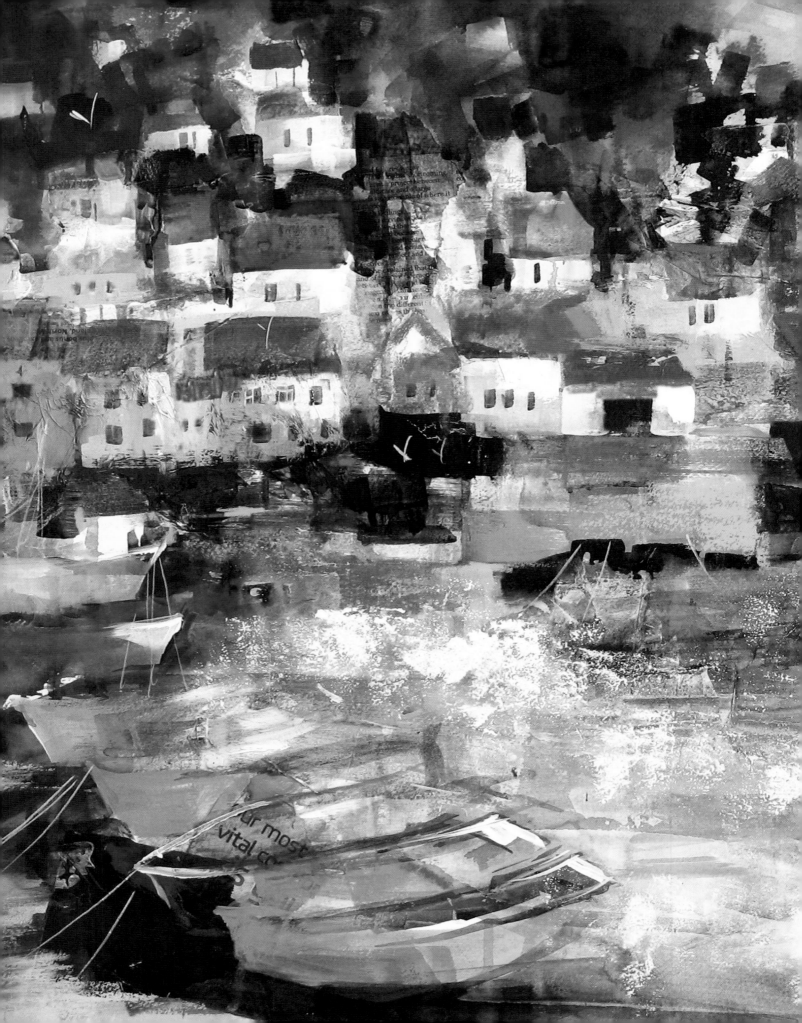

EXPLORING FURTHER

In this final chapter we will be examining a few more ways in which gels and pastes can enhance your work. Transferring images by using gels and media can offer you archival quality collage to use in your paintings. Stencils and stamps make a great team with the paints and inks to help you create interesting and evocative abstracted background patterns. And finally we consider how to protect your artwork from environmental damage.

We will also be exploring a few interesting subjects that not only lend themselves to the mixed media approach but also will give you valuable lessons in practising restraint from including every little detail in your paintings. Learning to simplify and extract the key elements of the subject matter is highly important for creating paintings with maximum impact and a clear message.

Too many disjointed and isolated shapes confuse the viewer as to what the painter is trying to project. Subjects with multiple shapes need to include variety in size and an interlocking connection within the underlying structure to create cohesion and ultimately engage the viewer.

Once again the liberating aspect of painting in mixed media helps you through the complexity of these types of subjects with no need for tedious planning associated with challenging transparent media such as watercolour. Your process can begin by breaking the surface with collage pieces and washes of colour, safe in the knowledge that not only can the opaque media rectify any mishaps but in the process they may also add to the interest and the surface quality.

Frequent assessment of the painting's progress is crucial so that you retain the happy accidents and pleasant surprises that you can exploit to create more dynamic images.

OPPOSITE: **Cornish Harbour** (collage, acrylic inks, heavy body acrylics, oil and soft pastes).

BELOW: **City by Night.**

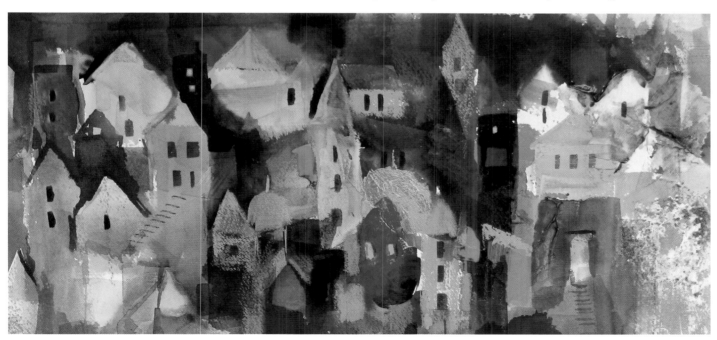

Demonstration: Simplification

It is so easy to get totally overwhelmed by the sheer amount of information when painting subjects with multiple shapes. You are presented with a staggering number of shapes and it is hard to decide where to begin. Giving equal attention to everything that you are presented with in the scene in front of you will be confusing for the viewer or will make them totally bored from the outset.

Simplification is at the heart of the successful depiction of scenes that are simply overladen with detail.

- A viewfinder can help you narrow down a section of the scene in front of you that presents the most dynamic composition.
- Modern gadgets such as iPads and digital cameras with good viewfinders are also useful for helping you to take out a section of an otherwise quite overwhelmingly busy scene such as a harbour scene or a Mediterranean hillside village.
- If you do not intend to paint en plein air, a few sketches backed up by photographic references should give you enough information for a painting back at the studio.

Greek Hillside Village

I have simplified this busy hillside village right down to the shapes that I found pleasing and felt would make a good composition.

Materials

Gels and grounds
Hard moulding paste
Extra heavy gel matte
Extra coarse pumice gel
Gesso
Absorbent ground
Light molding paste

Acrylic inks
Yellow ochre
Quinacridone magenta
Flame orange
Phthalo blue

Canvas

Objective treatment

Hard moulding paste is great for leaving the imprints of objects on and also for embedding interesting objects.

Stage 1

I prepared the surface of my canvas with extra layers of gesso as I did not want the texture of canvas coming through, and followed this with generous applications of absorbent ground in thin layers. The scene had an overwhelming number of buildings, but I chose a few and then applied hard moulding paste to a number of them. When the paste was half dry I pressed bubble wrap into the façade of a few buildings to add interest. I chose random buildings to add light moulding paste to; as this paste is quite absorbent I knew that it would bring a different type of visual texture. I did the same with extra heavy gel. I then applied a wash of high flow yellow ochre ink as an underpainting to create a sunny glow and unify the surface. I scratched the heavy gel with a sharp object and pressed a cloth over some of the other parts to create different types of texture on the surface.

Demonstration of Greek Hillside Village *stage 1.*

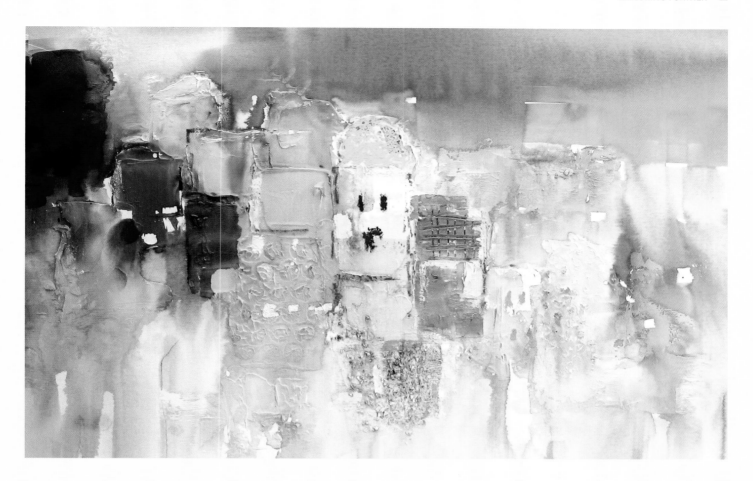

Demonstration of Greek Hillside Village *stage 2.*

Stage 2

I flooded my phthalo blue high flow inks over the absorbent ground which made the canvas almost like watercolour paper. I followed the blue ink with more washes of yellow ochre and let the inks run to mix and mingle and create interesting patterns.

Drying time

The drying time of the gels and pastes depends on environmental factors, such as temperature and air flow and the thickness of the materials. The thicker the gel the longer it takes to dry, so be patient; for very heavy applications if possible make the base the day before. You can speed up the drying time by hairdryer, but it is not the ideal method.

Close-up of Greek Hillside Village *showing the detail of imprints on gels and pastes. The thicker the gel, the longer it takes to dry, so be patient; if possible make the base the day before.*

Stage 3

I added the flame orange ink to a few of the buildings with terracotta facades. This also helped to break up the overall yellow and blue colour scheme. I used gravity as one of my tools and by working upright allowed the drips and dribbles of ink to run freely and make some lovely vertical shapes. Adding some details in the shape of a few windows brought the buildings to life. Through painting the negative shapes I found some of the rooftops from the early washes of colour. Buildings that are found this way tend to recede and create a certain amount of depth and recession in the painting .

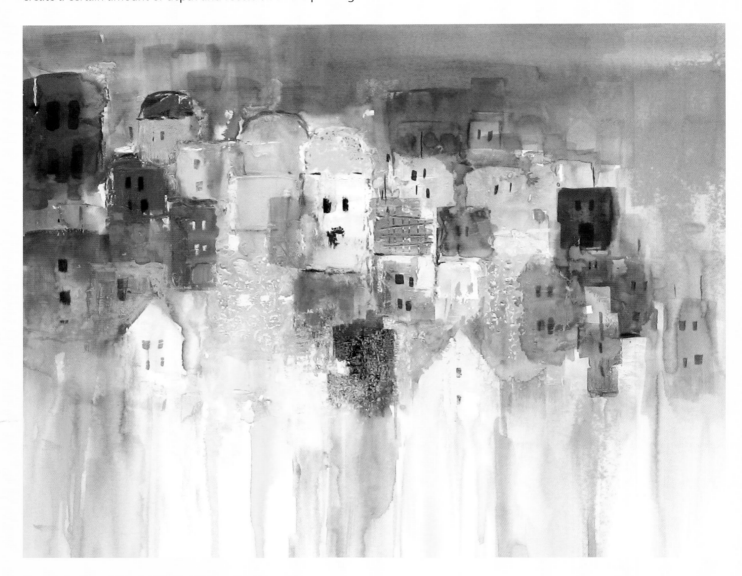

Demonstration of Greek Hillside Village *stage 3.*

Painting windows

The edge of a flat brush dipped in ink is ideal for painting windows. Pastels and acrylics make a clumsy mark. If the colour is too strong dab it immediately after application to take away the excess ink and lighten the colour.

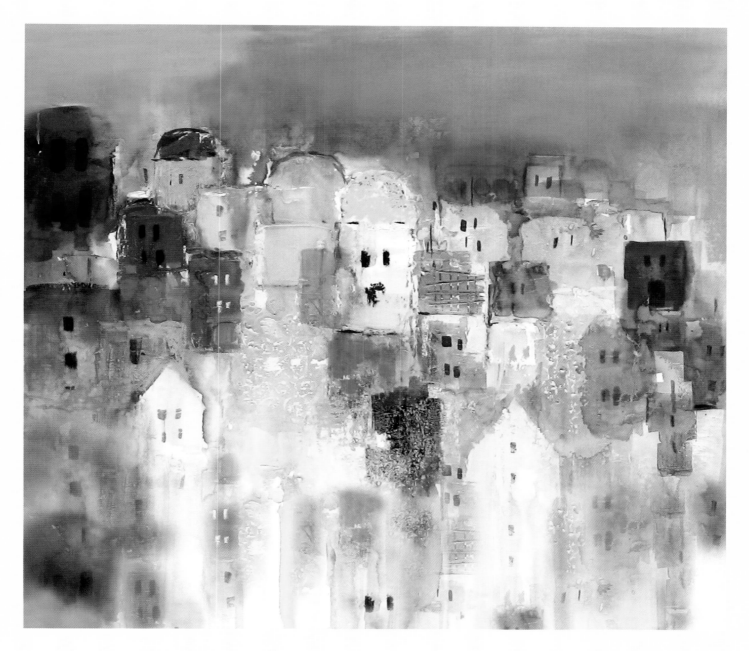

Greek Hillside Village. *The finished painting.*

The finished painting

I strengthened the colours over the buildings to give them more substance and then to finish the painting added the magical reflections which had interested me in the first place. I had to replicate some of the textures in the reflections in small amounts so had to take this into account when I was preparing my surface, although it is possible to introduce more texture at any time during the course of the painting. I applied more absorbent ground in the area of the reflections to be able to flood in some wet-into-wet washes for the reflections and make them soft and blurry and not as sharp as the buildings. This was probably the most difficult part of the painting. I feel that this simple semi-abstract sums up my feelings about the scene to my viewers without bombarding them with all the information that I had in front of me.

Getting creative

With collage

For collage I use all manner of handmade papers as well as fabric or any material that can take inks and paints on its surface, to bring variety to my paintings. One of my favourites is Latradur, a non-woven, man-made polyester material; it looks quite fragile but it is in fact rather tough and can be used very nicely as collage without disintegrating. It is sold in different colours and different weights but I prefer to stain my own so I usually use white and sometimes gold, depending on the painting. It can be used for ink jet printing as long as you give it two coats of digital ground and use a paper carrier to support it through the printer. Its inherent strength and spun bond (non-woven) nature makes it hard to tear, but it is possible to do this by tugging at it hard. In fact I really like the shredded bits, which make yet another visual texture of their own.

Different types of fabric are also interesting to use; lace, chiffon and cotton can all be incorporated beautifully. I usually test them to see how they react with inks and fluid colours, and if they make interesting patterns then I use them as collage where it is appropriate and they can contribute a nice pattern or texture. Acrylic paints and mediums and gels can protect and preserve the fabric. Varnishes with UVLS can protect materials against fading as long as they are suitable for varnishing.

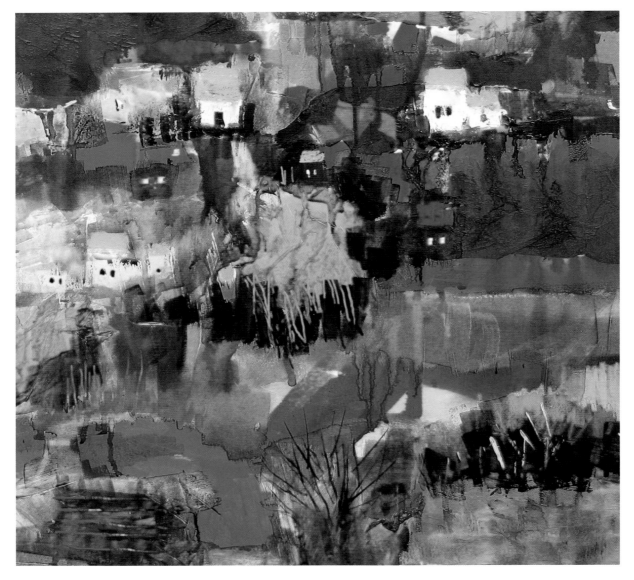

Cottages on the Hill. *The collage in this painting is made up of large pieces of purple and blue acrylic skin with accidental but quite attractive jagged edges. I used small pieces of a mixture of fabrics such as cotton and chiffon, and also coloured papers which I stained with inks and protected with UV varnish. This type of collage has given a patchwork appearance to the painting, which was my intention.*

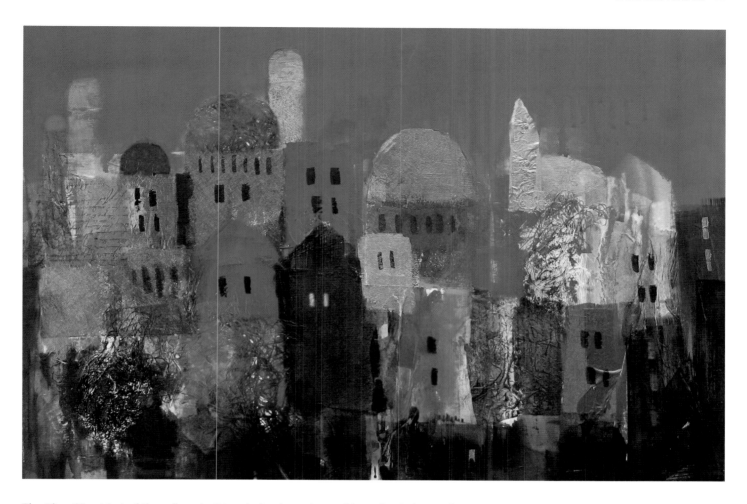

The Blue City. *Most of the collage in this painting is made up of Latradur. I also used written text and one or two other types of paper. I applied Latradur on the surface where I intended to place the buildings. I then flooded the inks and used dabs of vivid green pastels plus little touches of paint to add interest.*

Close-up of **The Blue City** *showing the attractive woven appearance of Latradur and its reaction with the inks.*

Close-up of **The Cottages on the Hill** *showing the use of acrylic skin, fabric and paper collage.*

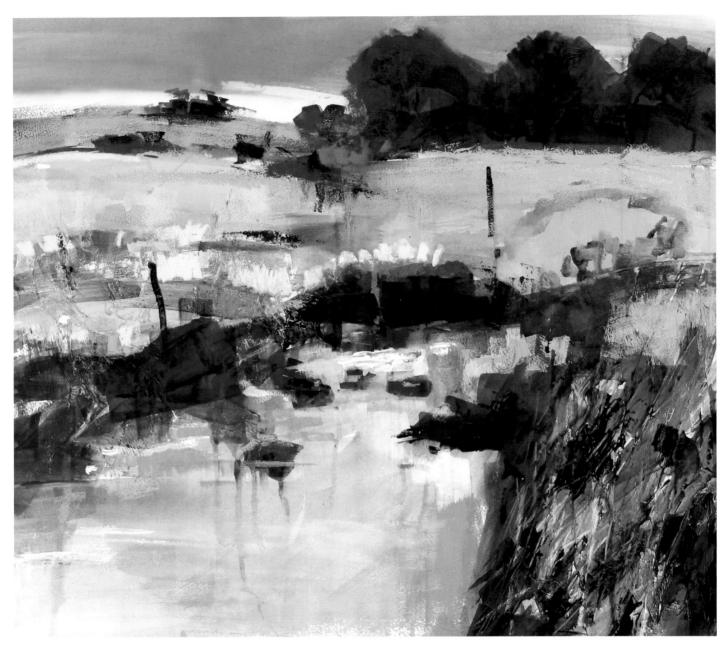

Yellow Fields. *For me there is something missing in this painting and I somehow failed to get excited about its progress. I prefer the two cropped versions on the right-hand side.*

Hampshire Fields. *This is a small corner of another larger painting which failed to excite me, but this little 8×8in version has a good balance.*

Cropped corner of Yellow Fields *square version. I prefer this small abstract to the larger image. Reducing the number of trees as well as the proportion of the yellow fields on the right-hand side improves the image instantly.*

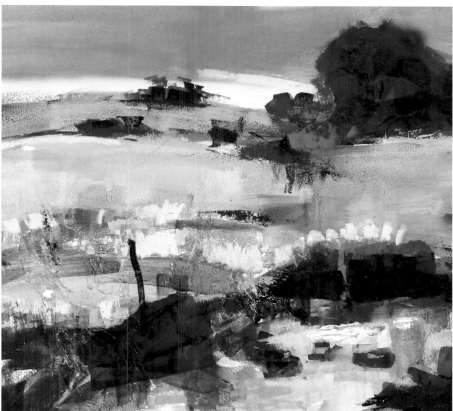

Cropped corner of Yellow Fields, *the long and narrow version. I quite like this even more abstract version, which also has good balance. The wooden pole on the two-thirds adds a vertical to an otherwise quite horizontal composition.*

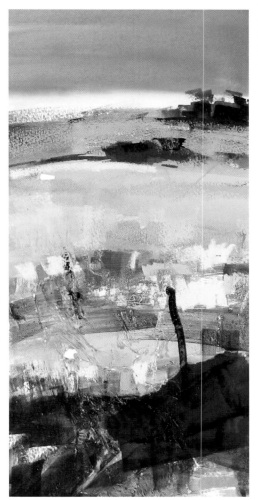

Treasure or trash?

Unfortunately painting has a very unpredictable nature and things do not always go to plan. There are many reasons for failed paintings: discordance between the various elements, colour scheme or overall composition are just examples but the list is long. The bigger the size of the painting the more disappointment and frustration is felt by the artist when the painting fails. A badly thought through composition makes the subject look insignificant without any cohesive message. This is quite disheartening for the artist when a lot of time, not to mention expensive materials and energy, have gone into producing a painting which is only fit for the bin.

This is when you can try to isolate the image using different shape mounts to see if there are any little hidden gems within the discordant image. This exercise is quite enjoyable and very gratifying when it pays dividends and you end up with at least one, two or more smaller good paintings out of the failed larger piece of work.

Finally if you cannot find any joy by cropping, the piece of paper can always be recycled by a layer of gesso, overall tissue paper treatment, texture gels or as a background colour for the next piece of work.

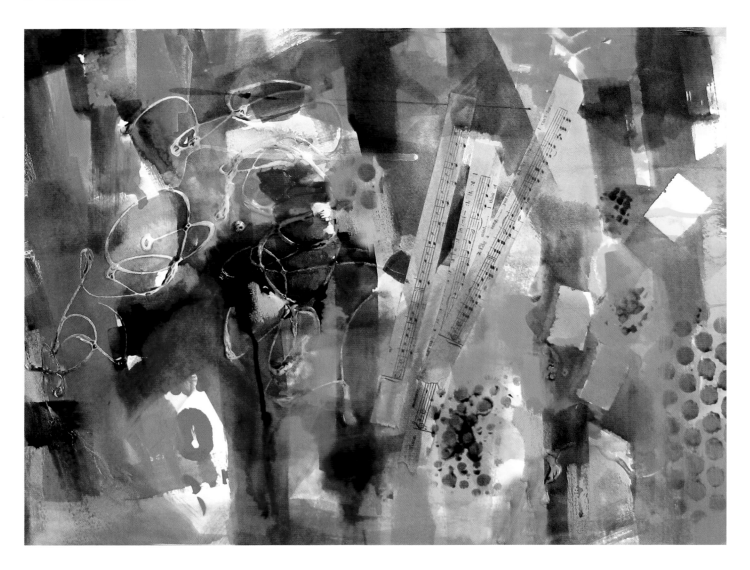

Painting in progress. I would like to work some more on this painting. It started with drizzles of matte medium to create rope-like lines which resist washes of ink. I added some collage by cutting up strips of music sheet, then flooded the surface with flame orange ink. I used stencils to make random marks which look like larger versions of sequin relief. After the first washes I masked out areas to miss the subsequent washes and bring a different dimension to the surface. I think I will continue to have fun with this piece of work.

Using stamps and stencils

Stamps and stencils are a great aid for creating abstracted backgrounds by making definite marks that do not look stylized. I find using paint works better than inks when I am using stencils; sometimes the inks seep underneath the stencil and ruin the effect by leaving an unwanted wash of colour behind. There are so many different stencils with numerous designs and patterns around, but do be careful what you chose, as some can be rather pretty and might make the painting look more decorative and crafty than fine art. The same thing goes for stamps.

Heavy body acrylics, acrylic inks, watercolours and gouache can all be used successfully for this technique. You can build up the painting layer by layer, masking out areas with pieces of masking tape to preserve the colour in the masked area while changing the colours around it. This treatment makes the masked area recede and creates a wonderful depth in the painting.

These techniques can be used either as a background for a subject-based painting or for an abstract piece of work.

Interference colours on black. Interference colours really show off on dark surfaces and are great to use in more abstract pieces of work. I have used a number of stencils and stamp samples to show you the sparkly effect they have on dark backgrounds. They make fabulous glazes over normal colours by creating a slight sheen which is subtle and beautiful. Gold mica flakes can also be used effectively on dark backgrounds

Pattern Sensation. *I used a number of stamps and stencils for this abstract with generous washes of quinacridone magenta and indigo blue ink. I used a fair amount of bright gold with sequin relief and bubble wrap as well as stencils to create some glowing areas.*

Image transfer with gel media

Transferring images with gel medium is another way to use text and pictures as collage. You can use photocopies, magazine cutouts, digital images or laser prints. Try out different quality papers to find the best one for you. Any number of gels and media can be used for this method, but a gel such as Golden's soft gel gloss gives the best result as it dries clear and reveals the whole image without clouding. For pouring methods you can use clear tar gel or self-levelling gel. These gels tend to level out without leaving any brush marks.

For best results with the soft gel I suggest smoothing out the gel with a large palette knife similar to the ones for icing cakes. The thickness of the gel layer should be at least $\frac{1}{32}$ to $\frac{1}{16}$ of an inch to avoid tearing when handling the image.

Applying gel to the support

There are different ways of transferring an image. You can apply the gel to the surface of your choice such as paper or canvas. While the surface is still wet place the image face down onto the wet gel and smooth it out using a roller. Wait until the surface dries completely and re-wet the backing paper to gently rub it off and reveal the image. You may have to re-spray several times to finally make the image free of backing paper and get a clean image. You must do this gently to avoid damaging the image.

This is such a great way of producing your collage matter. You can even make a collage of several images then take a digital photograph and transfer the image that way.

Youf Culture. *For this painting I made up a collage from some magazine cut-outs and written text that I liked, and after the collage dried I added washes of colour. I then took a photo so that I had a one-piece image to transfer. I used a good quality photocopy paper and put the image through my best printer with archival inks. I then coated the paper with a generous amount of polymer medium and placed the image face down onto the paper. I waited until the image dried and then sprayed the back of the picture to take the backing paper off. I now had a collage encased in polymer medium. After sticking down the collage on my paper I proceeded to paint the figures of the young boys.*

Written text collage piece for a larger painting. For this gel I produced a photo of the lettering which was on a packing case I had – I happened to like the font and always wanted to use it as collage – so I took my image with a digital camera and printed it off. This time I applied a layer of GAC 500 over the image and left it to dry, then added a generous layer of regular gel medium. Once the gel dried I took off the backing paper by gently rubbing the back of the image; as I intended to use this as collage in my painting it did not matter if all the backing paper came off or not. The gel gave it a lovely surface for the washes of colour.

Applying gel to the image

Alternatively you can apply the gel to the image that is being transferred and leave it to dry completely. To avoid the paper wrinkling too much you can use a medium such as GAC 500 to brush on the image and leave it to dry before you apply the gel for the transfer.

Be patient and if you can, leave the image two to three days to cure completely. When the image looks totally clear it is time to soak the gel containing the image in lukewarm water and gently rub off the backing paper. The image will be intact within the gel. This can be used as it is or as collage material in your art work. By soaking and reintroducing the water the gel may start to look cloudy but it will dry clear again, however, keep the soaking time to less than 10–15 minutes. You can always take off the little extra bits of paper by spraying the back of the gel. If you use a black and white image you can actually colour the image by painting the back of the gel.

Separating gels

Always keep the gel transfers in separate layers, as they will stick to each other. Make sure you have a paper like glassine between each layer. Glassine is also useful for storing pastel paintings and keeping them safe and smudge free.

Adhering the transfer

To apply the transfer to your paper or canvas you can use Soft Gel (Gloss) or any other Gel Medium as an adhesive. Simply brush the medium to the back of the gel and place it onto paper or canvas. Just add enough pressure to make sure that the gel is firmly fixed in place. Sometimes I place a grease proof paper on top and gently apply pressure. Allow enough time for the gel to dry.

Protecting your painting with varnish

There are divided opinions amongst acrylic and mixed media artists regarding the varnishing of paintings. For some artists a key factor in the painting is the different levels of sheen on the surface, and the unifying element of varnishing creates a problem. For some it is the fear of colours running through and giving the painting an unwanted glaze. However, if you are framing your painting without glass then varnishing will protect the surface.

There are a number of reasons for varnishing paintings that are displayed without glass. Varnish protects the surface against the dust and dirt in the atmosphere. It can unify the surface by introducing an overall matte or gloss finish as well as enhancing and enriching the colours. Varnishes with UVLS can also protect the less lightfast colours from fading. Acrylic by nature dries to a slightly soft and spongy finish which is quite receptive to pollutants in the air. This means that years later the layer of varnish can be removed to expose the clean painting underneath.

If you have used soft pastels and water mixable wax in your paintings then I recommend displaying your work behind glass without varnishing. If the painting contains just collage, acrylics and perhaps oil pastels then you may be able to use a spray varnish to protect the surface, but always do a test run on another unwanted piece before you spray. You can do the same test with paintings containing soft pastels or graphite, although I imagine the spray will darken these materials. Brushed-on polymer varnish works better on acrylic paintings without any dry media on the surface.

Thoroughly dry

Always allow time for the painting to be completely dry before varnishing. Thick acrylic may feel touch dry but the underneath layers take some time to dry.

Retail Therapy. *This is a painting on an MDF board primed with gesso which has been varnished with polymer varnish satin. Unfortunately I had forgotten about a small amount of off-white oil pastel which ran across the whole painting. By brushing on the polymer it spread the pastel and gave a hazy look to the painting.*

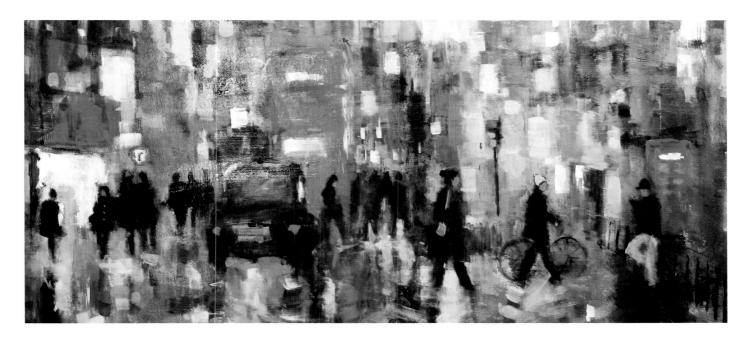

London Reflections. *This is an acrylic painting on canvas with a small amount of collage adhered with medium; it has been sprayed with archival MSA varnish.*

Isolation coat

To ensure successful removal of varnish at some time in the future to reveal an undamaged painting underneath it is advisable to use an isolation coat which basically creates a barrier between the painting and the varnish. This coat is not removable and adheres to the painting surface. However, when the varnish is removed, this layer will protect the artwork underneath from being disturbed and damaged. To make a brushed-on isolation coat dilute two parts soft gel to one part water and brush on several coats.

UV protection

I personally use Golden Archival Varnish which contains ultra violet light stabilizers (UVLS) to protect materials from damaging light sources. The amount of protection from light damage is directly related to how many coats of varnish are applied to the painting. In general, spray-varnish layers are thinner than varnish that is brushed on. If the artwork is going to be exposed to extreme light and possible damage then it is best to brush on several coats of polymer varnish gloss before using a spray varnish on the final coat to unify the sheen that you wish to achieve.

Another option is polymer varnish with UVLS, a water-based acrylic polymer varnish which protects the surface not only from dirt but also from light damage. This varnish provides an easily removable top coat for your painting with a film harder than acrylic paint itself and less susceptible to environmental damage. You can choose from matte, satin and gloss. This varnish can be removed with ammonia. The dust and dirt will be removed along with the layer of varnish revealing the clean painting underneath.

Golden gel top coat with UVLS coat was originally produced as a top coat to protect digital prints, but it can be used on paintings to protect collage or any digital media against fading, although this coat is not removable. It comes in gloss and semi-gloss so you can use it as a top coat to modify the sheen of the surface. This gel is also versatile, as it can be used for image transfer, creating gel skins and extending paints, making texture or as a ground to paint on.

If you are not framing your work behind glass then to fully protect the surface you will still need a layer or two of varnish.

Varnish advice online

There is a tremendous amount of information online about the correct way to varnish and the removal of varnish. Choose the website of one or two reputable brands and do some thorough research before embarking on varnishing your painting.

One final thought

Years ago an art tutor told me that it is only the first 1,000 paintings that are hard, it gets easier after that. I can reveal that 9,999 paintings later I am still waiting. However, on reflection, it is exactly the challenging nature of painting that has kept me motivated all this time and spurs me on to continue learning and exploring new avenues and discovering yet another aspect which keeps me going for a while.

We have now reached the end of this exploration together and I hope that this is just the beginning of your adventure in the exciting world of mixed media. Of course, no amount of reading or watching others will make up for the practical effort that you put into learning your craft. Nurture your vision to bring individuality and originality to your art; this is what will make you stand out from the crowd. Strive to create your own personal visual language through which you can communicate, and your authentic emotional response will resonate with your viewer.

The road to creativity is full of highs and lows. The highs are great but you also need to be equipped to deal with the lows. Disappointment is the fruit of high expectation. Always match your expectation to the level and the quality of your effort, and you will avoid being disheartened and able to go on improving. Try not to be too focused on the end result to the extent that you forget to enjoy the act of creating.

City Lights.

OPPOSITE: Jamaican Street Vendors *(acrylic, collage and soft pastels).*

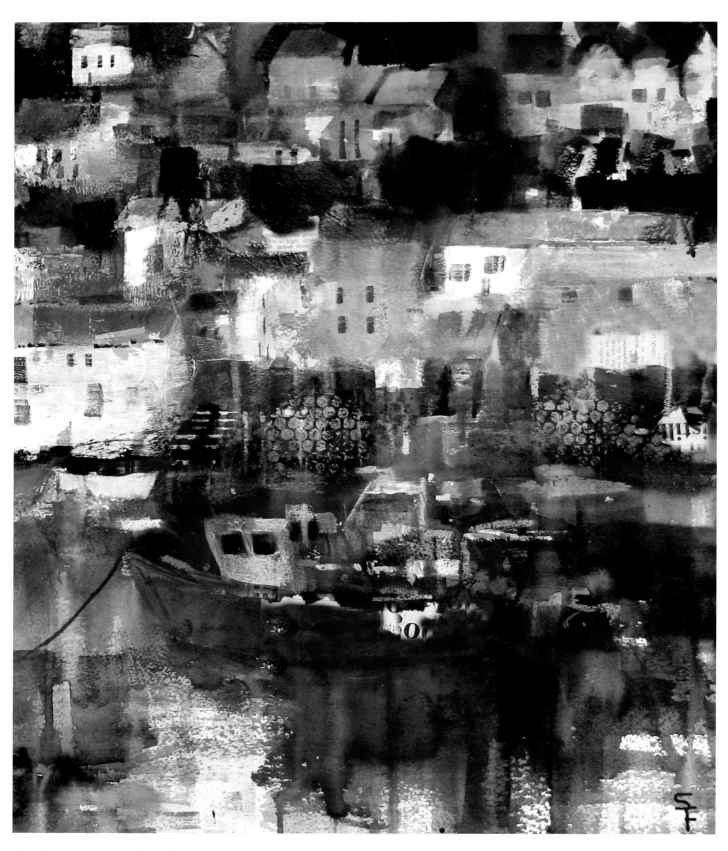

Cornish Harbour at Dusk. *Golden High Flow Fluids, heavy body acrylics, heavy gel and soft pastels.*

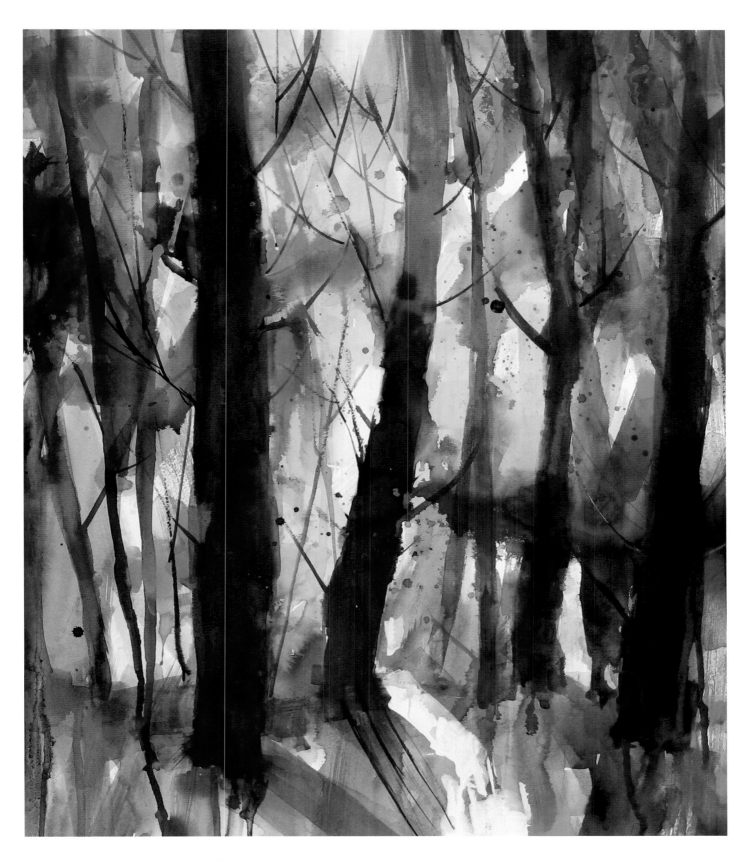

Rainbow Woods. *Golden High Flow oil pastels and soft pastels.*

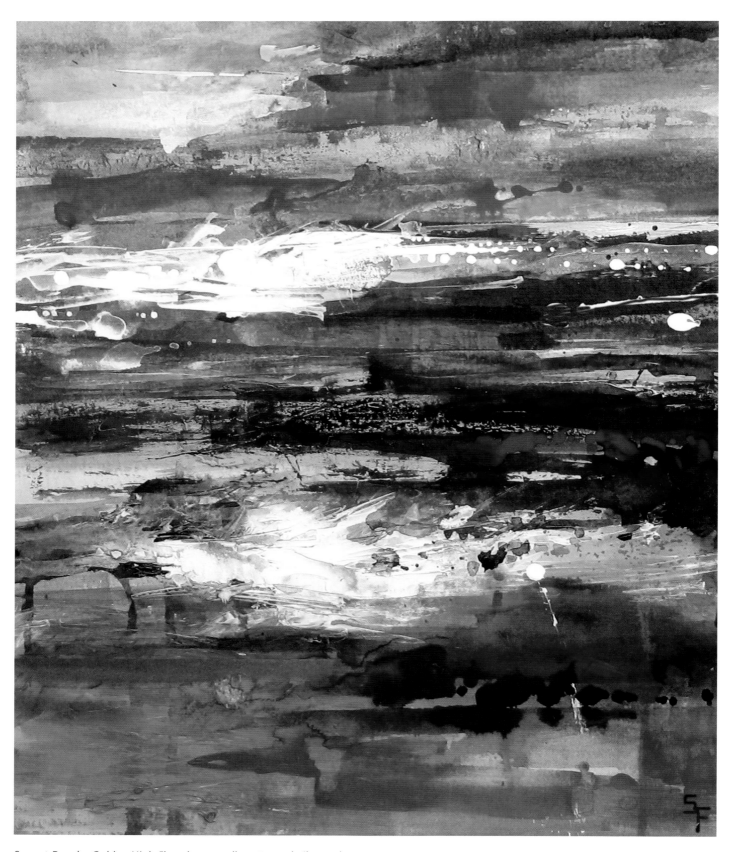

Sunset Beach. *Golden High Flow, heavy gell matte and oil pastels.*

LIST OF SUPPLIERS

GOLDEN Artist Colours
www.goldenpaints.com

Global Art Supplies
www.globalartsupplies.co.uk
www.stcuthbertsmill.com

INDEX